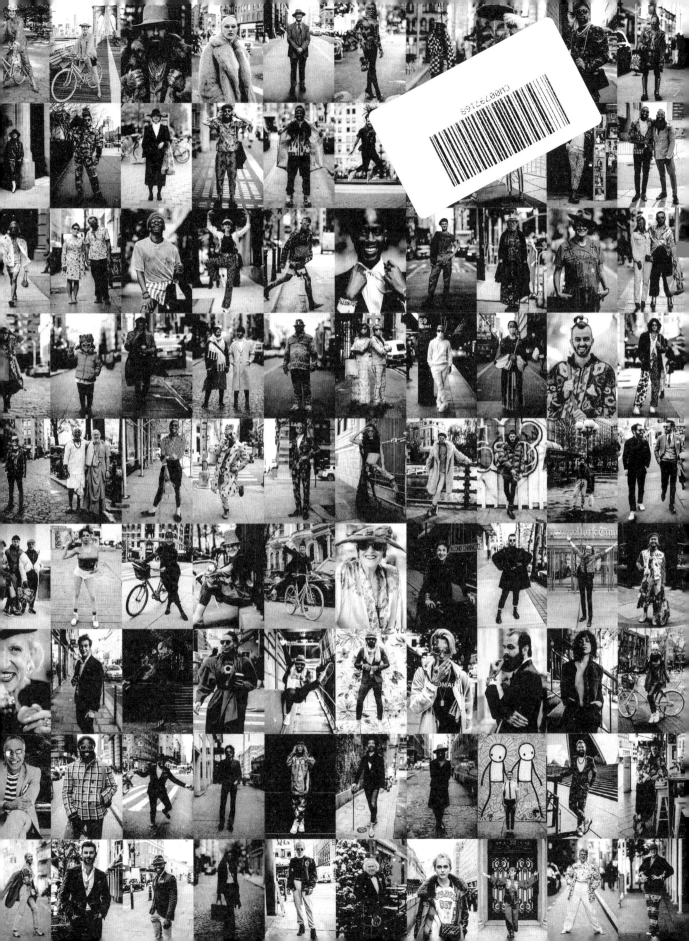

STREET
UNICORNS

BOLD EXPRESSIONISTS *of* STYLE

STREET UNICORNS

BOLD EXPRESSIONISTS *of* STYLE

ROBBIE QUINN

CERNUNNOS

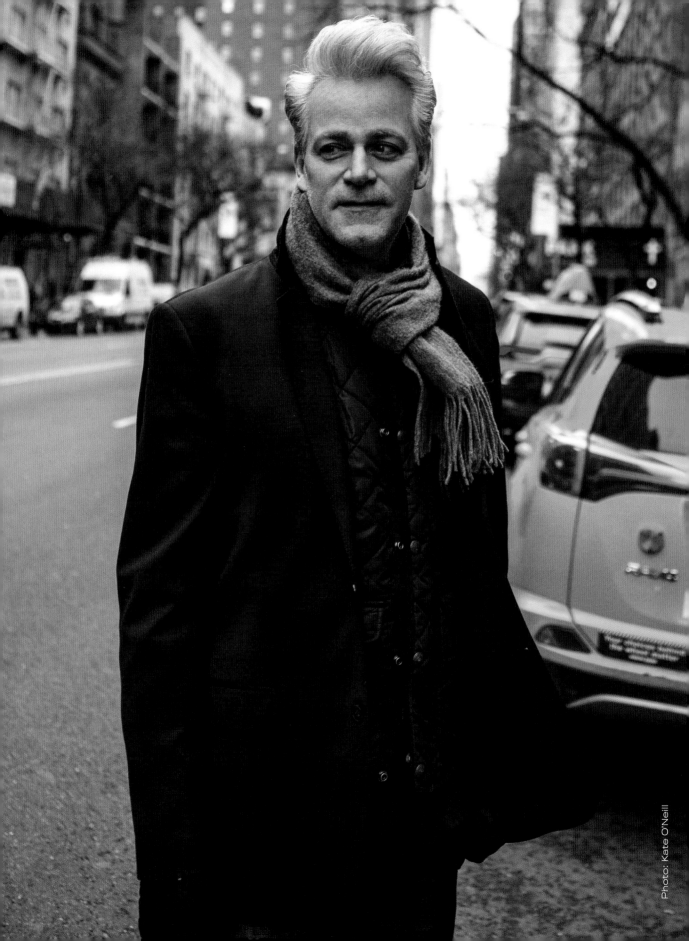

Walking alone in Nolita, I feel like I am entering a scene of a movie that no one told me I was going to star in. I assume I'm the protagonist and that something exciting is about to happen. I expect it. So without turning my head or looking down to avoid attracting attention, my eyes pan the street to see if there's anything unusual. Something that stands out. I find myself on the edge of the neighborhood near Sant Ambroeus, and in the crosswalk among the mass of nondescript pedestrians, a Street Unicorn gleams.

For my purposes, a Street Unicorn is someone that presents themselves in a unique way, with purpose. Someone that stands out, even if they are afraid, because, for them, it would be unnatural *not* to stand out.

As they come close enough to engage, I say, "Excuse me," the way someone might if they were about to ask directions. But then I compliment them on how dazzling they look in the way someone might tell a famous musician how their music changed their life forever. It's genuine enthusiasm, because in a sea of anonymous faces consumed with their own lives, here's someone that clearly is intentional about their existence—or at least searching for a meaningful life.

This is someone who is among the most interesting of humans, and I want to know them. Not just because of the way they look, but also to know about their journey. I want to learn from them. What was it that brought them to this point, where they feel their need for freedom of expres-

sion outweighs the possibility of a lack of acceptance? I want to hear their opinions. I don't have to agree with them; I'm more interested in what sets them apart.

―

Along my travels, I have stumbled upon, been sought out by, and pursued individuals that have the exceptional ability to boldly express themselves through their own personal style. In some, this may seem subtle; they're considered someone who pays attention to detail in the way they dress. Society may call them polished, dapper, elegant, or refined. Others draw even further outside the lines, and the fearful unadventurous may call them misfits, oddities, or freaks.

I call them all Street Unicorns, bold expressionists of style. I don't measure them by the extent of their unconventionality but by their common resistance toward choosing what is expected of them by media, friends, family, or society in general. The calculated choices we make by presenting ourselves in a unique way says, "We matter." Our choices declare, "This is me." Because we are not all quite the same, we can learn and grow from each other.

And now, inside this book, I share these images, viewpoints, and aspirations of Street Unicorns in an effort to not only inspire, but also to encourage people to gain more acceptance of and appreciation for others.

COLORFUL BACKGROUNDS

Where we live is as much a part of our identity as anything and I find that cities are a haven for bold expressionists of personal style.

Some people that are raised in the city know that in order to stand out among the masses you need to be innovative, creative, and sometimes outrageous. How we dress can be a reflection of that attitude.

Transplants to the city often make the journey because they couldn't be themselves wherever they were from originally. Diversity in smaller communities is rare, and acceptance can be hard to find. In a city, there is a certain freedom that doesn't exist anywhere else. I believe this is why so many great ideas have come from cities.

It may sound counterintuitive, but perhaps because there are so many new people coming to cities all the time, everyone seems to be more curious rather than suspicious of one another. Presenting yourself in a different way might not be judged as harshly, and there's always somebody that gets you, somebody that feels something similar. And ideas get shared and movements are born. This can happen with regard to music, fashion, social issues—any situation where open minds and hearts meet.

We're all trying to do the same thing: express ourselves. And there is no right way. I recently posted a photo series and asked a few people I know to share it if they cared to. Everyone enthusiastically did, except for one individual who thought that the subjects had horrible style. I wouldn't have minded had they said they

felt it didn't line up with their audience, but I was so disappointed that this person had such a narrow, exclusionary perception of taste. We don't need to dress the same way as someone else to appreciate their approach, just as we don't need to have the same beliefs as each other to know that most of us are hoping for world peace and good will. It's our openness toward each other that leads to understanding and appreciation. Just because we don't understand someone else's approach to style and life doesn't mean it doesn't have value.

So how do we allow ourselves to be accepting of others for who they are? Diversity in a community is one thing, but integration is essential to growth. It's the birthplace of new ideas. Tolerance is better than violence, but it's still a lost opportunity. Real acceptance of those who are different brings about opportunities for everyone. When someone's personal style is completely different from another's, it provides an opportunity to learn from each other. We shouldn't let that go. Rather than regarding it nervously, we should count ourselves fortunate, embrace it, and be hungry to expand our perspective.

COLORFUL PEOPLE

To be seen or not to be seen.

Think of it: If we were all exactly the same, like clones, we would wear the same clothes, like the same drinks, enjoy the same foods, and listen to the same music. There would be little need to go to parties. What's the point of going out at all? This would certainly be a boring existence. It's

true that most of us have some friends who are similar to ourselves. We feel a certain comfort there, and that's okay. But it's what is different about us that's stimulating. We also like, and need, to have people around that challenge us so that our understanding can expand and our perspectives can evolve.

Blending in and keeping a low profile can be just as much a personal expression as standing out. It's okay to not want to be noticed, but being intentional about personal style leads to more purposeful days. Sometimes we may not want all the attention, and we'll dress down as much as possible to go out and observe rather than be observed. Simply observing can be a delightful way to spend the day, especially in the city. A person can be anonymous and watch the world like a movie. I find that both introverts and extroverts need time to stand out and also to simply blend in. They're both looking for balance, but perhaps for different reasons.

On some level, we all want to be noticed. Some of us want to be stars; others at least want to be acknowledged. The bold expressionists of style are the ones that, as a photographer, I'm particularly interested in at the moment. These people, whether introverts or extroverts, all have a lot to say. They are the risk-takers. An individual needs real vulnerability to put themself out there in an authentic way. They must set aside the fear of being criticized in an effort to understand themselves and to be understood. Street Unicorns have interesting stories, and I want to hear them and learn from them. They often use their personal style to inspire others to embrace themselves and celebrate who they are. I find that these are some of the kindest, most sensitive, and sincerest people I've ever met.

THE POINT

Here's to hoping that you're the type of person that recognizes and celebrates that you actually are unique. With so much pressure to fit in with one group or another, we can often resign ourselves to conforming and not really adding anything to the conversation. But deep down, we all want to.

Inside of all of us is this unique individual waiting to be explored or rediscovered. Although in our DNA we have so many similarities to one another, there's still something in each of us that sets us apart. As a result, we struggle to be a part of a group and yet distinctly different. It's the element that makes us different from one another that's most intriguing to me. I believe we are not always supposed to be afraid of the unknown or unfamiliar but to embrace it, learn from it, and help each other advance as humans.

Without diversity, we grow stagnant. Freedom of expression, on the other hand, stimulates progress. And as the world connects through the Internet, many of us are finding there's so much more diversity out there that we can appreciate.

When the great experiment of America began (and I'm not going to pretend it was all pretty), New York became a convergence of new and different ideas. People that came to the city shared the common experience of encountering other cultures, which resulted in opportunities for people to learn from each other. Now, through social media, the world is exploring and discovering more opportunities. We are in a new, great experiment on an even larger scale. People are seeing the way others across the globe dress and express themselves while freely sharing thoughts, ideas, and dreams. This integration is the birthplace for big ideas that will impact the world on a larger scale. We are so fortunate to be a part of it, to embrace it, and to be hungry to expand our perspectives. Once again, this is stimulating progress, and of course the disruption scares those that are in charge who want to resist change. They don't really want us talking to each other. They want us to fall in line.

But that's not going to happen. People, by connecting with each other, are finding that the confines of restricted norms are false. And so it is with personal style. The brave are shedding the restrictions of lies and reflecting the version of themselves that lines up with who they really are or aspire to be. And bravo! We will all benefit from the opportunity we've been missing out on: the chance to be inspired and inspire others around the world to have a more meaningful, intentional existence.

Through the sharing of photography on the Internet, we've been able to distinguish a common thread of vulnerable humanity that can be found in each of us. I celebrate the people who have the courage to be brave enough to risk criticism and boldly express themselves through personal style. In doing so, others may be more willing to accept people who are different and be inspired to look within and feel free to discover the most authentic, unique version of themselves—and perhaps stand out as well.

I have found that when we show appreciation for an individual's uniqueness, they are more likely to be open and share their perspective in a vulnerable, honest way. It's during these times when I've been able to learn things about humanity that

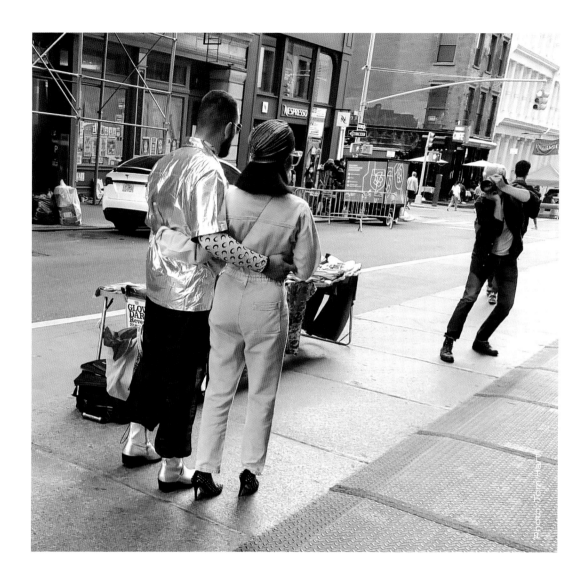

expand my worldview and understanding. The conversations can easily go from an individual's personal style to their hopes and dreams. Things that normally might not be easy to discuss are now safe to talk about, even with me, a stranger, all because I noticed them. I have to say that these are special moments in my life, and I encourage everyone to try it. You don't have to take someone's photo. Just say something nice to a person who is putting themself out there. See what happens.

WHY ME?

Why am I compelled to share these images and stories?

When I was younger, I played piano and keyboard in what I call a poser hair band. We performed mainly in the Philadelphia area, as my family had moved from New York when I was a child. We did end up doing a few gigs in New York and even had a show at CBGB. My bandmates and

I had high hopes and were on the brink of success, but then (like many bands) we broke up due to a toxic combination of too much ego and too little maturity.

During those years in the band, I had wanted to live the rock 'n' roll life, and a big part of it was the look. It had to be my own and scream cool.

I carefully cut leather strips and attached them to conchos and then pinned them down the sides of my black jeans. I put handcuffs on my belt loops and would cut my T-shirt sleeves at a precise angle. The arrangement of pinback buttons on my jean jacket involved a great deal of strategy, and I had a collection of dangling earrings that would show through my big hair. To achieve that hair, I used to use an entire can of Aqua Net every day. I used egg whites on it, mayonnaise, and even toothpaste to make it stand up. Sometimes I'd also spray paint it. Who needed hair dye?

I never considered this a costume that I only wore on stage. It was me. I would go to weddings, funerals, or anywhere else living, breathing, and sleeping who I was. It would empower me to have the confidence to believe in myself.

When the group broke up, it hurt enough to make me want to abandon music. I moved to Florida. I stopped performing and even listening to music for a number of years. I realize now that it was a very sad time for me. I cut my hair, wore disgustingly nondescript clothes, and had a number of office jobs.

It took some time, but I eventually started my own successful large-scale concert promotion company. I moved to Nashville, managed a few acts, and began pursuing things that made me happy again. While this was going on, people in Nashville were wearing backward baseball hats, bell-bottom jeans, and tacky T-shirts with scrolling type on them that was illegible. I admit, I succumbed to trying to fit in, but I never did. I always felt like a New Yorker at heart.

Then, some of the acts I was working with needed photos. So I taught myself how to shoot film, took some shots, and to promote the talent, I posted them on the only real social media at the time: MySpace. Within a month or two, record producers, other managers, and performers themselves started calling to hire me as a photographer.

All of a sudden, there was a creative element in me that came alive again. I started to feel like myself for the first time in a long time. I stopped doing everything else and ended up shooting every type of photography imaginable. I wanted to get good as fast as possible. But it wasn't until I moved to New York that I began to come into my own.

New York has been, for me, like it has been for millions of others, an empty canvas to be uninhibited and painted upon. I'm finally making some progress in creating my own personal style, too. It's been an adventure, and I'm still making my way there, but it's through walking the streets, seeing so many people, and talking to those that intrigue me that has helped. I've found that people's most extraordinary personal style has little to do with what they wear. It's how well they're visually able to communicate who they are.

So why am I compelled to share these images and stories? Because they have been my therapy, a way of searching not necessarily for who I am, but for the path toward how to express it. Hopefully you'll find something in the pages that will help you be the best and most authentic version of yourself as well.

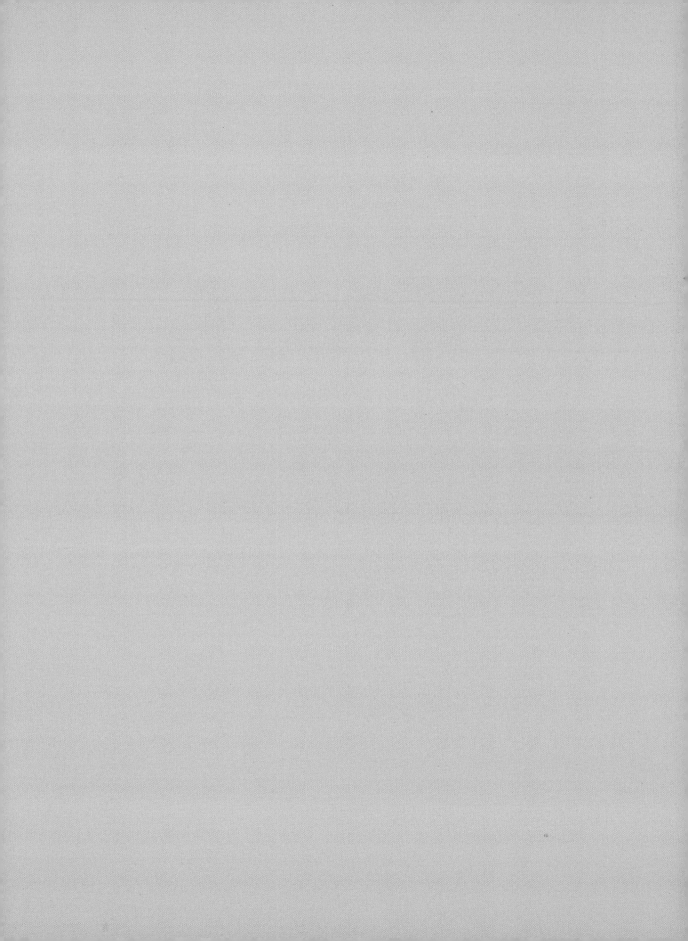

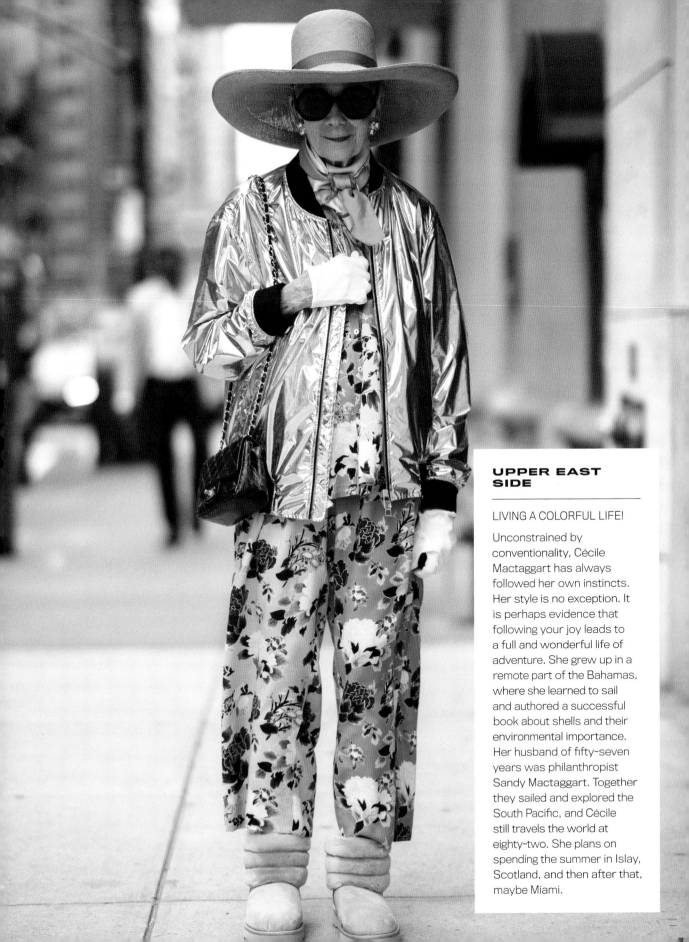

UPPER EAST SIDE

LIVING A COLORFUL LIFE!

Unconstrained by conventionality, Cécile Mactaggart has always followed her own instincts. Her style is no exception. It is perhaps evidence that following your joy leads to a full and wonderful life of adventure. She grew up in a remote part of the Bahamas, where she learned to sail and authored a successful book about shells and their environmental importance. Her husband of fifty-seven years was philanthropist Sandy Mactaggart. Together they sailed and explored the South Pacific, and Cécile still travels the world at eighty-two. She plans on spending the summer in Islay, Scotland, and then after that, maybe Miami.

WEST VILLAGE

"There was this moment. I was shopping at a thrift store
and there was this great ring I wanted, and then a customer
said, 'That's a woman's ring,' and I said, 'I don't care.
Fashion has no boundaries, and I like it.' From then on,
I promised myself I would stay true to my style according to
me. It often helps me tell the story of how I view the world
at this moment. I enjoy creating. I love how it brings me
nothing but happiness, joy, and peace."

@DEANDRE7501

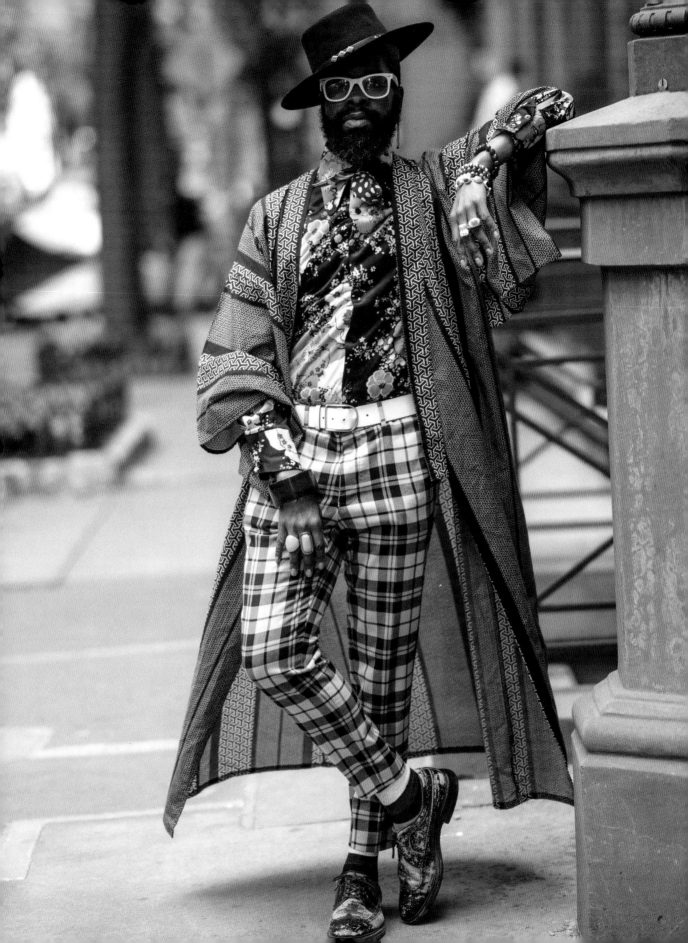

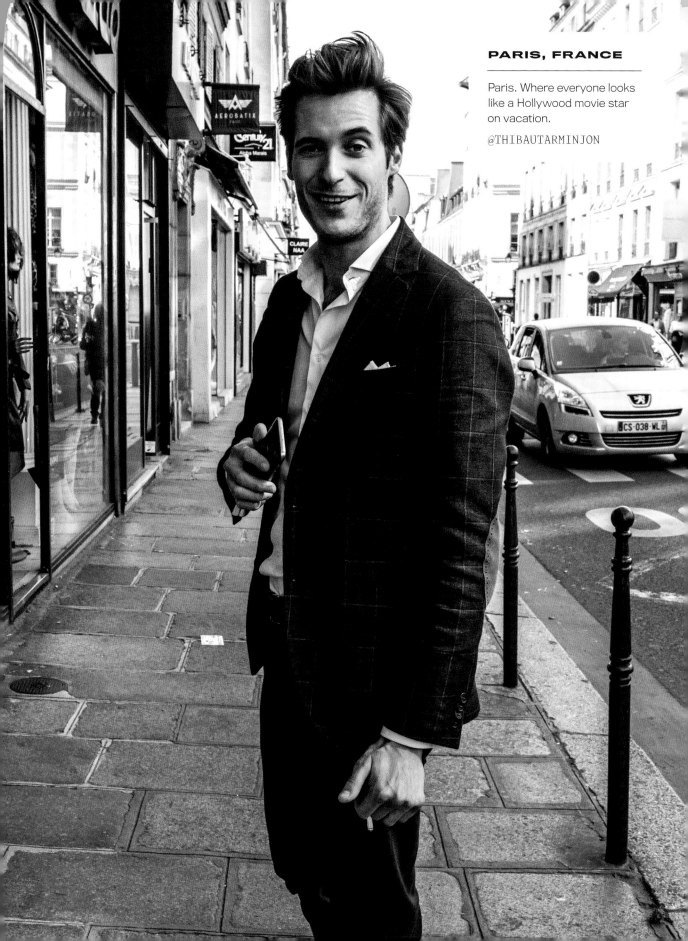

PARIS, FRANCE

Paris. Where everyone looks like a Hollywood movie star on vacation.

@THIBAUTARMINJON

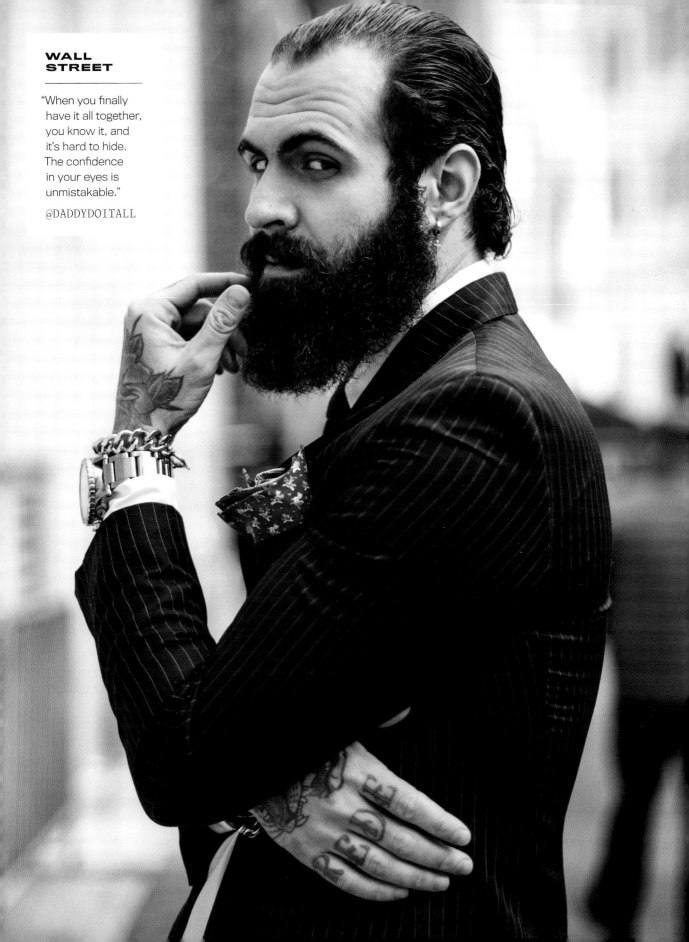

"When you finally
have it all together,
you know it, and
it's hard to hide.
The confidence
in your eyes is
unmistakable."

@DADDYDOITALL

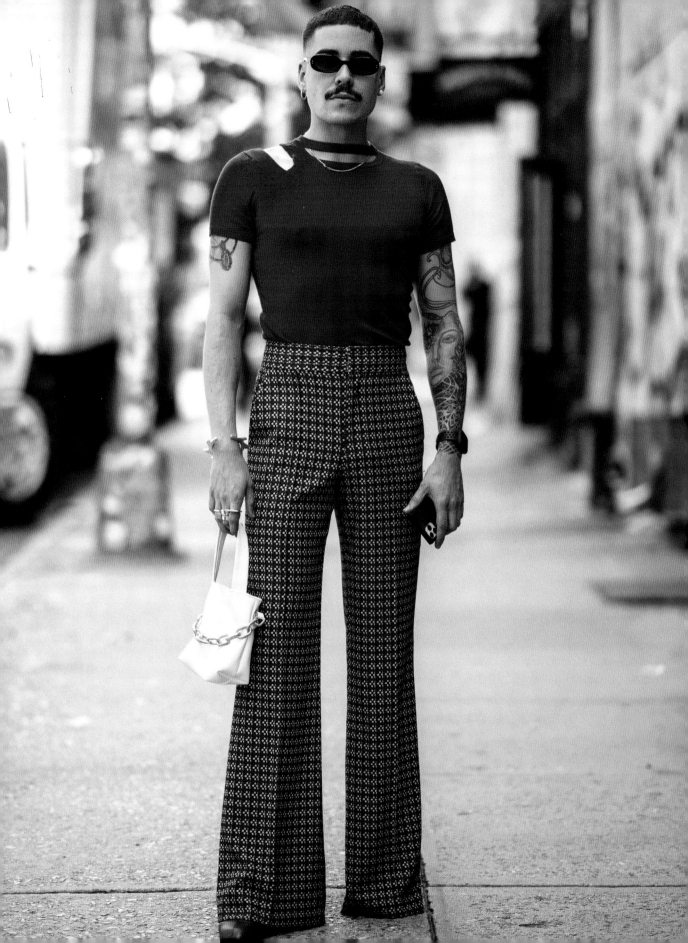

SOHO

"I've had several styles throughout the years, and with each transformation, I feel I learn more about myself and how to approach others. It's a gateway into having a beautiful conversation with a stranger. I truly never know who I'll meet just by expressing myself without any words through my style.

"I'm currently feeling a sense of adulthood but also a resurgence of youth all at once. I just turned thirty, and it's truly really awesome to be the most realized version of myself. I think this is a moment in life where I can just be rather than try and find myself."

@SANTIAGOBOUHOT

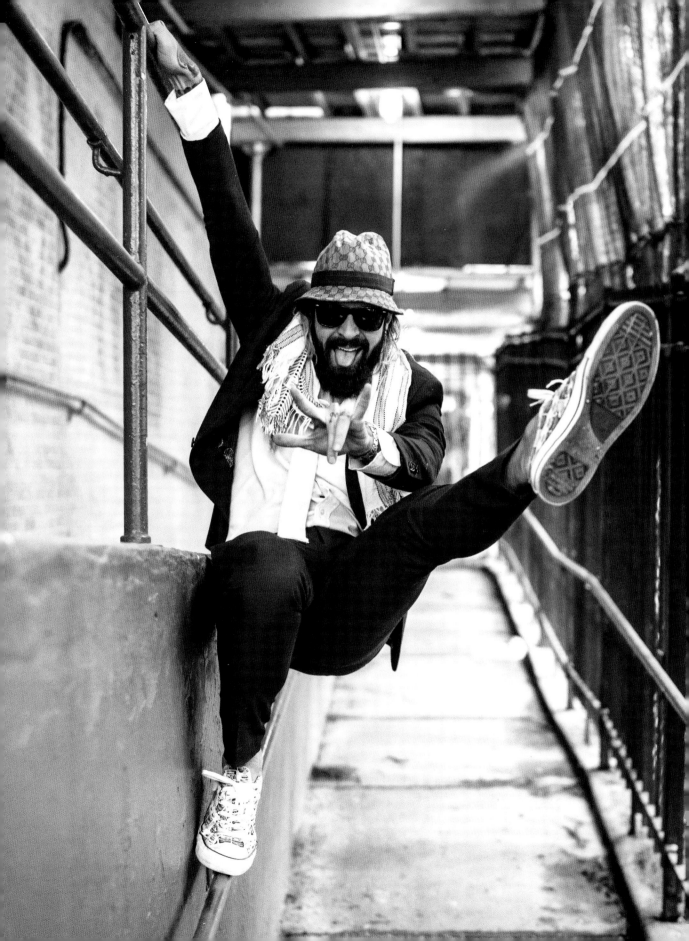

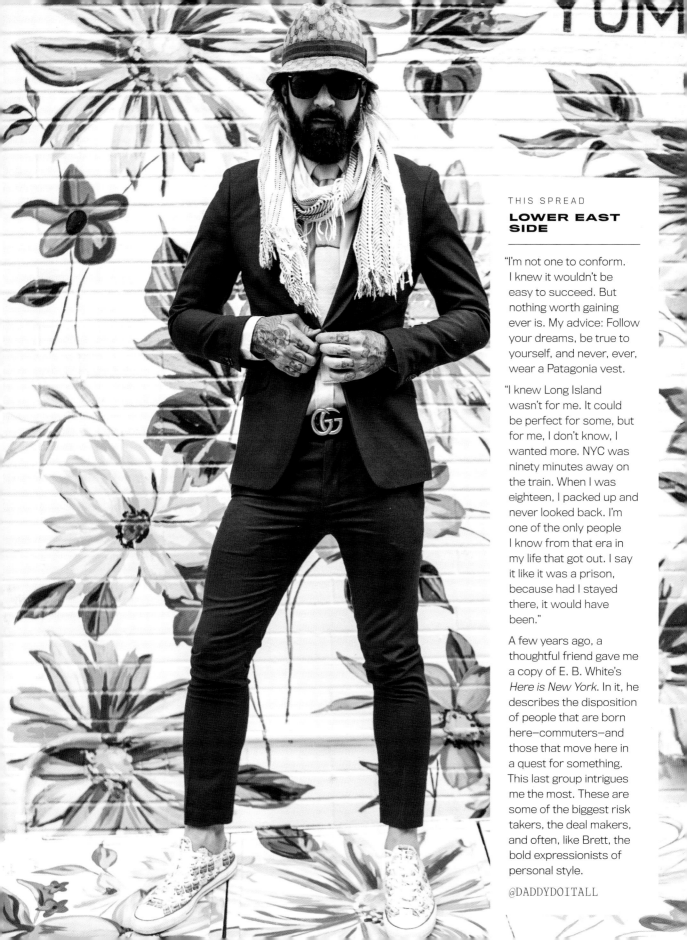

LOWER EAST SIDE

"I'm not one to conform. I knew it wouldn't be easy to succeed. But nothing worth gaining ever is. My advice: Follow your dreams, be true to yourself, and never, ever, wear a Patagonia vest.

"I knew Long Island wasn't for me. It could be perfect for some, but for me, I don't know, I wanted more. NYC was ninety minutes away on the train. When I was eighteen, I packed up and never looked back. I'm one of the only people I know from that era in my life that got out. I say it like it was a prison, because had I stayed there, it would have been."

A few years ago, a thoughtful friend gave me a copy of E. B. White's *Here is New York*. In it, he describes the disposition of people that are born here—commuters—and those that move here in a quest for something. This last group intrigues me the most. These are some of the biggest risk takers, the deal makers, and often, like Brett, the bold expressionists of personal style.

@DADDYDOITALL

CHINATOWN

"Being a little Black boy coming from Belize, I had to find my way to fit in. I was ten years old, and America was so big. The things other kids said about my cheap sneakers and hand-me-down clothes hurt. None of the girls liked me, and I sure wasn't popular enough to hang with the cool kids because my style was so boring and stale. I had no confidence, and I felt ugly.

"One day my older brother was watching an OutKast music video on TV, and I wanted style like them! I begged my mom to take me shopping for new clothes, but we weren't rich, so she took me to a thrift store. When I got inside, it felt like heaven! There was so much stuff! So much color! So much style! So many personalities! And everything was so cheap, so I was able to get a lot! The next day at school, I walked in with confidence.

"After that, everyone was coming up to me asking me where I got my stylish clothes. The girls even wanted me to walk them to class. I knew from that day that style was important. It allows me to speak without saying a word. It has been my way to fully be myself and fully embrace my creativity and share it with the world, one outfit at a time. My style helped me with the insecurities I once had as a kid. It has allowed me to manifest the person I always wanted to be."

@LEGEND_ALREADY_MADE

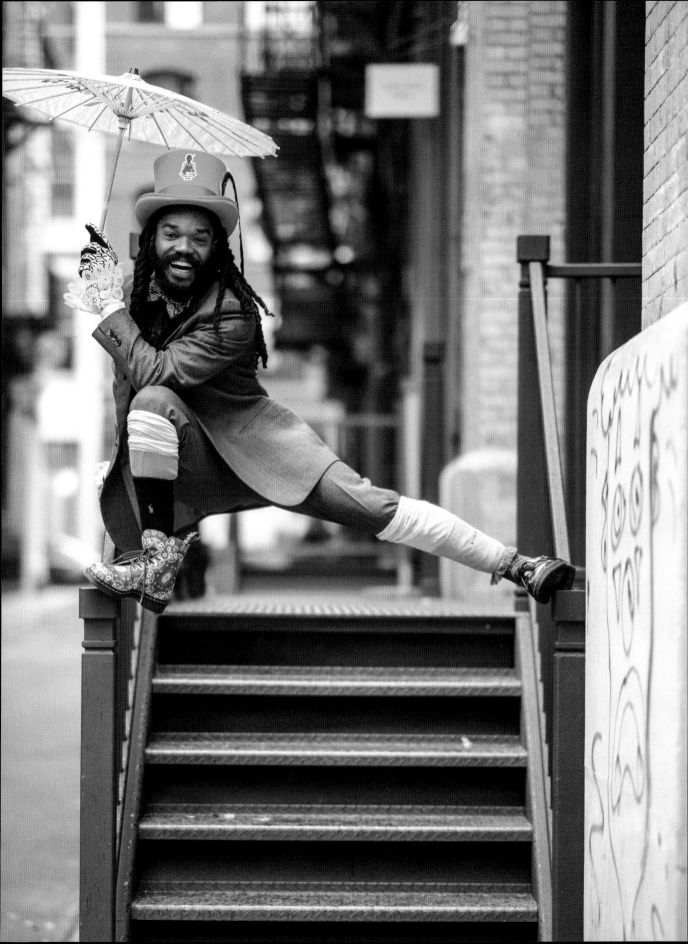

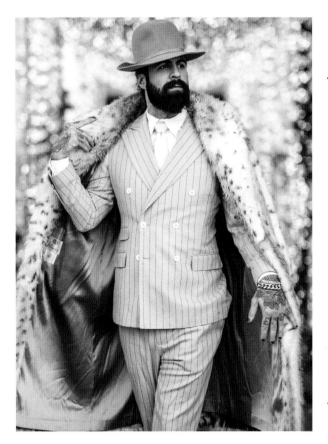

PUBLIC HOTEL, BOWERY

"Some may feel comfortable in the box that society has made for them. Basic black suit, square-toed shoes, hair parted down the side, with a jacket from Men's Warehouse. And don't get me wrong—there is nothing inherently wrong with that. But for some of us, for the select few that dare to dream, well, we just need more. More color. More style options. More risks. More life. The man in the simple suit would not be comfortable in the suit I'm in—and I would not be so in his either."

@DADDYDOITALL

BOWERY

"Style is so specific. Either you have it in you or you don't. I despise the word 'trendy.' Trends die. A great look should live forever. I dress for the day I want to have and for the life I've chosen to live. Be it denim or tailored suits, wing tips or Jordan's, tank tops or fur coats, like the Bard said, 'To thine own self be true.'"

@DADDYDOITALL

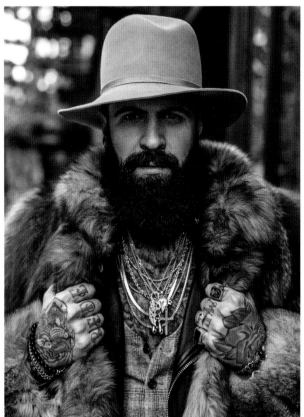

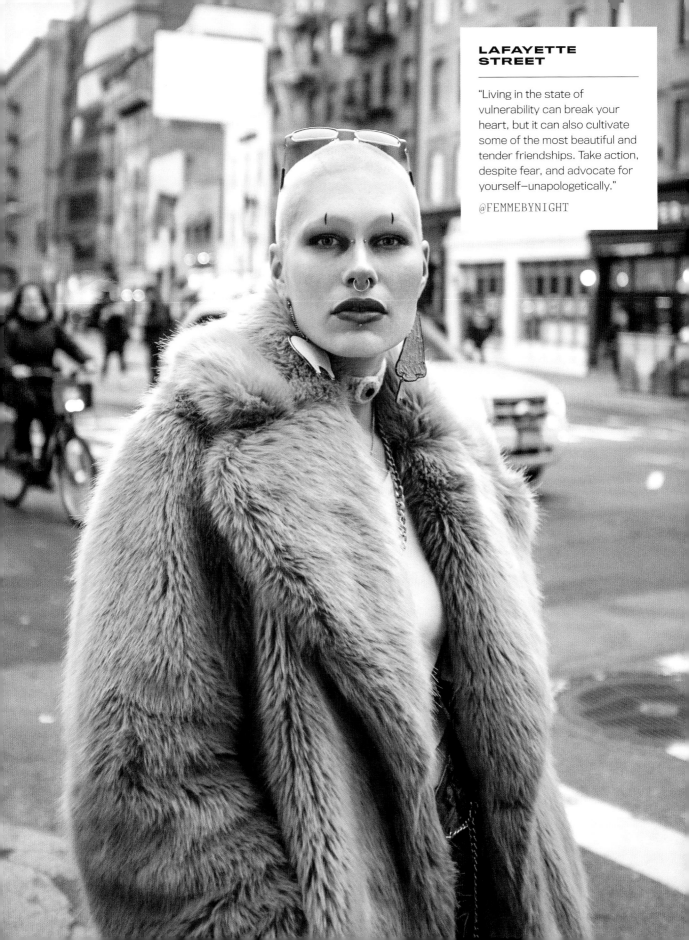

LAFAYETTE STREET

"Living in the state of vulnerability can break your heart, but it can also cultivate some of the most beautiful and tender friendships. Take action, despite fear, and advocate for yourself—unapologetically."

@FEMMEBYNIGHT

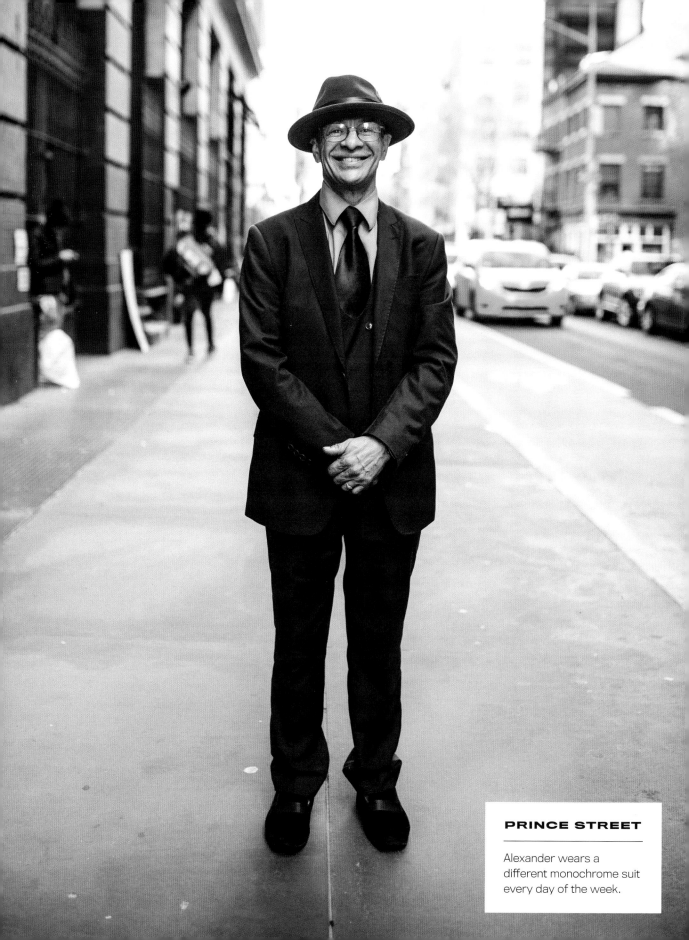

PRINCE STREET

Alexander wears a different monochrome suit every day of the week.

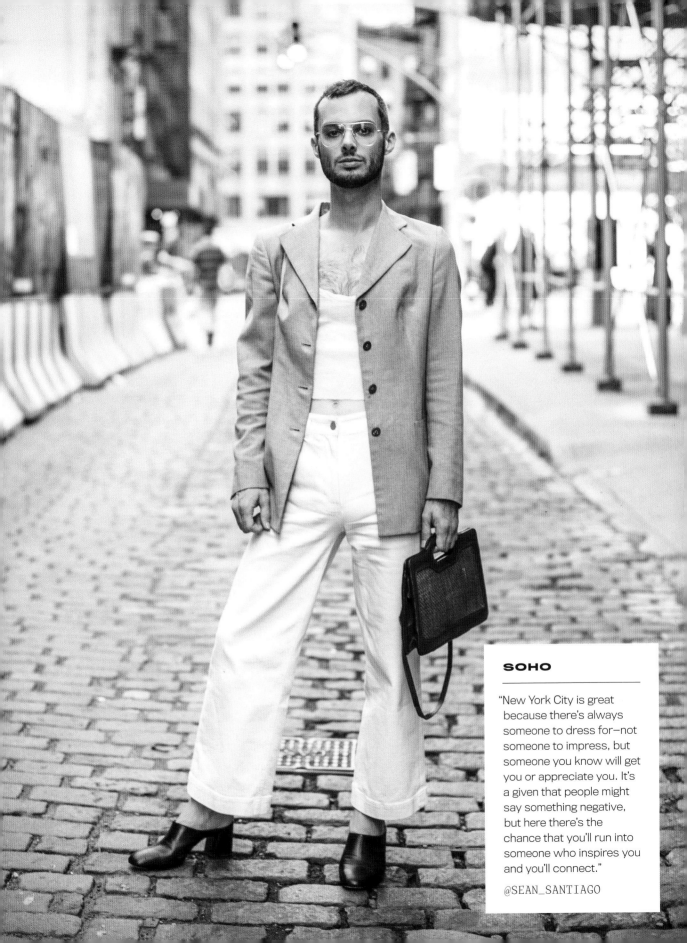

SOHO

"New York City is great because there's always someone to dress for—not someone to impress, but someone you know will get you or appreciate you. It's a given that people might say something negative, but here there's the chance that you'll run into someone who inspires you and you'll connect."

@SEAN_SANTIAGO

ROCKEFELLER CENTER

"Gretchen and I have been in style sync since the day we met. I couldn't imagine being with someone that didn't take pride and care in their dressing. It makes our being together whole. Wearing nice vintage clothing every day feels like the most honest and free life for us. If we are going somewhere special, we like to feel as if we are one in our appearance. I am very aware that we live in the year 2021, and certainly I know that we dress differently, but I am often told 'I wish I could dress that way,' and I always encourage people that they can!"

@CHROMEDEC with @CHAPEAUG

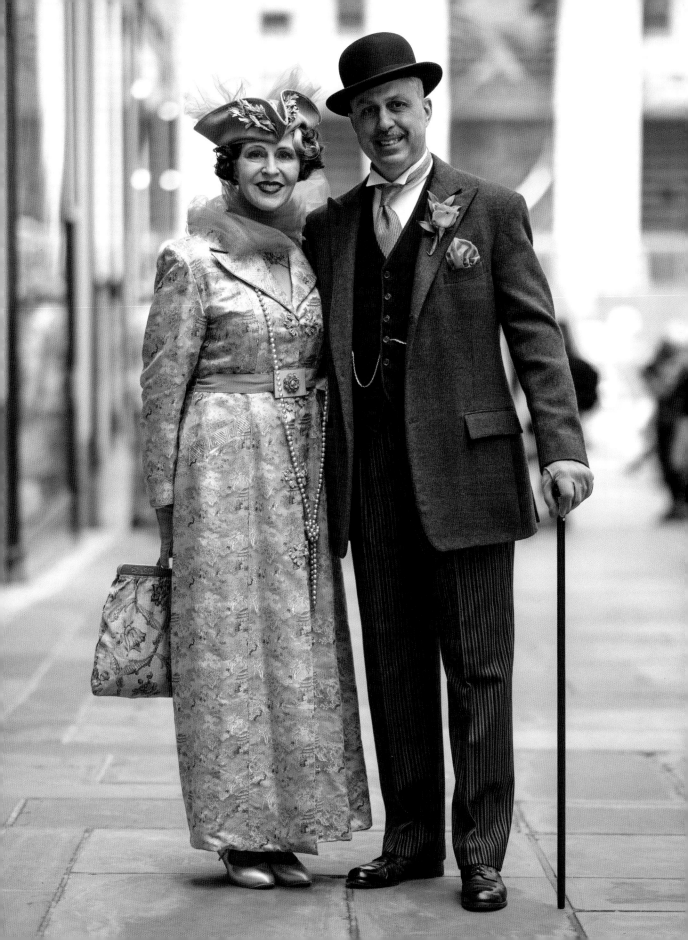

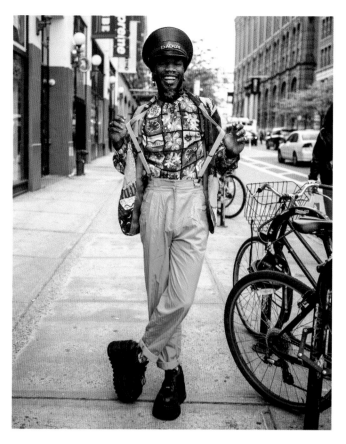

LAFAYETTE STREET

"My style is very unique, different, and a little crazy if you ask me—but it works. I LOVE COLOR and patterns; they make me happy. I dress the way I do to show kids it's okay to be different and to always be yourself. Happiness comes from within."

@JOJO.CLUBKID

GRAND STREET

"Most of the time, I live in Austin, Texas, where its population is just over eight percent Black. Because of my style, I often get invited to these fancy, formal events. Typically, I end up being the only Black guy there besides the janitors and cooks. I'll show up in one of my usual outfits and people want to be cool and hang with the Black guy. Then they use slang sayings improperly and make awkward jokes.

"This could all feel uncomfortable, but I choose to use it to get familiar with a different world and influence and inspire others there. I know my confidence, style, and fashion sense open up many opportunities for me, but I'm not waiting for the perfect moment. I want to take each moment and make it perfect."

@LEGEND_ALREADY_MADE

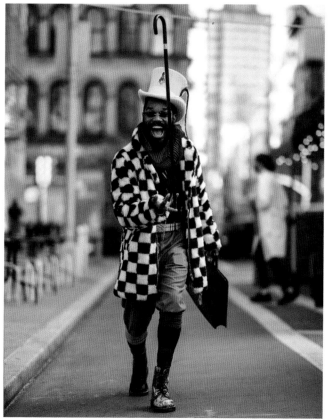

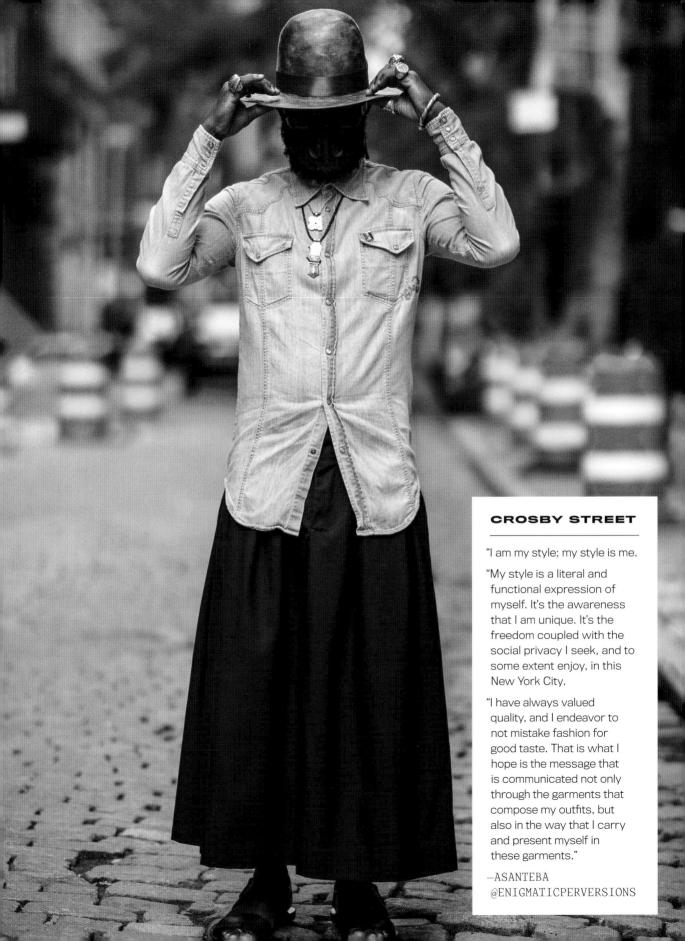

CROSBY STREET

"I am my style; my style is me.

"My style is a literal and functional expression of myself. It's the awareness that I am unique. It's the freedom coupled with the social privacy I seek, and to some extent enjoy, in this New York City.

"I have always valued quality, and I endeavor to not mistake fashion for good taste. That is what I hope is the message that is communicated not only through the garments that compose my outfits, but also in the way that I carry and present myself in these garments."

—ASANTEBA
@ENIGMATICPERVERSIONS

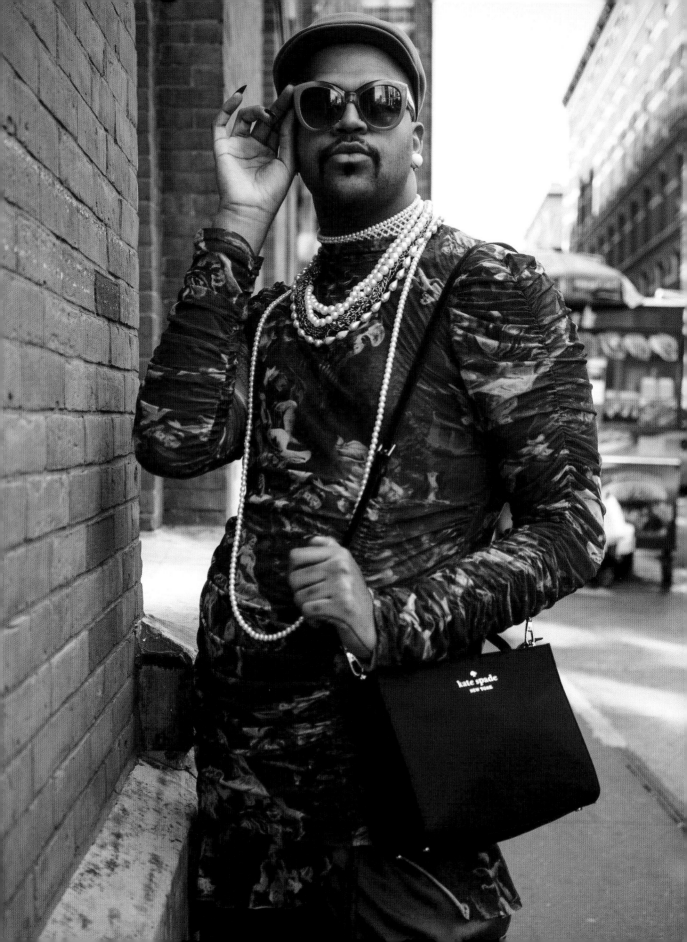

PRINCE STREET

"As an individual who identifies as nonbinary, I find clothing to be an integral part of my identity. Clothes influence my mood and overall confidence greatly. As a 6'8" person of color who outwardly presents as more feminine, I find myself thinking about my safety quite often. Yet when I step out of the house wearing an outfit that makes me feel beautiful and complements my figure, it's almost like my form of armor protecting me from some of the harsh realities of the world we live in.

"As a fashion designer, my experiences have greatly influenced my own design style and have led me to focus on a more androgynous-yet-theatrical approach. One of my goals surrounding my style is to help inspire individuals to get out and find their own style no matter how extravagant or minimalist it may be. The world can be a scary place, but we all have the ability to make it beautiful by trying to be our most authentic selves. The fact that we can spark this change each and every day just by getting dressed is one of the most beautiful gifts I believe fashion and style has ever given us."

@CRW_1999

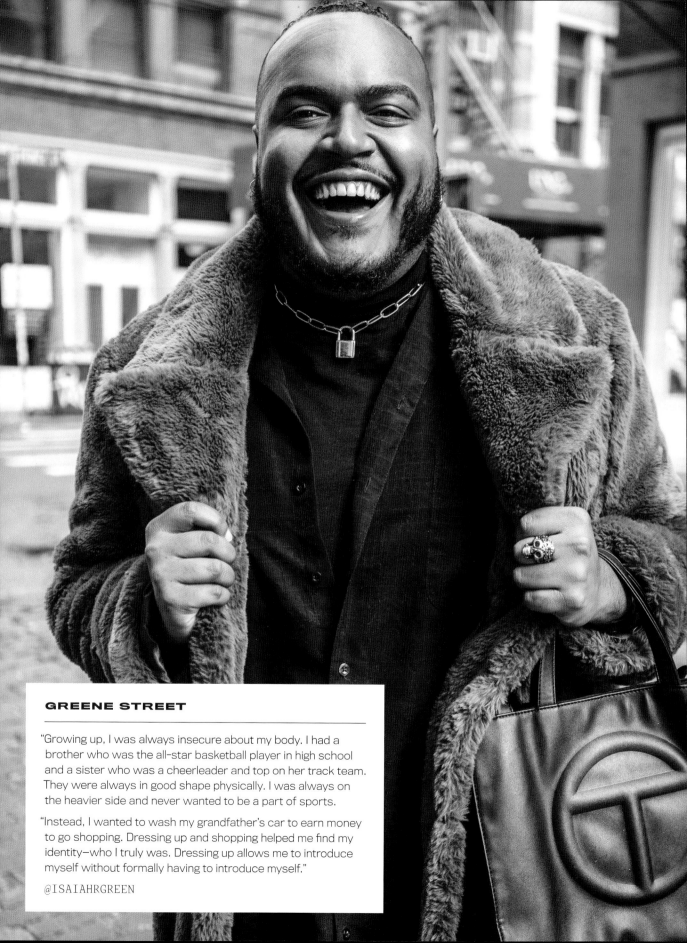

GREENE STREET

"Growing up, I was always insecure about my body. I had a
brother who was the all-star basketball player in high school
and a sister who was a cheerleader and top on her track team.
They were always in good shape physically. I was always on
the heavier side and never wanted to be a part of sports.

"Instead, I wanted to wash my grandfather's car to earn money
to go shopping. Dressing up and shopping helped me find my
identity—who I truly was. Dressing up allows me to introduce
myself without formally having to introduce myself."

@ISAIAHRGREEN

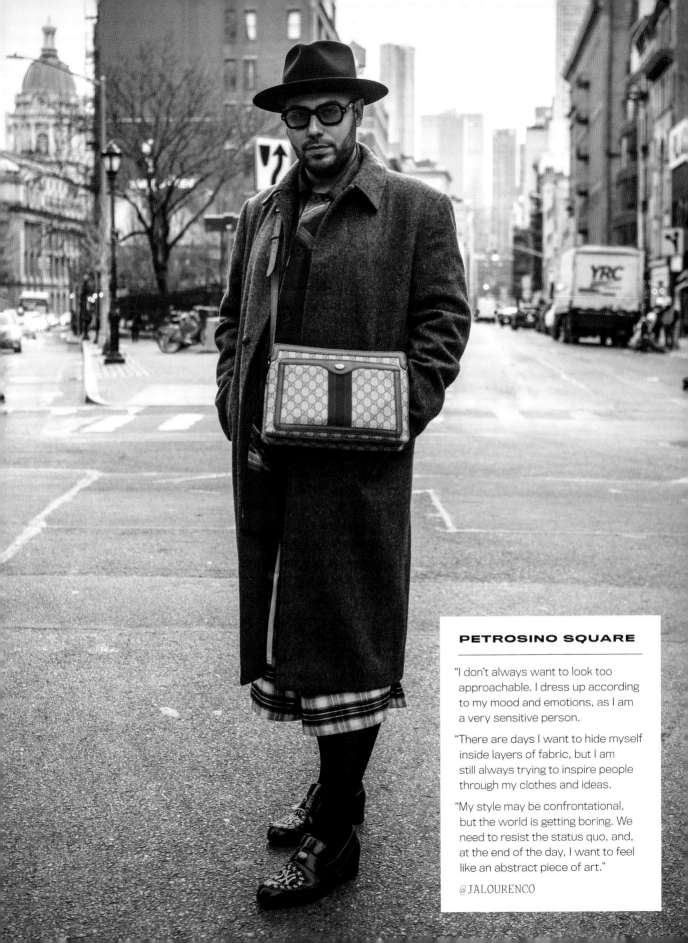

PETROSINO SQUARE

"I don't always want to look too approachable. I dress up according to my mood and emotions, as I am a very sensitive person.

"There are days I want to hide myself inside layers of fabric, but I am still always trying to inspire people through my clothes and ideas.

"My style may be confrontational, but the world is getting boring. We need to resist the status quo, and, at the end of the day, I want to feel like an abstract piece of art."

@JALOURENCO

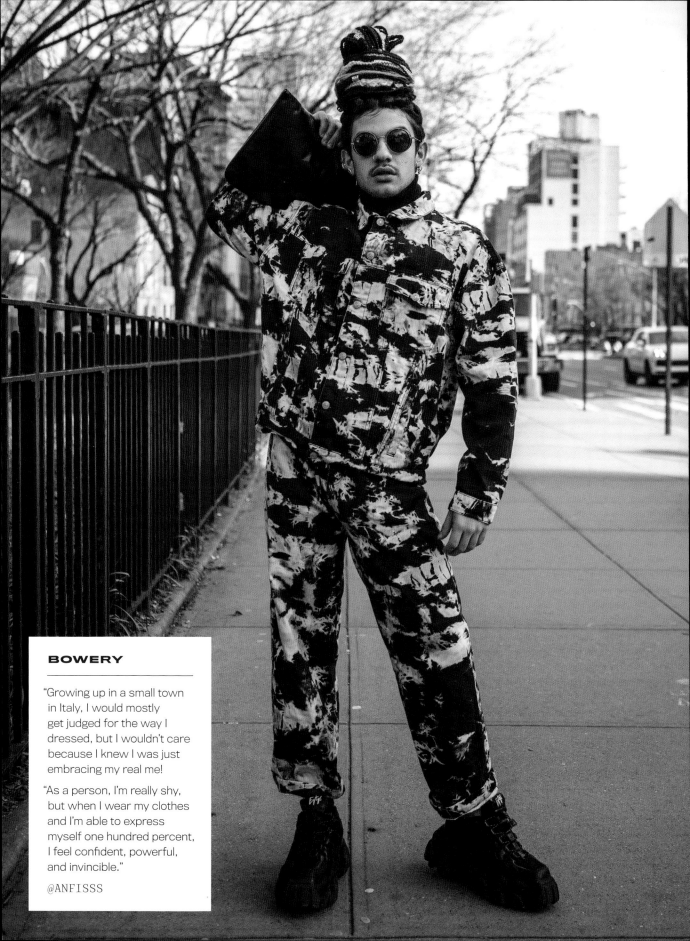

BOWERY

"Growing up in a small town in Italy, I would mostly get judged for the way I dressed, but I wouldn't care because I knew I was just embracing my real me!

"As a person, I'm really shy, but when I wear my clothes and I'm able to express myself one hundred percent, I feel confident, powerful, and invincible."

@ANFISSS

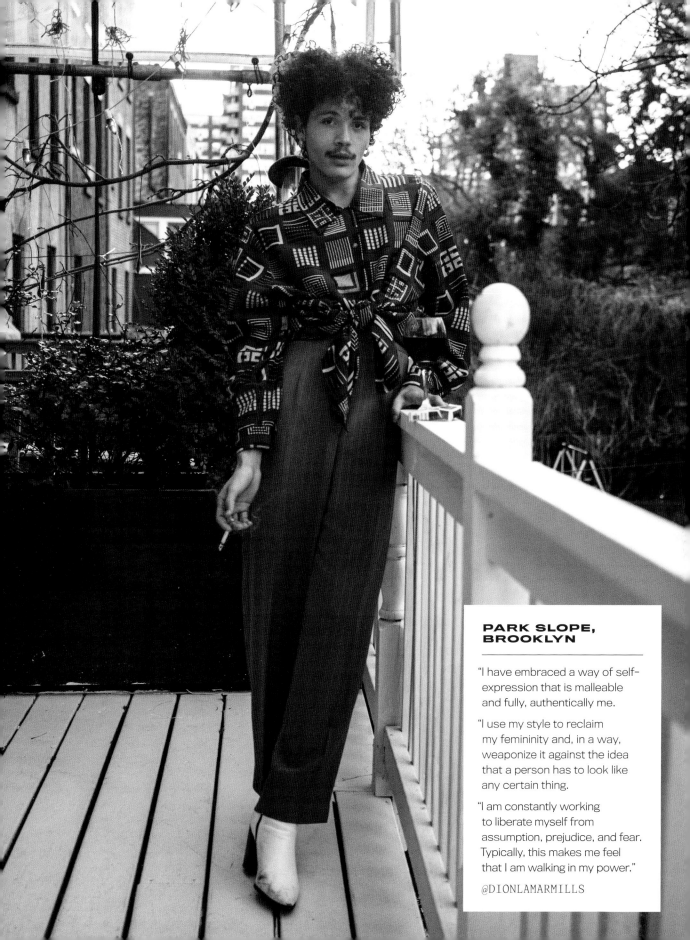

PARK SLOPE, BROOKLYN

"I have embraced a way of self-expression that is malleable and fully, authentically me.

"I use my style to reclaim my femininity and, in a way, weaponize it against the idea that a person has to look like any certain thing.

"I am constantly working to liberate myself from assumption, prejudice, and fear. Typically, this makes me feel that I am walking in my power."

@DIONLAMARMILLS

GRAND STREET

ReBLACKA For The BLACKs is the alter ego of the activist and educator dedicated to systemic change, Kanene Ayo Holder. Kanene uses ReBLACKa in her production of @BLACKISSUESISSUES, an explicitly anti-racist performance show. The social impact initiative uses humor, humility, and empathy to discuss ISSUES and showcases solutions that will positively impact Black and Latino communities.

It's a costume, a made-up character, yes, but a persona like ReBLACKa demonstrates how we can use style to help us release emotions and ideas that connect with others. It shows us a way to communicate what our inner selves struggle to say. Style can give voice where a voice is needed.

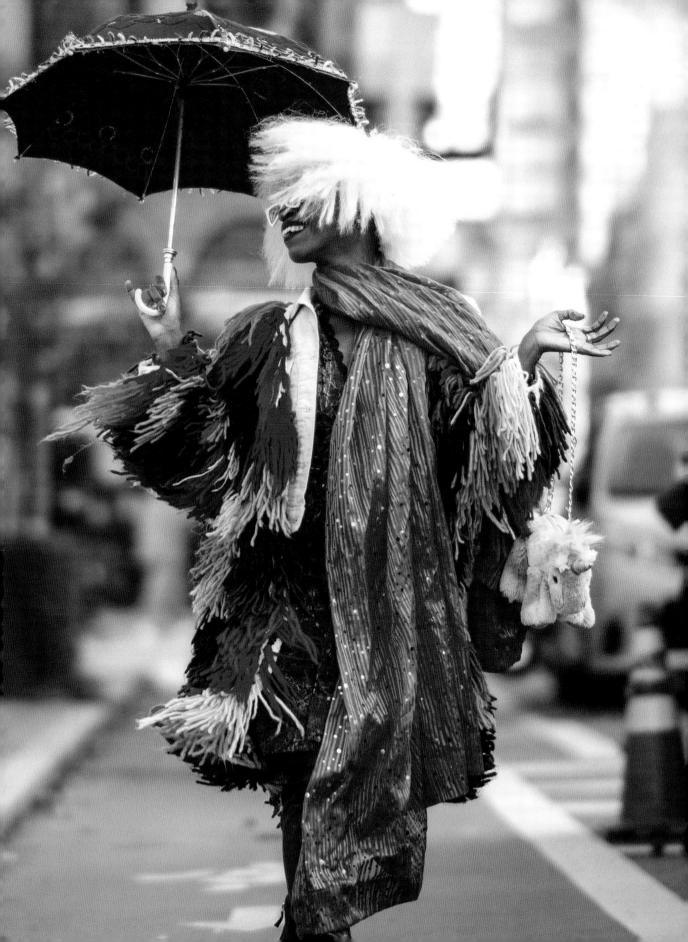

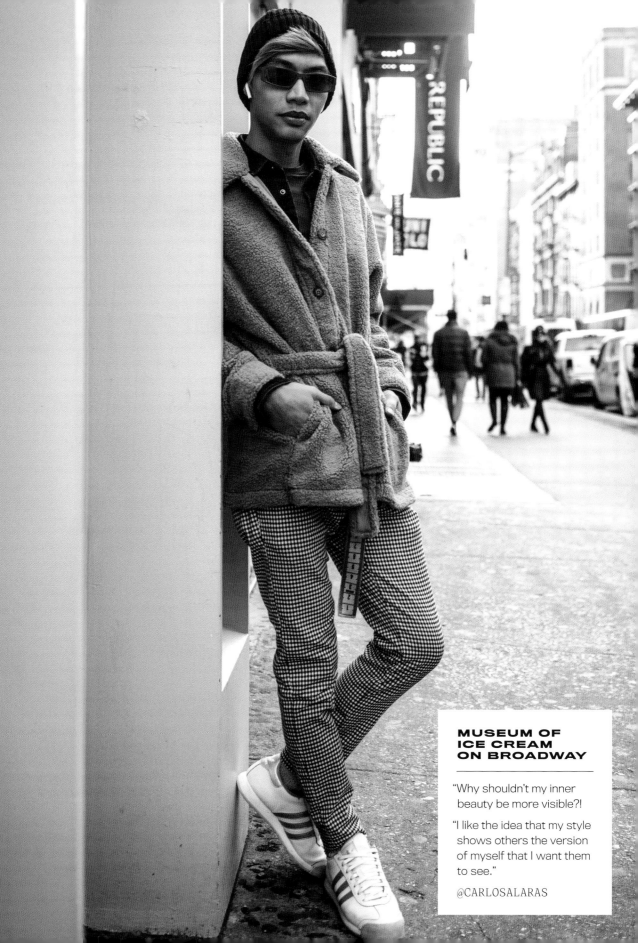

MUSEUM OF
ICE CREAM
ON BROADWAY

"Why shouldn't my inner
beauty be more visible?!

"I like the idea that my style
shows others the version
of myself that I want them
to see."

@CARLOSALARAS

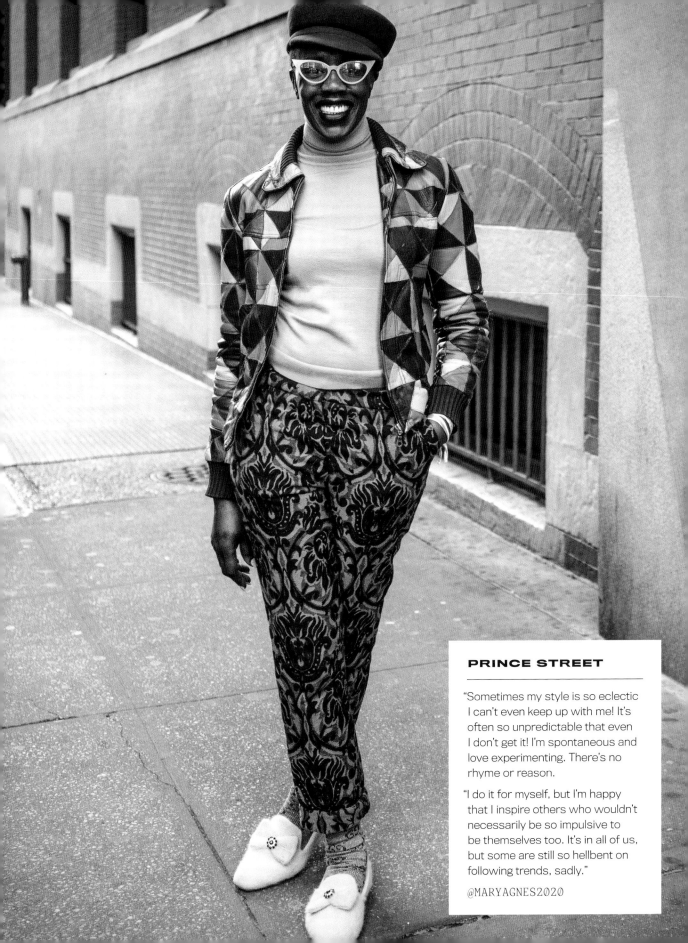

PRINCE STREET

"Sometimes my style is so eclectic I can't even keep up with me! It's often so unpredictable that even I don't get it! I'm spontaneous and love experimenting. There's no rhyme or reason.

"I do it for myself, but I'm happy that I inspire others who wouldn't necessarily be so impulsive to be themselves too. It's in all of us, but some are still so hellbent on following trends, sadly."

@MARYAGNES2020

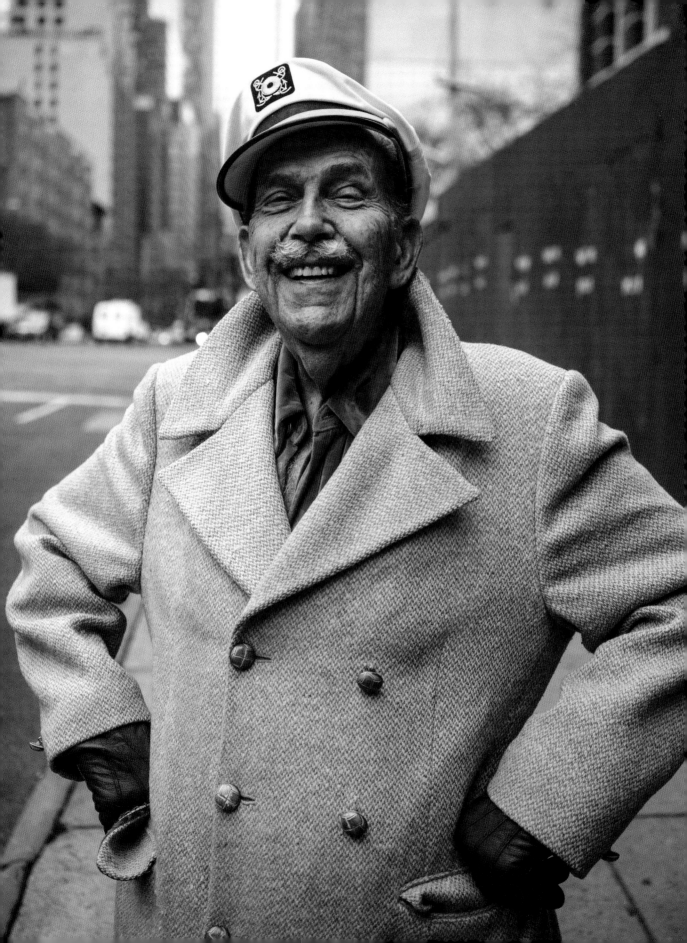

OPPOSITE PAGE
WEST 57TH STREET

BECAUSE FLEET WEEK CAN LAST YOUR WHOLE LIFE.

Mal Cross is actually a comedic magician, but he wears the captain's hat because he feels it helps him be more approachable with the ladies. See, he loves to dance at events at Lincoln Center, and he swears he gets to dance with more women because of the hat.

Turns out Mal has had a very successful career. I looked him up and he had appeared on all kinds of TV shows, including David Letterman. He's quite the character, and we got along great, but when I asked his age he said, "None of your damn business."

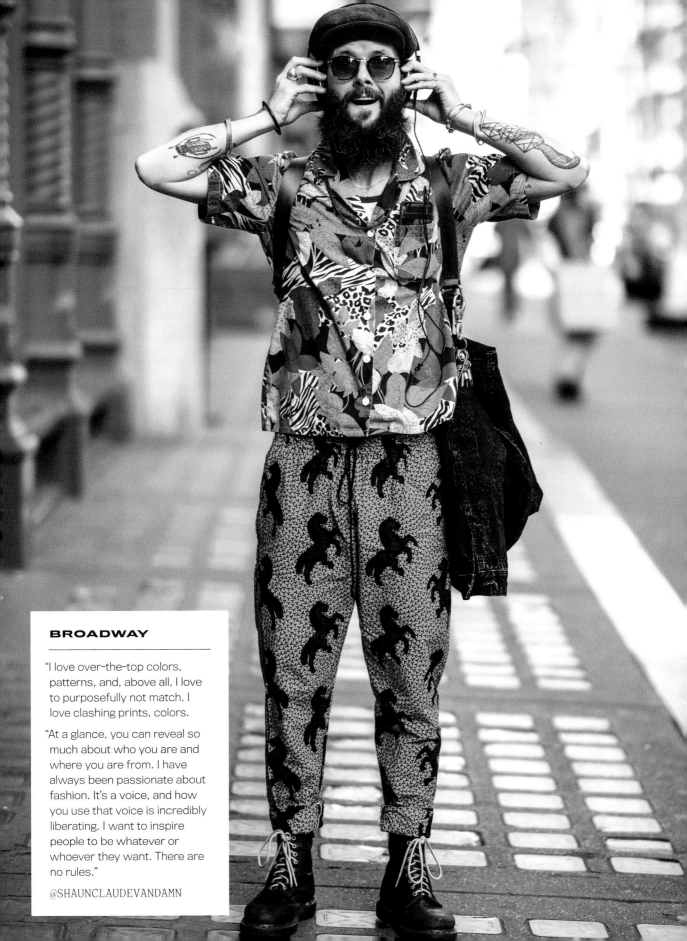

BROADWAY

"I love over-the-top colors, patterns, and, above all, I love to purposefully not match. I love clashing prints, colors.

"At a glance, you can reveal so much about who you are and where you are from. I have always been passionate about fashion. It's a voice, and how you use that voice is incredibly liberating. I want to inspire people to be whatever or whoever they want. There are no rules."

@SHAUNCLAUDEVANDAMN

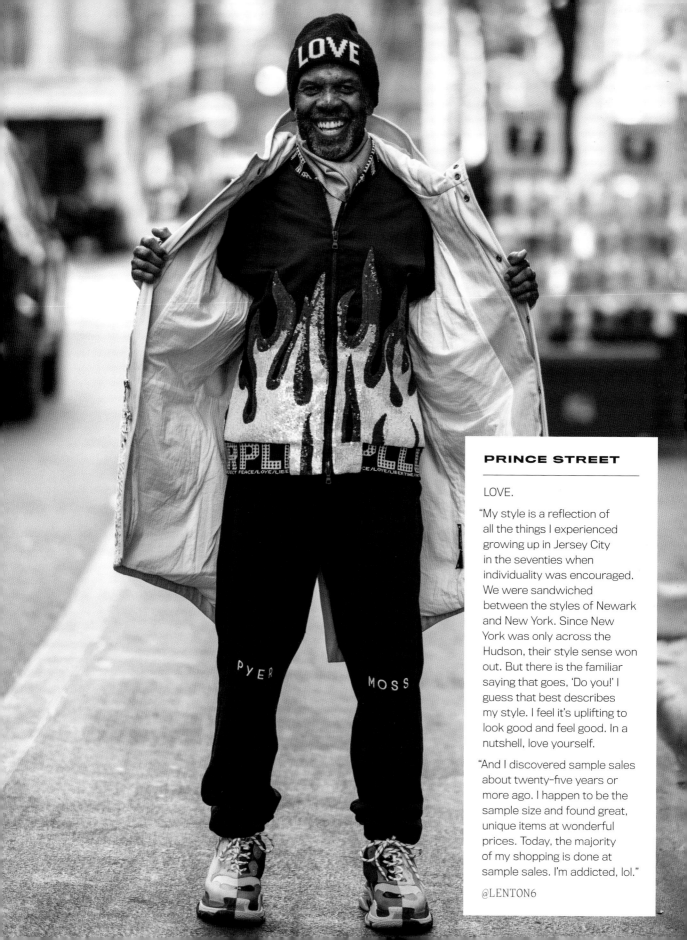

PRINCE STREET

LOVE.

"My style is a reflection of all the things I experienced growing up in Jersey City in the seventies when individuality was encouraged. We were sandwiched between the styles of Newark and New York. Since New York was only across the Hudson, their style sense won out. But there is the familiar saying that goes, 'Do you!' I guess that best describes my style. I feel it's uplifting to look good and feel good. In a nutshell, love yourself.

"And I discovered sample sales about twenty-five years or more ago. I happen to be the sample size and found great, unique items at wonderful prices. Today, the majority of my shopping is done at sample sales. I'm addicted, lol."

@LENTON6

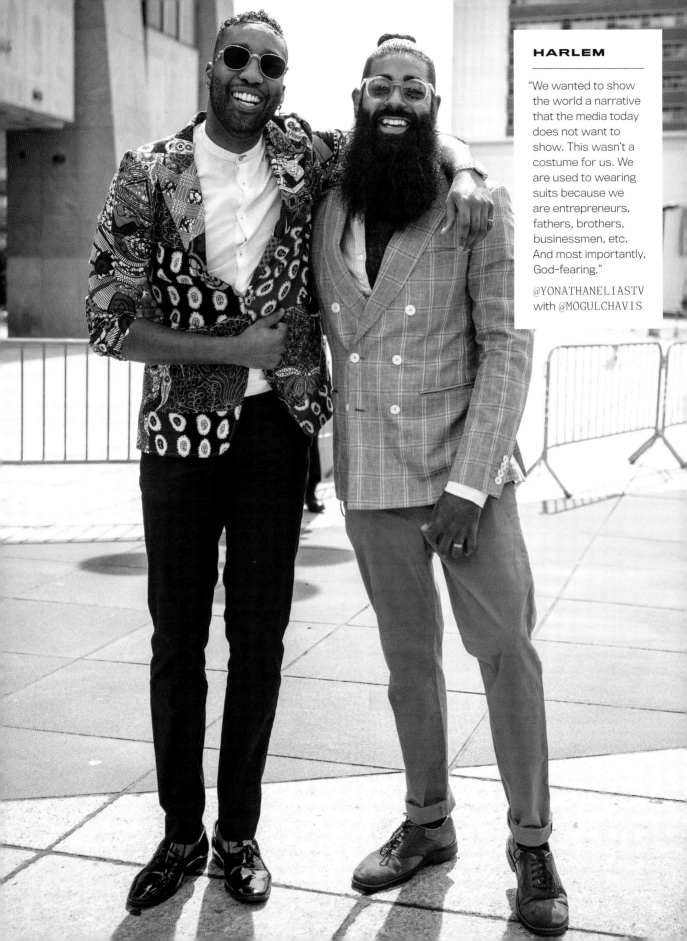

"We wanted to show the world a narrative that the media today does not want to show. This wasn't a costume for us. We are used to wearing suits because we are entrepreneurs, fathers, brothers, businessmen, etc. And most importantly, God-fearing."

@YONATHANELIASTV
with @MOGULCHAVIS

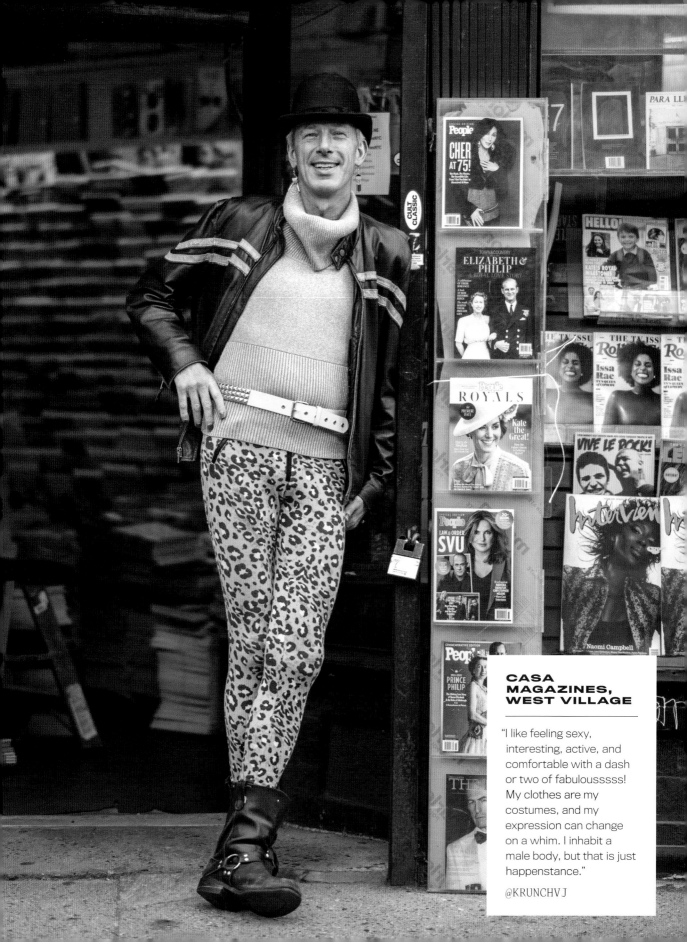

CASA MAGAZINES, WEST VILLAGE

"I like feeling sexy, interesting, active, and comfortable with a dash or two of fabulousssss! My clothes are my costumes, and my expression can change on a whim. I inhabit a male body, but that is just happenstance."

@KRUNCHVJ

CITY HALL, MANHATTAN

"As an artist, life itself has always been my canvas. I get my eclectic and posh style from the harmony of life I see around me. I don't dress for the world. I dress for myself and how it makes me feel.

"A suit always makes me feel powerful. It always makes me feel like I am ready and prepared for whatever obstacle might be thrown at me. It feels like my armor.

"I matter because I exist, and what I choose to wear is an extension of who I am. I am an artist."

@HAROLDWAIGHT

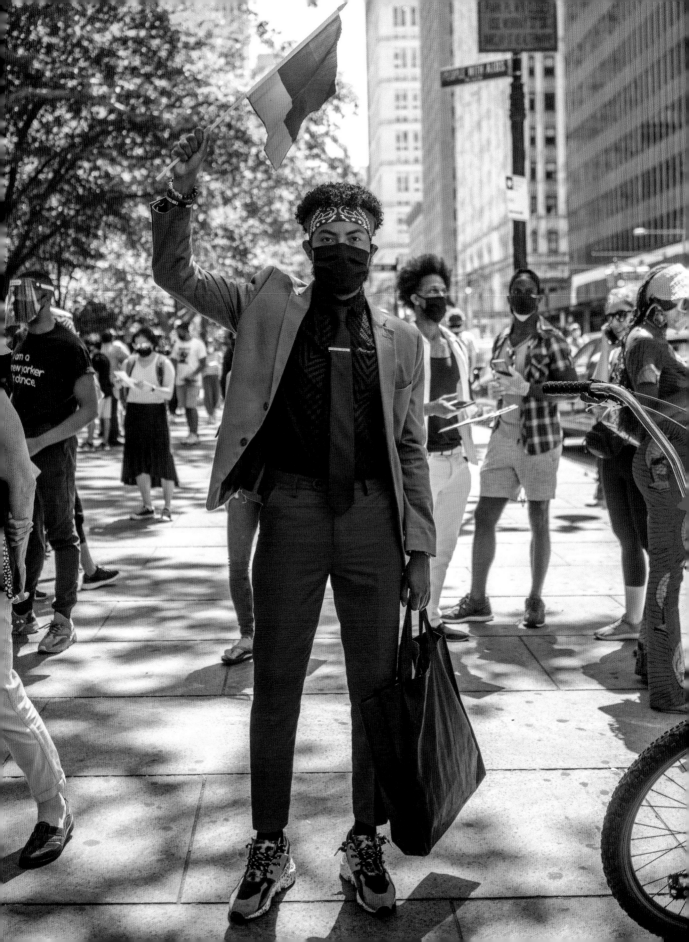

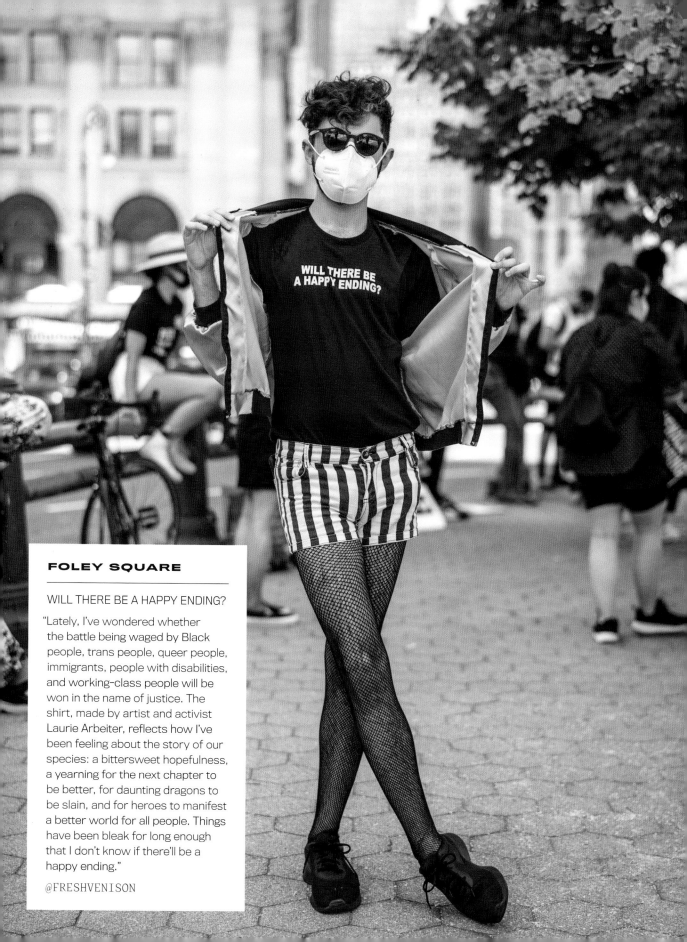

FOLEY SQUARE

WILL THERE BE A HAPPY ENDING?

"Lately, I've wondered whether the battle being waged by Black people, trans people, queer people, immigrants, people with disabilities, and working-class people will be won in the name of justice. The shirt, made by artist and activist Laurie Arbeiter, reflects how I've been feeling about the story of our species: a bittersweet hopefulness, a yearning for the next chapter to be better, for daunting dragons to be slain, and for heroes to manifest a better world for all people. Things have been bleak for long enough that I don't know if there'll be a happy ending."

@FRESHVENISON

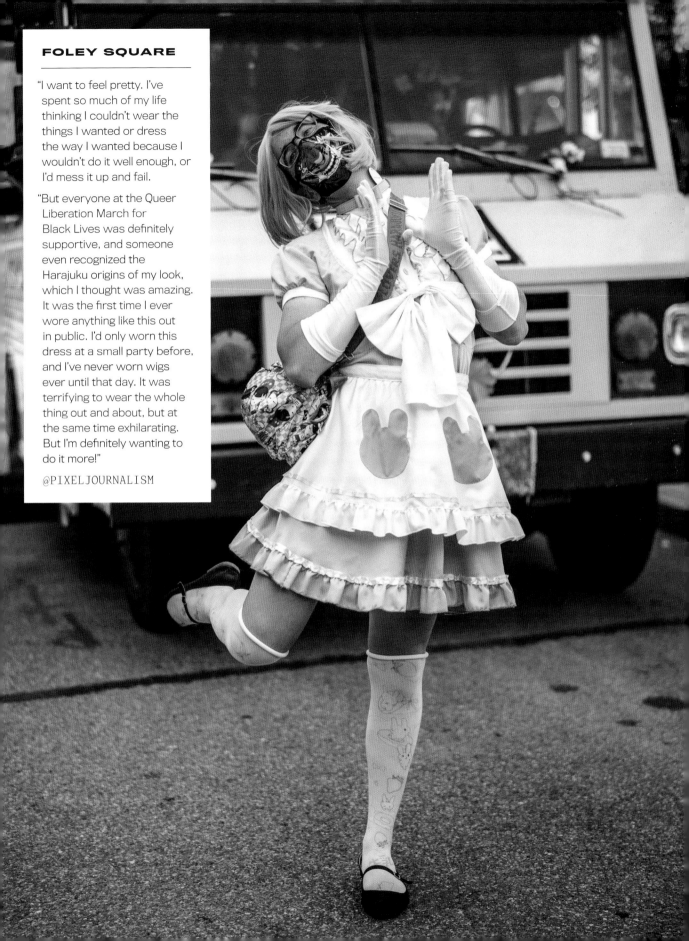

FOLEY SQUARE

"I want to feel pretty. I've spent so much of my life thinking I couldn't wear the things I wanted or dress the way I wanted because I wouldn't do it well enough, or I'd mess it up and fail.

"But everyone at the Queer Liberation March for Black Lives was definitely supportive, and someone even recognized the Harajuku origins of my look, which I thought was amazing. It was the first time I ever wore anything like this out in public. I'd only worn this dress at a small party before, and I've never worn wigs ever until that day. It was terrifying to wear the whole thing out and about, but at the same time exhilarating. But I'm definitely wanting to do it more!"

@PIXELJOURNALISM

HAPPY ACCIDENTS.

"The cargo pants were completely unplanned, but we actually ended up buying the hats from a vendor on 59th Street before we came into the park. Skateboarding has HUGELY influenced my style, especially because I need something comfortable to skate in, but I like to push the boundaries of which clothes are 'skateable' and which aren't. I've even learned to skate in heels."

@EMILYFUCKINGWILLIAMS

"Skateboarding has made me more fearless and free. It fits who I am as well as my style, which has always leaned toward queer and androgynous, but now I fully embrace it with love."

@CAROLINOLASCO

"Skating is my life. There's been times when I didn't know what to do with myself, but then I started skating. I love learning new things but also being able to lose myself in it. Skating will always be my home. It was my home when I didn't have one."

@_NIYAHH_

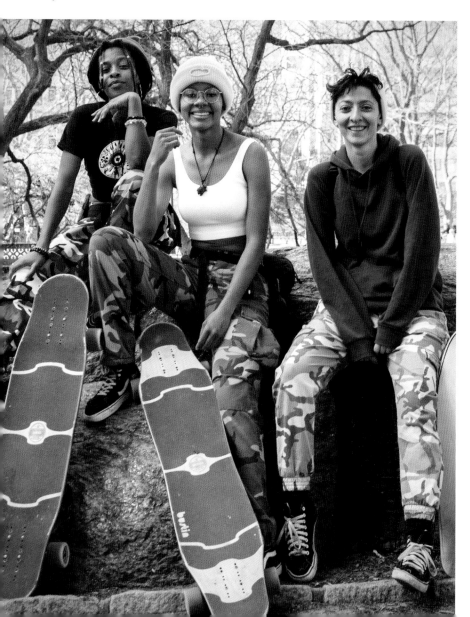

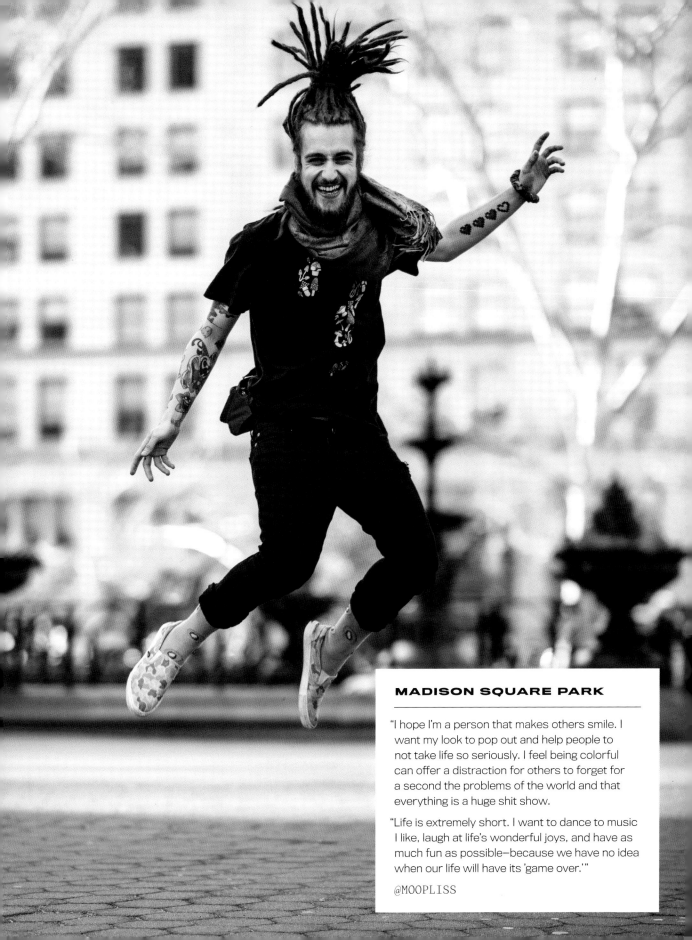

MADISON SQUARE PARK

"I hope I'm a person that makes others smile. I want my look to pop out and help people to not take life so seriously. I feel being colorful can offer a distraction for others to forget for a second the problems of the world and that everything is a huge shit show.

"Life is extremely short. I want to dance to music I like, laugh at life's wonderful joys, and have as much fun as possible—because we have no idea when our life will have its 'game over.'"

@MOOPLISS

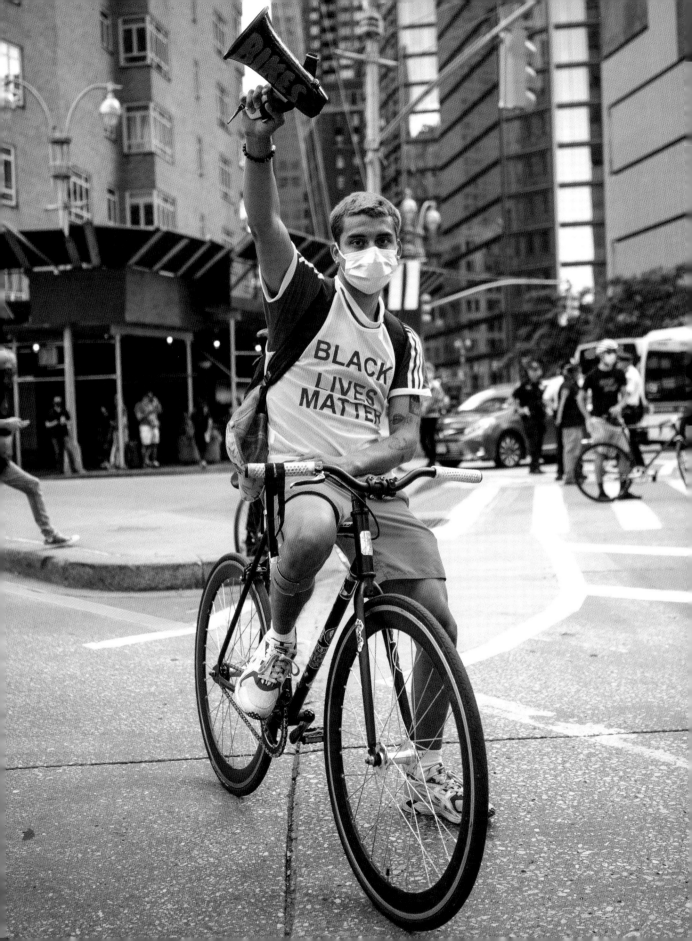

COLUMBUS CIRCLE

"I'm a Mexican man, but a little more than a week ago, myself and six others started a Black-led bicycle team to help with Black Lives Matter. We understood the necessity to be distinguishable from other protestors because of the energy and leadership we bring. I design clothing, so it was a no-brainer to have matching outfits for the occasion. My whole getup is brighter and more colorful than the others. It reflects my style and personality, but it also makes sense to be a little more visible as a designated guide for the others to see in case we have to make an immediate right or left.

"Originally, we started seeing each other EVERY SINGLE DAY, protesting on bikes and building connections as well as trust with one another. After a while, we saw the amount of people who recognized us, respected us, as well as followed us so we decided that we would create @streetridersnyc. The connections are so organic that it really astonishes me, because the demographic in our group is so vast, from eighteen to thirty and from Asian to white to Mexican to African American.

"As protestors, we aren't just protesting. We have to understand that when we are out there for BLM, we are also protectors of BLACK LIVES. I'll put my body literally in between the police and protestors if shit goes down. I'm only twenty-four, and I feel it's necessary for me to be protesting. I can't vote due to my status, so literally one of the biggest things I can do is protest to help fight for justice. I need to fight because it is my fight too, and I feel like the police have fucked with the last generation. So yeah, my name's Antonio Garcia, and I'm gonna be protesting my ass off every day until I can wake up every day without having to hear in the news or over social media that another Black man was killed, or another Black woman was lynched."

@ANTONIOGARCIA274

HARLEM

"Attending the peaceful protest in Harlem was very important for me. The location alone holds so much historical significance. And marching down the streets, parading our pride in who we are as Black and brown people, that day is recorded in my bank of memories forever.

"My dress is from a collection I did back in December called 'water.' As a clothes designer, an artist, and a Black man, I share what I've experienced and the emotions that I've felt. With my unisex clothing brand, I always strive for unity and how I can bring people together to feel as one and not so segregated and separated, especially by the things that we choose to wear. So why I protest and why I design clothes is for the same reason. I want everyone to be united and to have real freedom with real human rights."

@XO.BONES

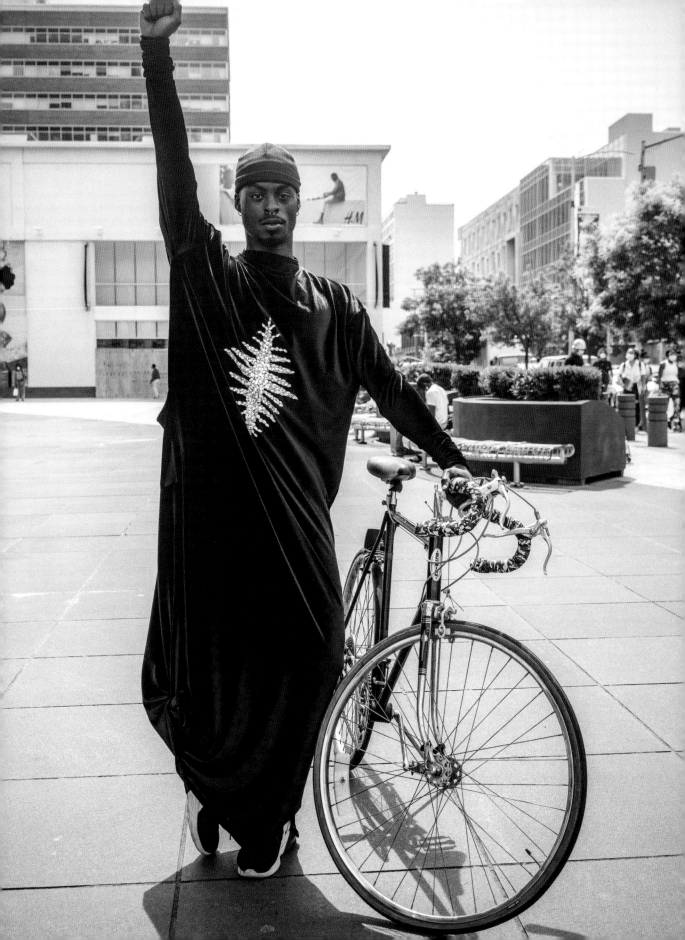

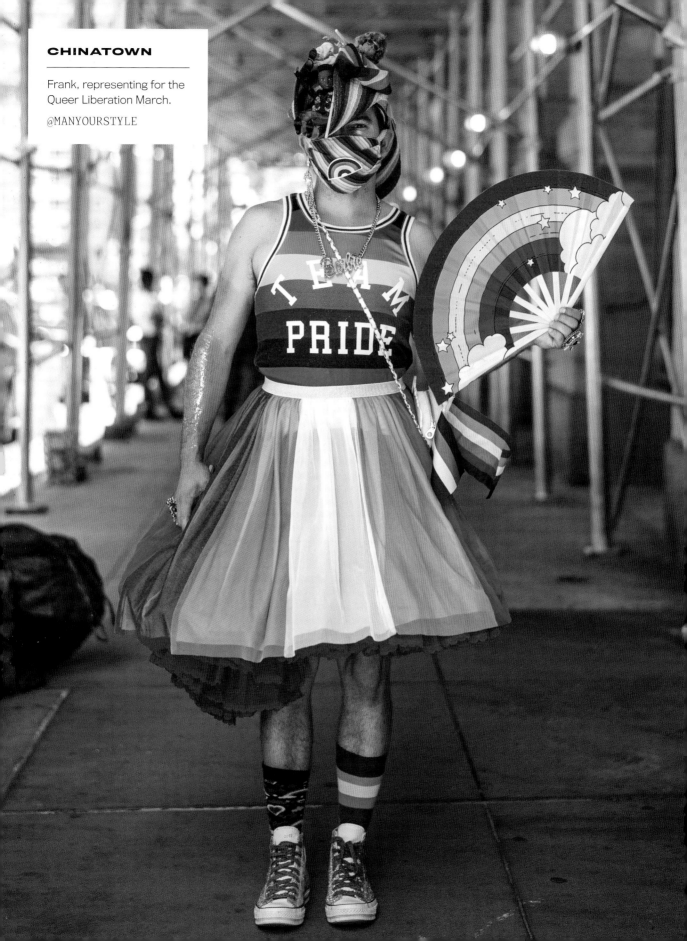

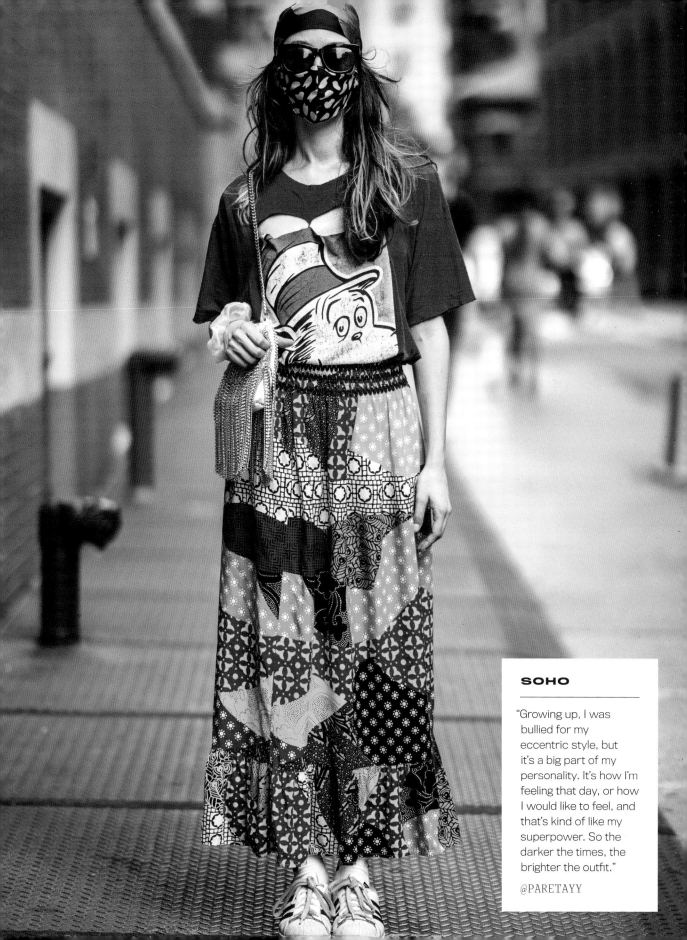

SOHO

"Growing up, I was bullied for my eccentric style, but it's a big part of my personality. It's how I'm feeling that day, or how I would like to feel, and that's kind of like my superpower. So the darker the times, the brighter the outfit."

@PARETAYY

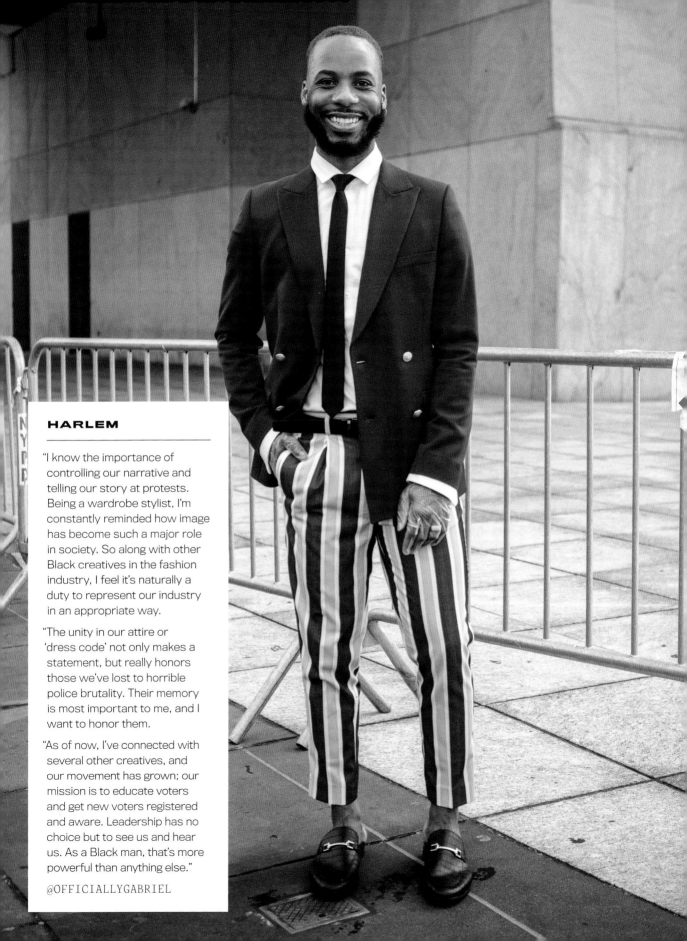

HARLEM

"I know the importance of controlling our narrative and telling our story at protests. Being a wardrobe stylist, I'm constantly reminded how image has become such a major role in society. So along with other Black creatives in the fashion industry, I feel it's naturally a duty to represent our industry in an appropriate way.

"The unity in our attire or 'dress code' not only makes a statement, but really honors those we've lost to horrible police brutality. Their memory is most important to me, and I want to honor them.

"As of now, I've connected with several other creatives, and our movement has grown; our mission is to educate voters and get new voters registered and aware. Leadership has no choice but to see us and hear us. As a Black man, that's more powerful than anything else."

@OFFICIALLYGABRIEL

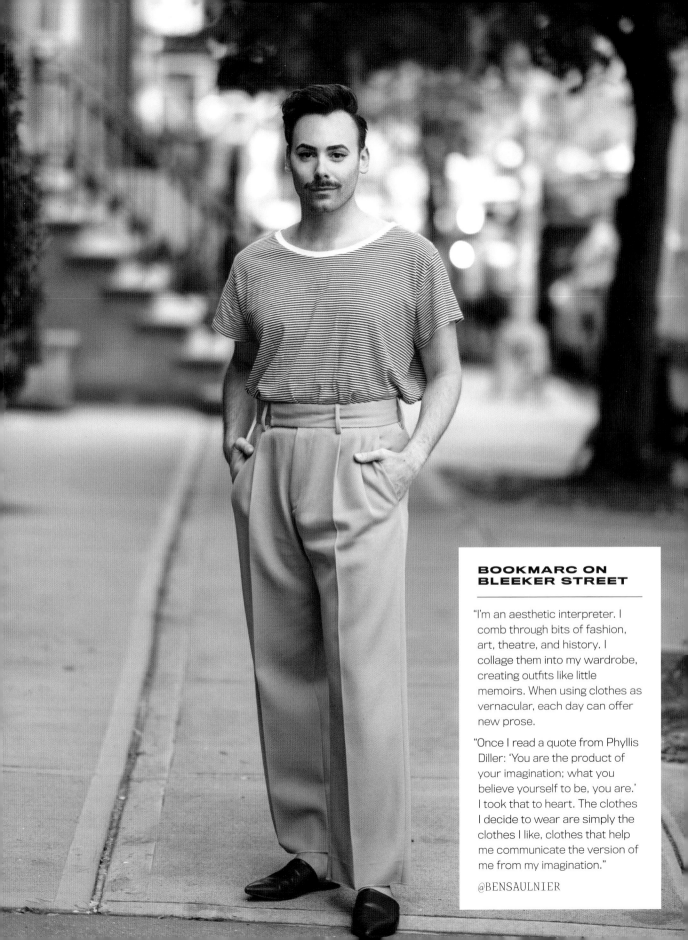

BOOKMARC ON BLEEKER STREET

"I'm an aesthetic interpreter. I comb through bits of fashion, art, theatre, and history. I collage them into my wardrobe, creating outfits like little memoirs. When using clothes as vernacular, each day can offer new prose.

"Once I read a quote from Phyllis Diller: 'You are the product of your imagination; what you believe yourself to be, you are.' I took that to heart. The clothes I decide to wear are simply the clothes I like, clothes that help me communicate the version of me from my imagination."

@BENSAULNIER

SOHO

"I see my hair like a gateway to dialogue of expression and open-mindedness. Until I dyed my hair, I was shy, nervous, and full of anxiety. Now I'm outgoing and a risk-taker."

@THRSHER2X

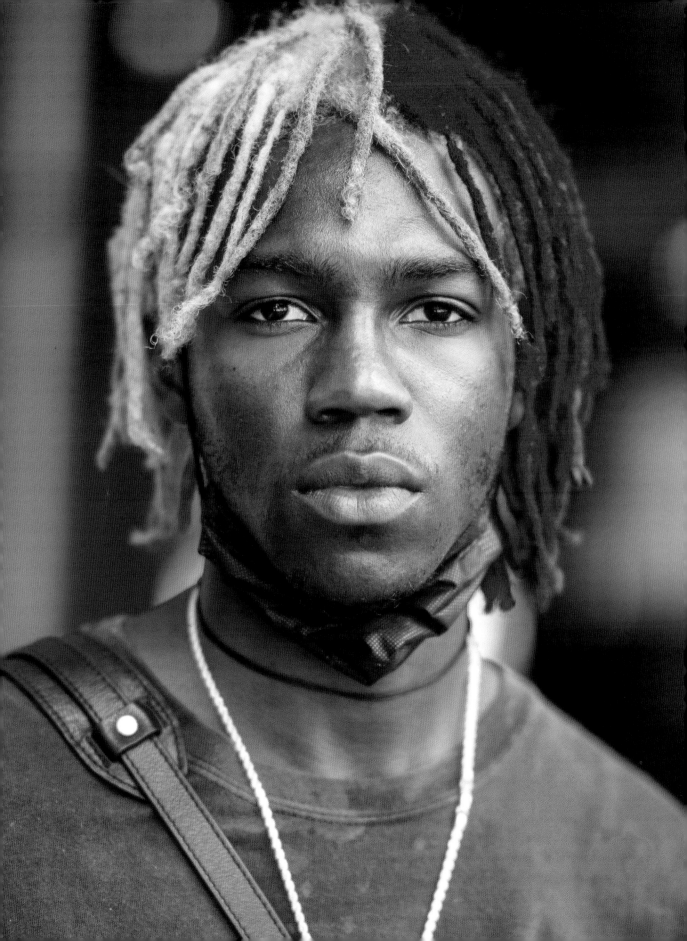

MACDOUGAL STREET

"I grew up in a very conservative and devout religious family in Indiana. Coupled with being homeschooled for a long time, my personal style and sense of creativity had been stifled until I moved to New York.

"As I've gotten more comfortable, I've slowly pushed my own 'personal' comforts in exchange for freedom in style.

"Showing skin has always been something I've been afraid to do in public due to body insecurity and just the way I grew up. Pink represents me shattering the preconceived toxic masculinity notion that men can't/shouldn't wear pink (which is rampant where I'm from). My pink beret is an homage to Prince ('Raspberry Beret'), who inspires me to challenge these norms and explore my own sense of style regardless of gender expectations. And the pasties are an homage to my conservative upbringing: 'Leave something to the imagination.'"

@JAMEOSOMM

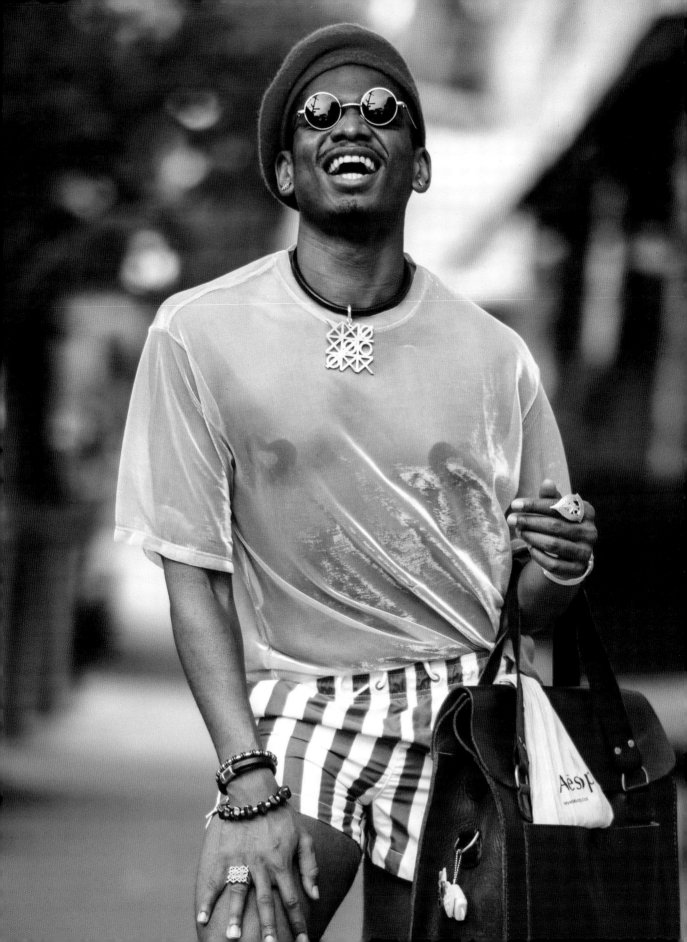

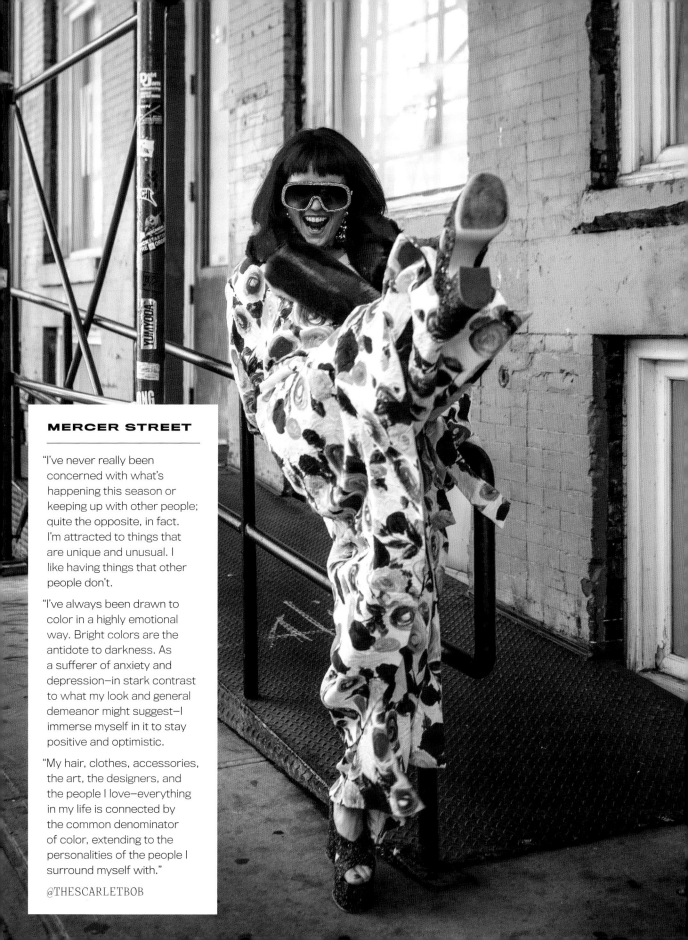

MERCER STREET

"I've never really been concerned with what's happening this season or keeping up with other people; quite the opposite, in fact. I'm attracted to things that are unique and unusual. I like having things that other people don't.

"I've always been drawn to color in a highly emotional way. Bright colors are the antidote to darkness. As a sufferer of anxiety and depression—in stark contrast to what my look and general demeanor might suggest—I immerse myself in it to stay positive and optimistic.

"My hair, clothes, accessories, the art, the designers, and the people I love—everything in my life is connected by the common denominator of color, extending to the personalities of the people I surround myself with."

@THESCARLETBOB

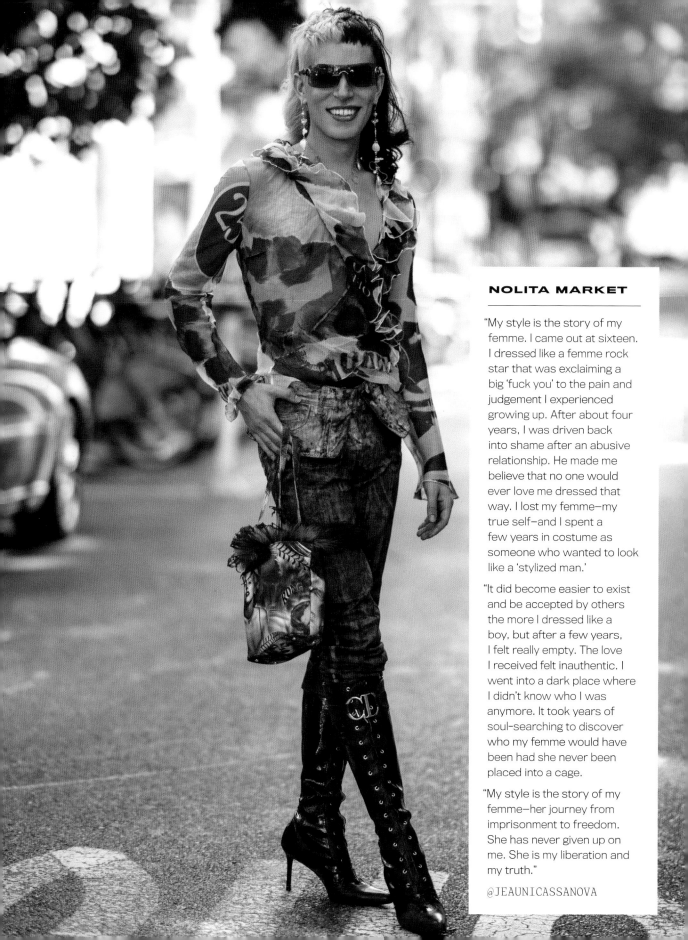

NOLITA MARKET

"My style is the story of my femme. I came out at sixteen. I dressed like a femme rock star that was exclaiming a big 'fuck you' to the pain and judgement I experienced growing up. After about four years, I was driven back into shame after an abusive relationship. He made me believe that no one would ever love me dressed that way. I lost my femme—my true self—and I spent a few years in costume as someone who wanted to look like a 'stylized man.'

"It did become easier to exist and be accepted by others the more I dressed like a boy, but after a few years, I felt really empty. The love I received felt inauthentic. I went into a dark place where I didn't know who I was anymore. It took years of soul-searching to discover who my femme would have been had she never been placed into a cage.

"My style is the story of my femme—her journey from imprisonment to freedom. She has never given up on me. She is my liberation and my truth."

@JEAUNICASSANOVA

"I was excruciatingly shy until my early twenties, which is odd because that's a contradiction to my style. I had this strong love for clothing since I was a child. Maybe the yellow Dior baby blanket my mom wrapped me in at the hospital to take me home had some sort of magic in it.

"I was always style-conscious and expressive, but I was made fun of a lot because of that and many other reasons. It took years, but I finally got my style down. I used to dress to express myself, but now that I've combated the shyness, I dress to make others happy and excited."

@SOFAUSTI

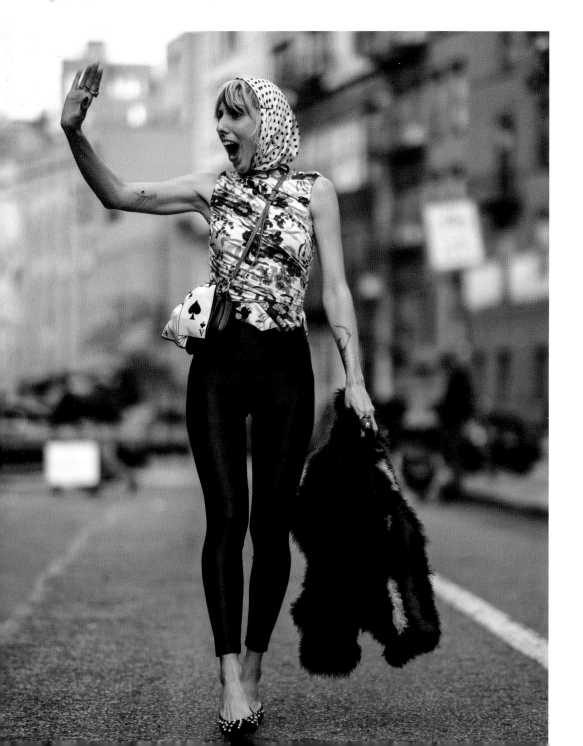

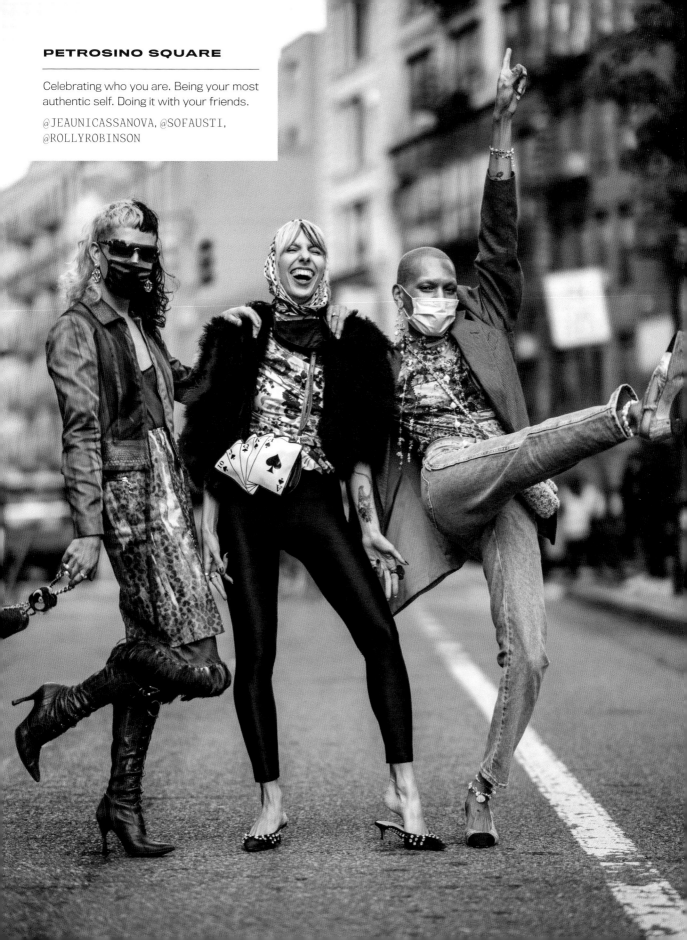

PETROSINO SQUARE

Celebrating who you are. Being your most
authentic self. Doing it with your friends.
@JEAUNICASSANOVA, @SOFAUSTI,
@ROLLYROBINSON

CORTLANDT ALLEY

ART, ACTIVISM, AND, OF COURSE, STYLE.

Back in the height of the pandemic, these performance artists set out to inspire others to wear masks. They walked through the city giving away masks to anyone that wanted one. It turned into a fantastic, successful mask-wearing awareness campaign. It was the perfect antidote to the thousands of bots pushing out anti-mask and conspiracy theory propaganda. In what seems like something out of a *Project Runway* episode, each look features about 150 blue 16-cent non-surgical masks sewn onto used clothing, for a total cost of about sixty-five dollars.

I'd like to applaud this pair for their initiative, creativity, and help while bringing a smile and encouragement to us when we most needed it.

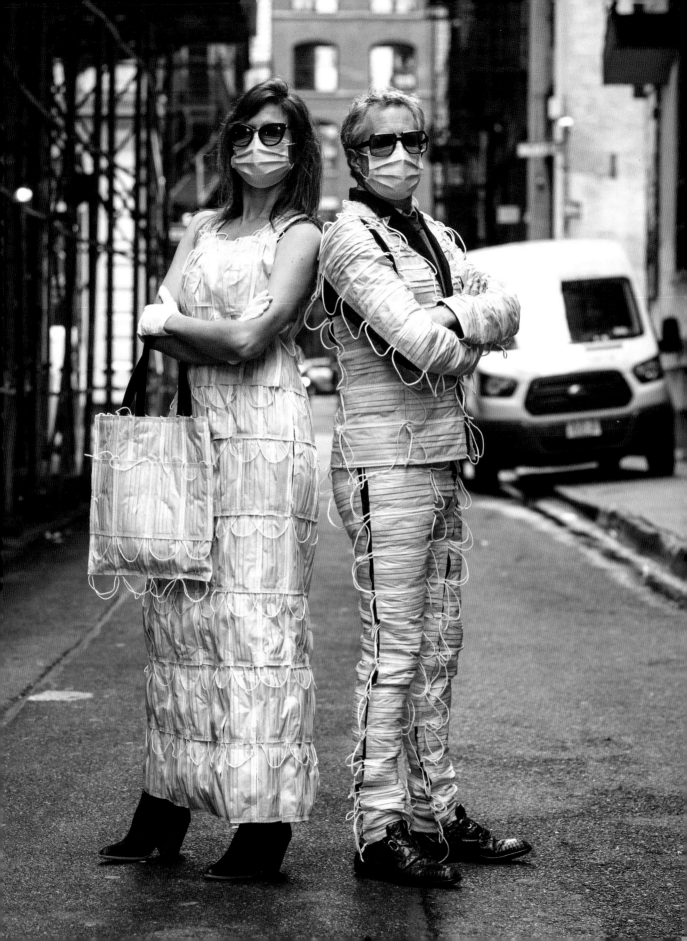

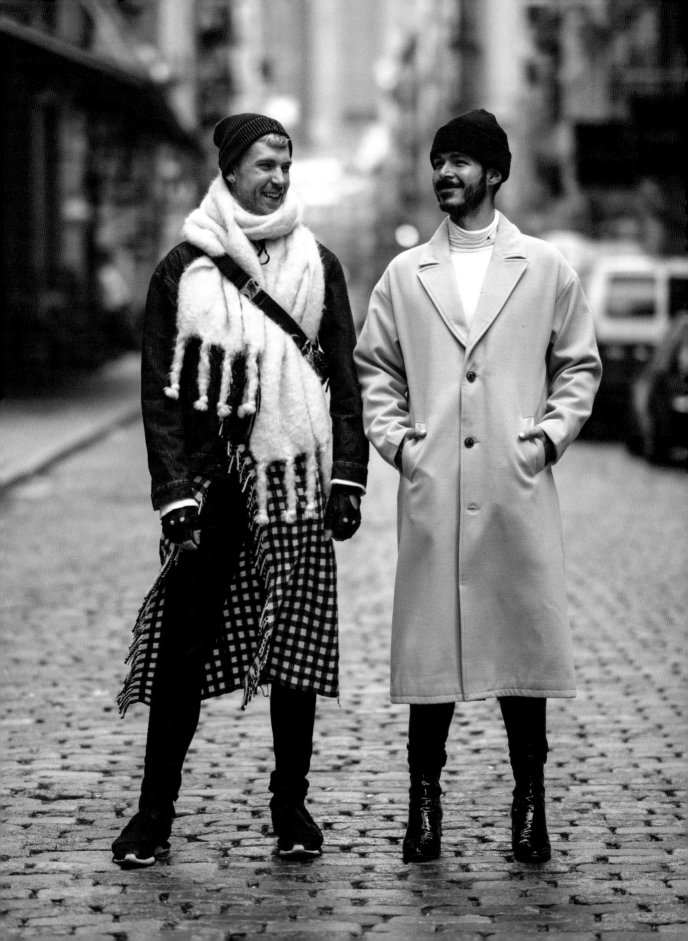

MERCER STREET

"It's wild to think that once I was just a little gay boy in a Wisconsin farm town, shopping the Old Navy clearance rack for school clothes. Now I dress to devastate not only the world, but also my opinion of myself. I'm never afraid to let my light shine, no matter what I wear. I paint myself with joy picking out my clothes and show everyone how I feel beneath the fabric. Be that confident, sexy, or just plain smart, I've been able to overcome my anxiety and just be me. If I love it, the confidence will follow. I wrap myself in things I love and let that happiness flow. I deserve to feel that."

@DARRIN.CLAYTON

"When I was younger, I gravitated toward feminine or traditionally non-masculine pieces. That became challenging to express in my teen years with peer pressure to conform. Fast forward and I now have more supportive and nonjudgmental friends. They inspire and help me think about my style in a less conventional way. In a way that gives me the freedom to change or reinvent it if I choose to."

@NICKCOLLINSOFFICIAL

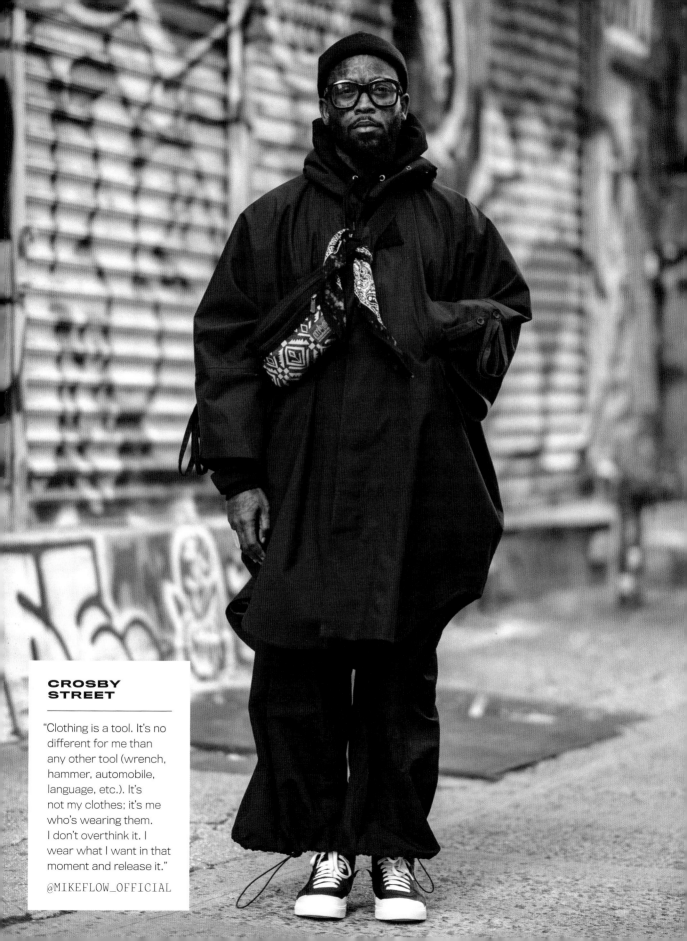

CROSBY STREET

"Clothing is a tool. It's no different for me than any other tool (wrench, hammer, automobile, language, etc.). It's not my clothes; it's me who's wearing them. I don't overthink it. I wear what I want in that moment and release it."

@MIKEFLOW_OFFICIAL

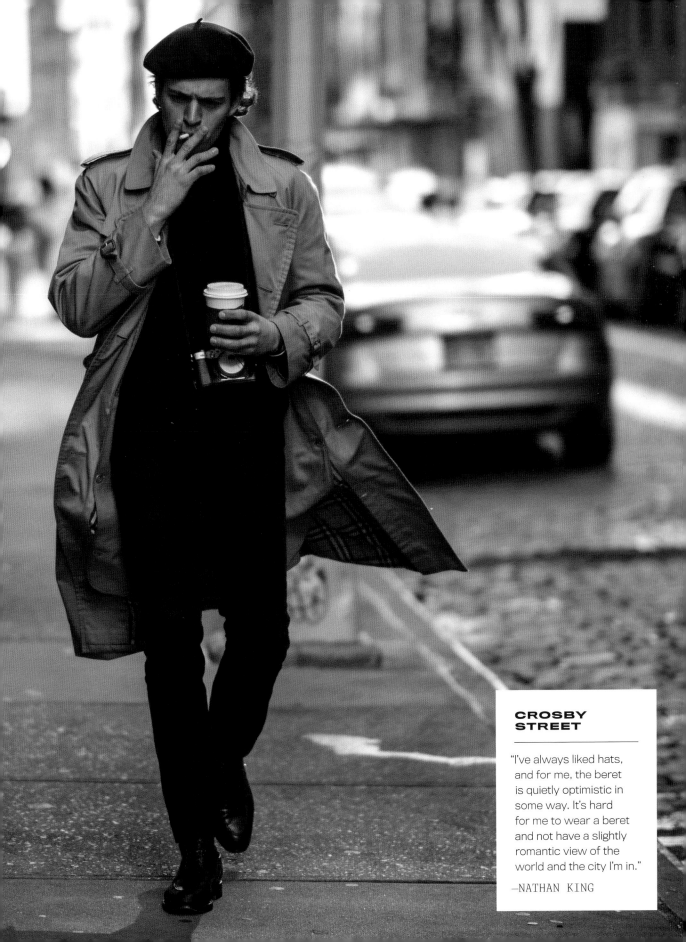

CROSBY STREET

"I've always liked hats, and for me, the beret is quietly optimistic in some way. It's hard for me to wear a beret and not have a slightly romantic view of the world and the city I'm in."

—NATHAN KING

SOHO

"Existing in my truth. Throughout my life, there were always constant voices and noises from people telling me what I should or should not look like, BUT I had a vision of the person that I wanted to be, and this is him. I was always very insecure growing up, and all I ever wanted was to be able to walk in a room and be remembered.

"My hairstyle is my armor, I suppose. I constantly think about linearity in terms of my look, and having this hair adds the height and the lines that I appreciate in a design aesthetic.

"My look is not for everybody, but I rock it with confidence all day, every day!"

@SEANSDG

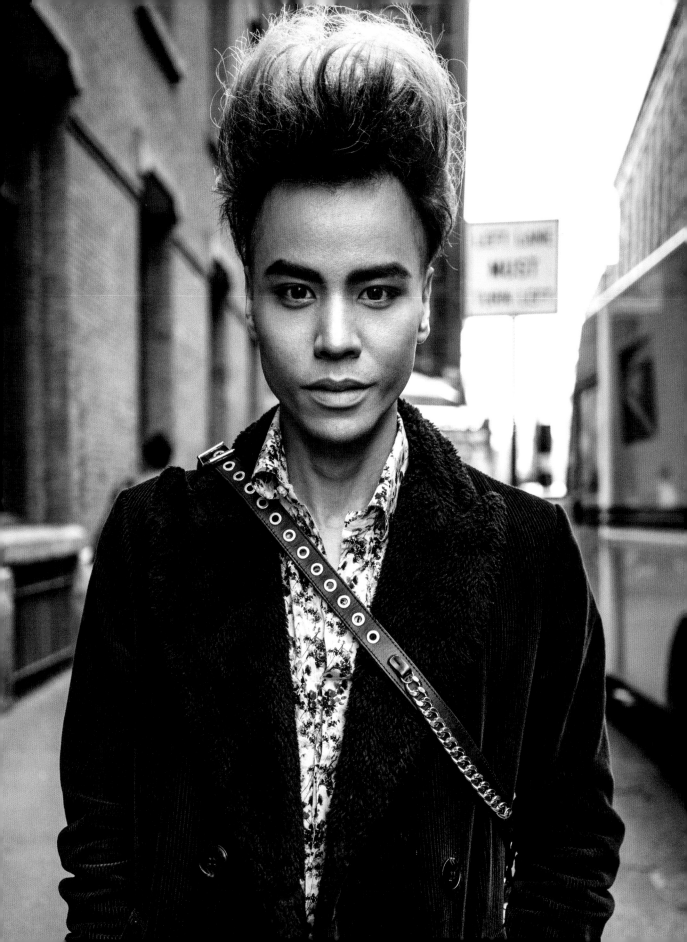

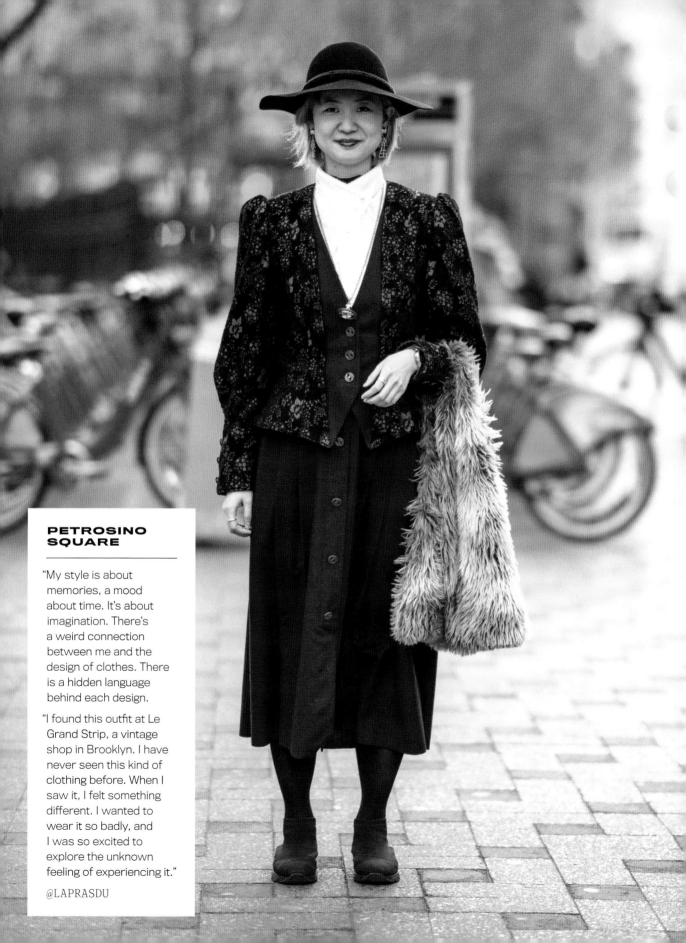

PETROSINO SQUARE

"My style is about memories, a mood about time. It's about imagination. There's a weird connection between me and the design of clothes. There is a hidden language behind each design.

"I found this outfit at Le Grand Strip, a vintage shop in Brooklyn. I have never seen this kind of clothing before. When I saw it, I felt something different. I wanted to wear it so badly, and I was so excited to explore the unknown feeling of experiencing it."

@LAPRASDU

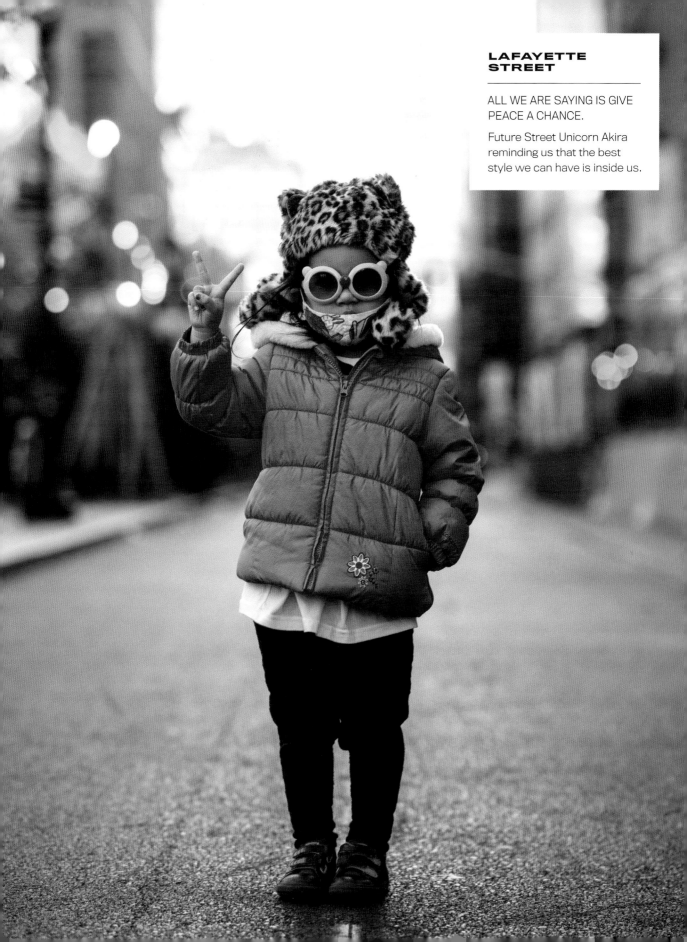

LAFAYETTE STREET

ALL WE ARE SAYING IS GIVE PEACE A CHANCE.

Future Street Unicorn Akira reminding us that the best style we can have is inside us.

WASHINGTON MEWS

"I started sewing in high school. I loved going to Gimbel's fabric department. I also went to thrift stores and antique shops in the East Village. I kind of morphed into someone who wanted to be noticed yet wanted to remain mysterious. I prided myself in never wearing store-bought clothing.

"Dressing for work was always fun; it gave me a confidence and pride in being creative. Working in an art department was very cool. Everyone had a style.

"For a few years, I happened to lay out the fashion pages with Bill Cunningham at the *New York Times*. Bill always looked at my outfit, then gave me the history of the designer, the era, the fabric, the style. He was a genius who inspired me to just be myself. To wear what brings me joy, not necessarily what is in style at the moment. I can hear his voice in my head every day: 'Hello, Miss Carol, what are you wearing today?' And then my lesson began . . ."

@CAROLELIZABETHDIETZ

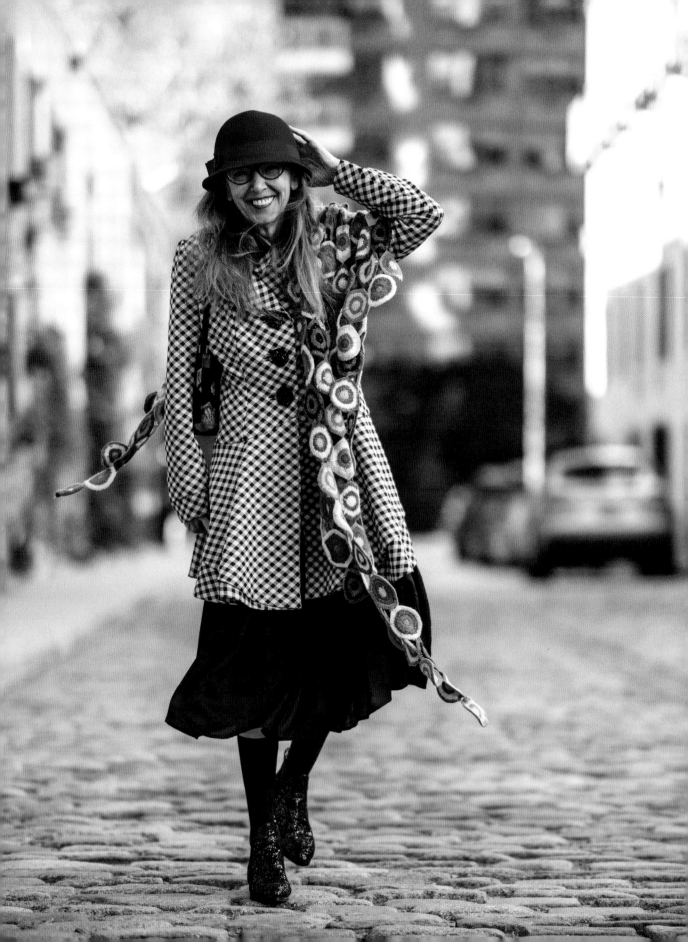

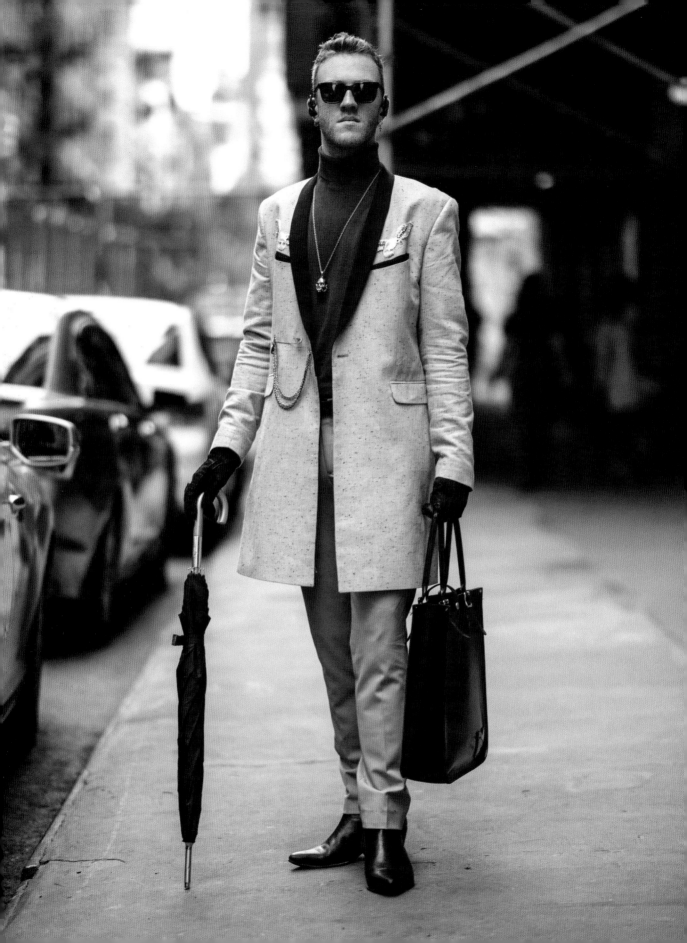

SPRING STREET

"I always knew there was a peacock ready to burst from inside, but I had tried to hide it. I come from a very large family on little ol' Staten Island. We were encouraged to be the way our parents were, and I never saw myself fitting into that narrative. It had me feeling different, lost, and I couldn't find who I was. I left home around fifteen and found the always-accepting love of heroin.

"After many years of not loving myself, I found my way to sobriety at twenty-one. I learned to embrace what I'd always disliked about myself. What I wear now is to show that I'm finally in love with who I am. It's so fun to play dress up every day! It's like putting on my own show for the world. I hope to show that we should never be afraid of our inner peacock.

"And I actually make clothing now! I'm a self-taught tailor and seamster. I also taught myself French and Japanese, so it's gotten me work all around the world. I manage a hotel restaurant down in SoHo, too. After being homeless for a few of those dark years, I'm incredibly grateful for what I have. I didn't think I'd even live long enough to see myself accomplish so many things."

@RRR_DESIGNS

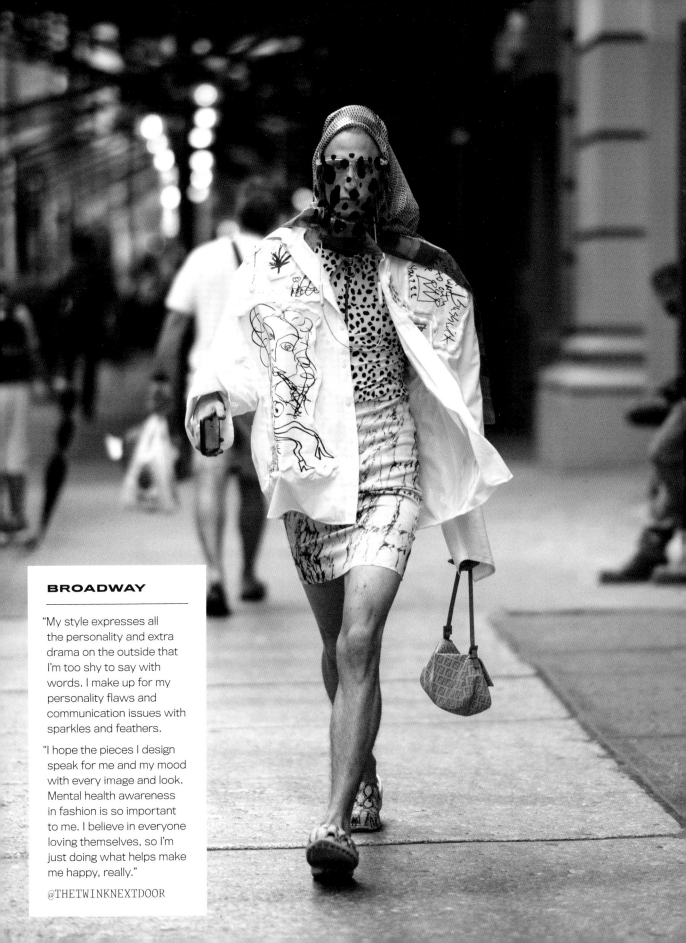

BROADWAY

"My style expresses all the personality and extra drama on the outside that I'm too shy to say with words. I make up for my personality flaws and communication issues with sparkles and feathers.

"I hope the pieces I design speak for me and my mood with every image and look. Mental health awareness in fashion is so important to me. I believe in everyone loving themselves, so I'm just doing what helps make me happy, really."

@THETWINKNEXTDOOR

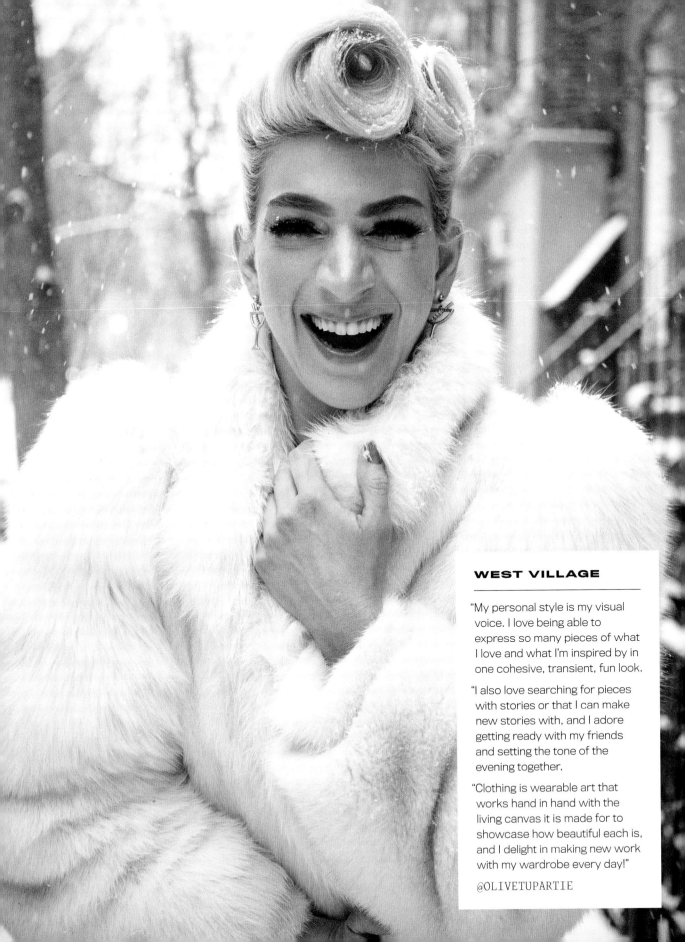

WEST VILLAGE

"My personal style is my visual voice. I love being able to express so many pieces of what I love and what I'm inspired by in one cohesive, transient, fun look.

"I also love searching for pieces with stories or that I can make new stories with, and I adore getting ready with my friends and setting the tone of the evening together.

"Clothing is wearable art that works hand in hand with the living canvas it is made for to showcase how beautiful each is, and I delight in making new work with my wardrobe every day!"

@OLIVETUPARTIE

PRINCE STREET

Fashion friends. They lost their day jobs because their employer went bankrupt. Now Niesha and Josip give each other emotional support, brainstorm together, and help create content for both of their solopreneur fashion businesses.

"I always want to reflect good vibes in what I wear and give much flavor wherever I go. It's important to keep my spirits lifted high, because things can appear hopeless and bleak, and I need something good to look forward to. I absolutely feel my best when I look my best."

@COMPASSVINTAGE

"I'm fashion brave, and it comes with the risks of not pleasing the crowds. But in the end, at least for me, it is all about how I feel when I get dressed. I like to merge high-end fashion with secondhand vintage pieces.

"I won a green card lottery six years ago and moved to NYC from Croatia. What inspires me the most are the people I see every day. Ideas just come to me by observing the motion of the city. This is a place where I can dress and be whatever I want. I don't have to play the game of trends or markets, so I am on my way to creating my own unique style. It's kind of Eastern European with a boho New York touch. It's the sum of my life experiences, cultural background, and artistic sensibility."

@COUTURELIFEROAD

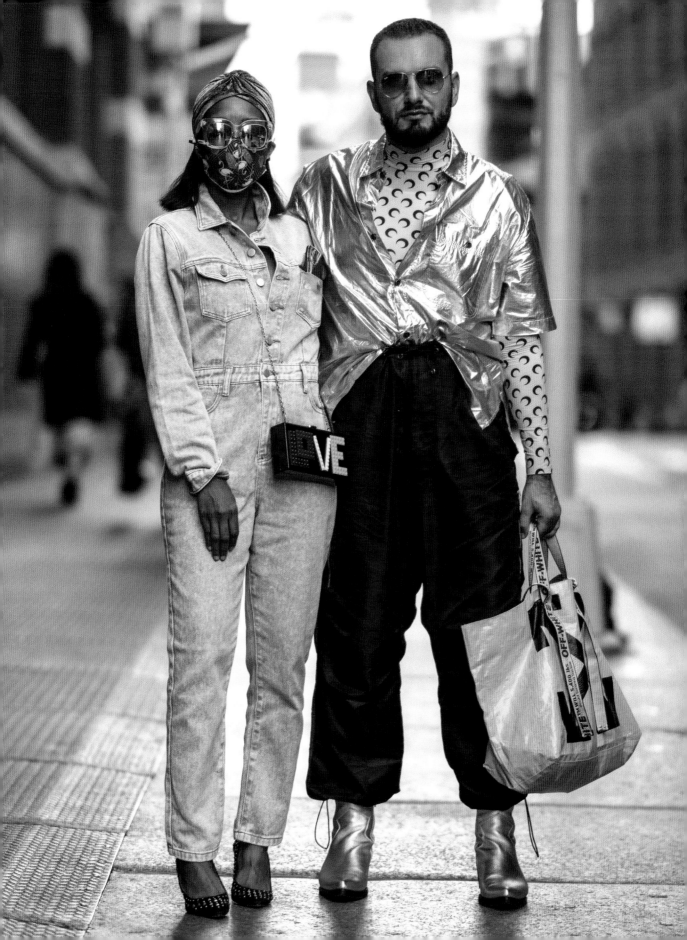

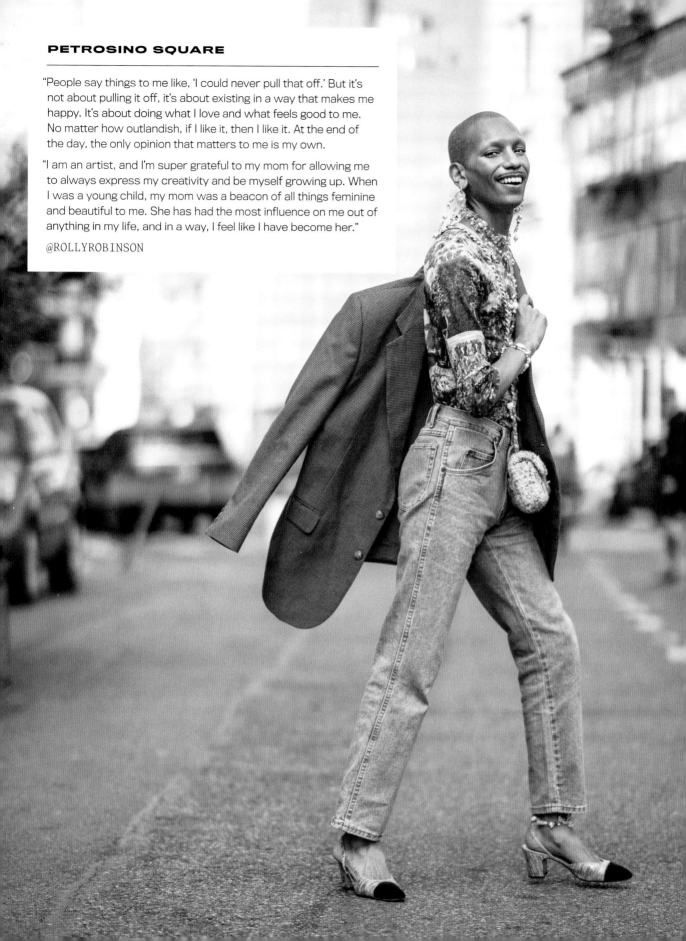

PETROSINO SQUARE

"People say things to me like, 'I could never pull that off.' But it's not about pulling it off, it's about existing in a way that makes me happy. It's about doing what I love and what feels good to me. No matter how outlandish, if I like it, then I like it. At the end of the day, the only opinion that matters to me is my own.

"I am an artist, and I'm super grateful to my mom for allowing me to always express my creativity and be myself growing up. When I was a young child, my mom was a beacon of all things feminine and beautiful to me. She has had the most influence on me out of anything in my life, and in a way, I feel like I have become her."

@ROLLYROBINSON

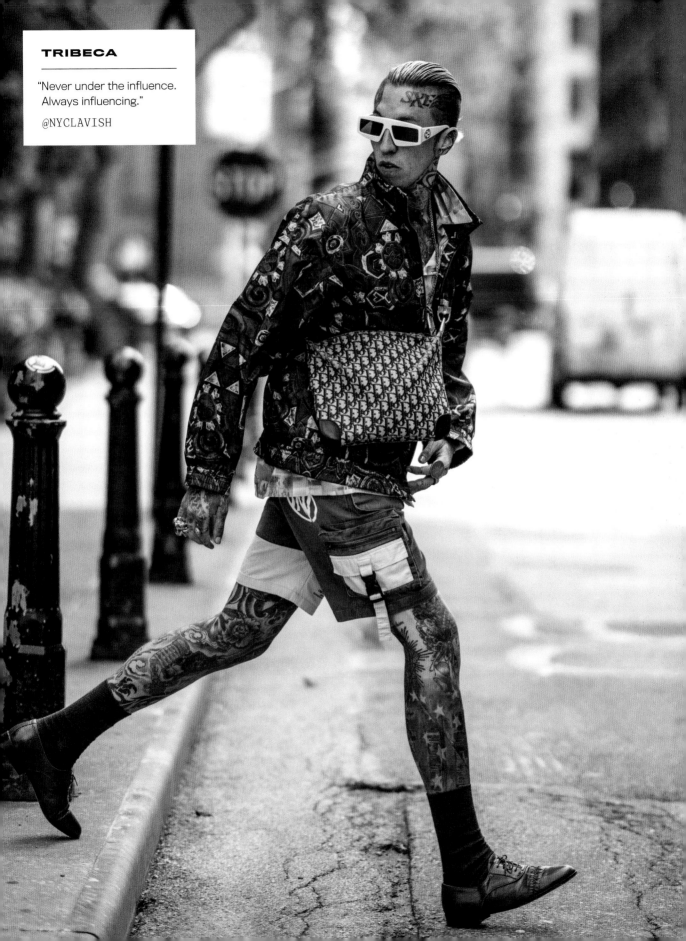

PRINCE STREET

"My hat, overalls, various jackets, vests, boots, and more, all feed into the same kind of world I create with my photographs. I consider my photography Americana that is romantic and surprising. Like the music I listen to, the books I read, and the movies I seek out, there's a consistency, a kind of magical, timeless view of America and the American road.

"I like to jazz it up a little, though, so it's not just faithfully retro. Often my photos have a splash of color that draws your eye. I guess I like that with clothes, too. When I first saw those pink sneakers, I wondered if they were a bit much for me, but then I thought, 'Hell no, I'm an artist!' That's the fifth or sixth pair of those shoes that I've owned."

@ROB.HANN

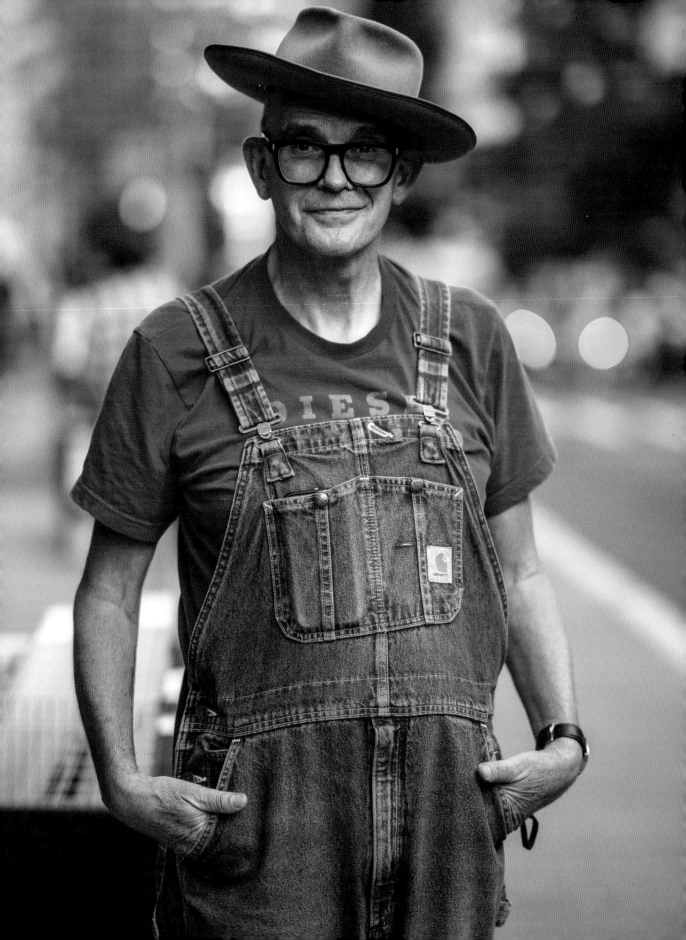

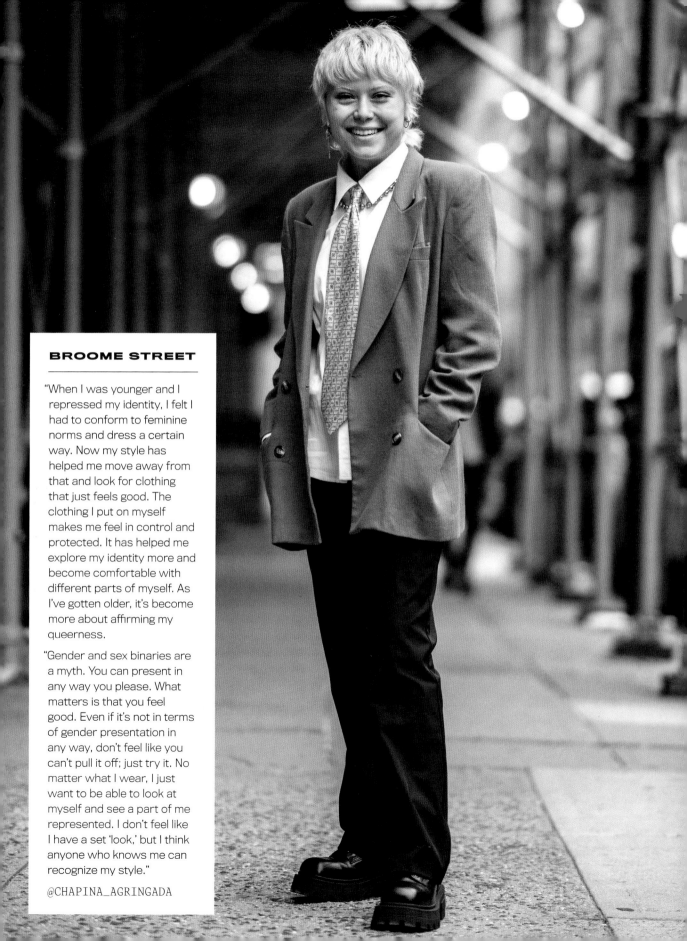

BROOME STREET

"When I was younger and I repressed my identity, I felt I had to conform to feminine norms and dress a certain way. Now my style has helped me move away from that and look for clothing that just feels good. The clothing I put on myself makes me feel in control and protected. It has helped me explore my identity more and become comfortable with different parts of myself. As I've gotten older, it's become more about affirming my queerness.

"Gender and sex binaries are a myth. You can present in any way you please. What matters is that you feel good. Even if it's not in terms of gender presentation in any way, don't feel like you can't pull it off; just try it. No matter what I wear, I just want to be able to look at myself and see a part of me represented. I don't feel like I have a set 'look,' but I think anyone who knows me can recognize my style."

@CHAPINA_AGRINGADA

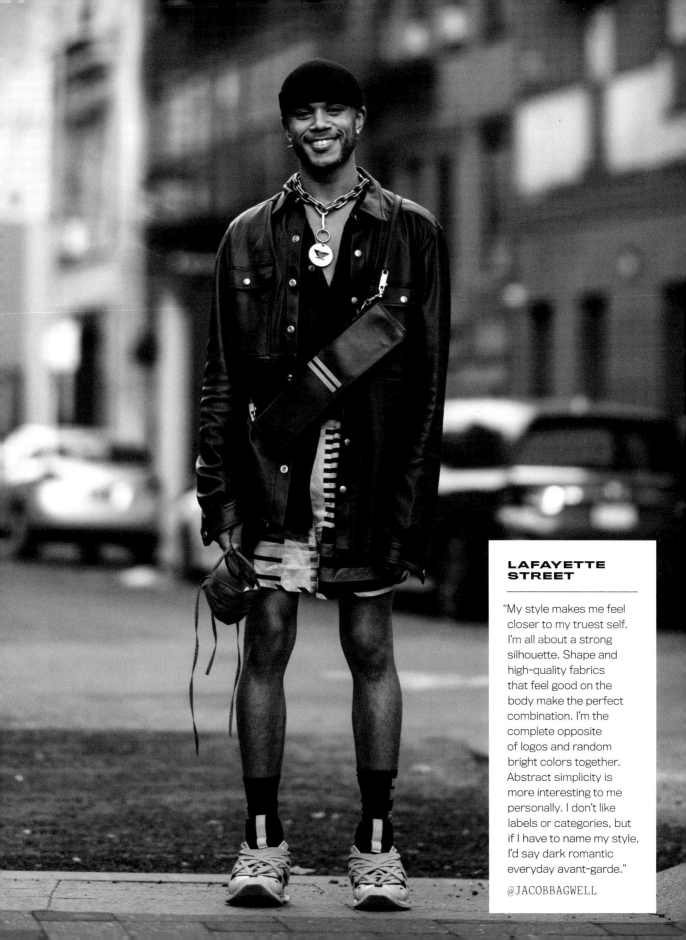

LAFAYETTE STREET

"My style makes me feel closer to my truest self. I'm all about a strong silhouette. Shape and high-quality fabrics that feel good on the body make the perfect combination. I'm the complete opposite of logos and random bright colors together. Abstract simplicity is more interesting to me personally. I don't like labels or categories, but if I have to name my style, I'd say dark romantic everyday avant-garde."

@JACOBBAGWELL

SPRING STUDIOS

Charlii interviews fashion designers but has the style like he might actually be one. Here, sporting a crested pocket blazer, Charlii mixes it up and adds a lavallière bow for this creative look. He was one of the fortunate few that were in attendance at the "phygital" (a new word I just learned) New York Fashion Week.

@CHARLIISEBUNYA

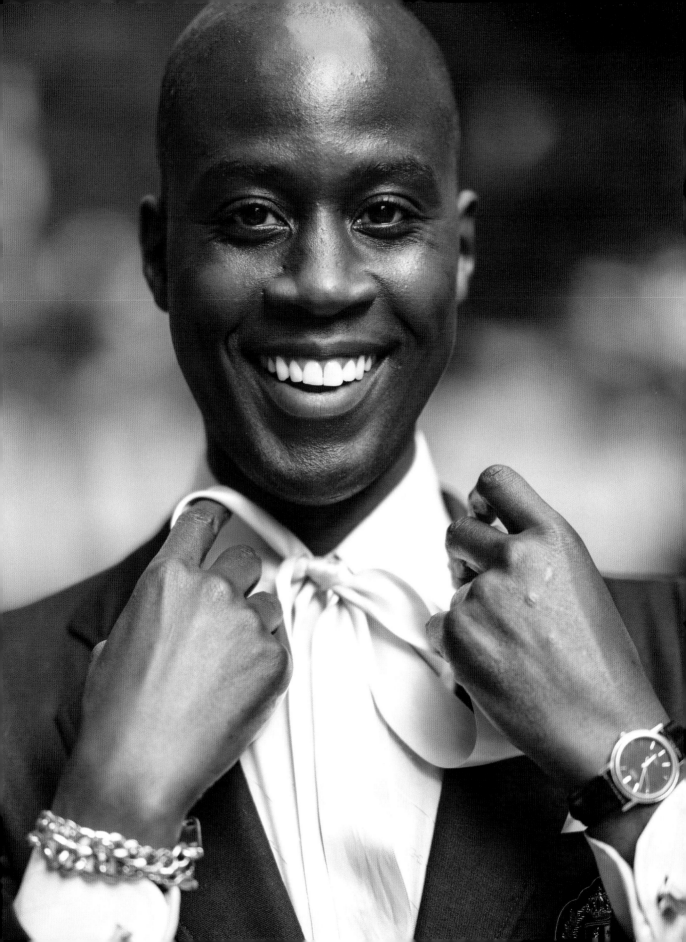

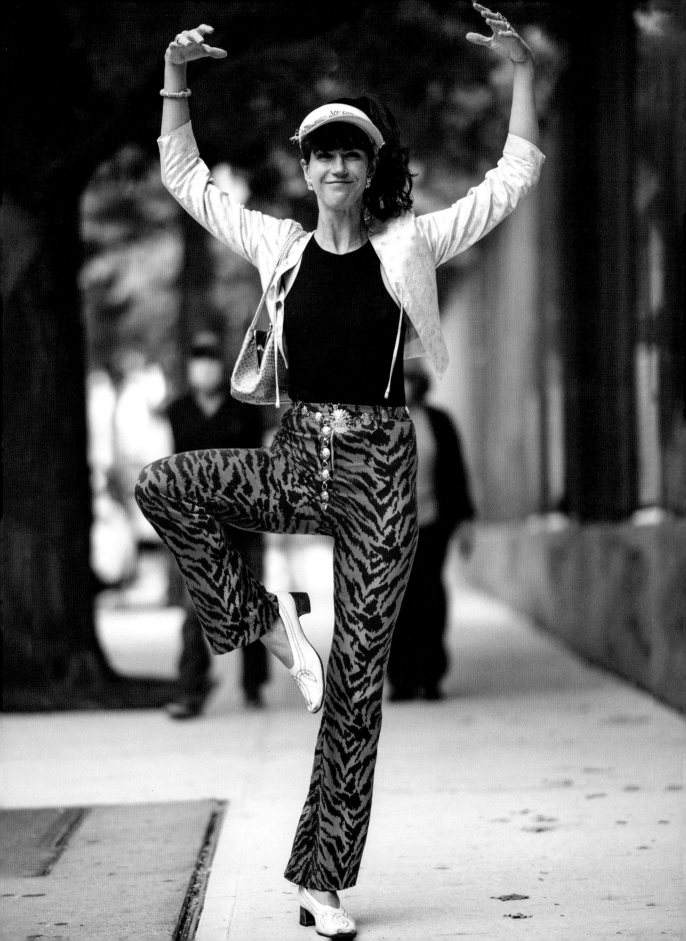

LOWER EAST SIDE

"After my PhD, I moved to New Orleans, and I was so inspired by the sense of freedom and liberty there. And for me, Mardi Gras was this time when we masked in order to show our true selves. I liked that idea of kind of having a costume to show your true self. I was so inspired, I started to also approach my everyday dress not just as a costume, but as a *genuine* costume. Like a costume as a means of expressing myself. Then I started to see a more genuine version of myself.

"I think it's actually benefited me in my work and in my life that I can be honest and vulnerable as well as playful and alive. My style and my dress are actually a strength and something that really, I think, makes me feel better. It allows me to show up in a more authentic way, even if that's in a way that is over-the-top or bold or, you know, takes up a bit of space."

@RETIRED__LESBIANS

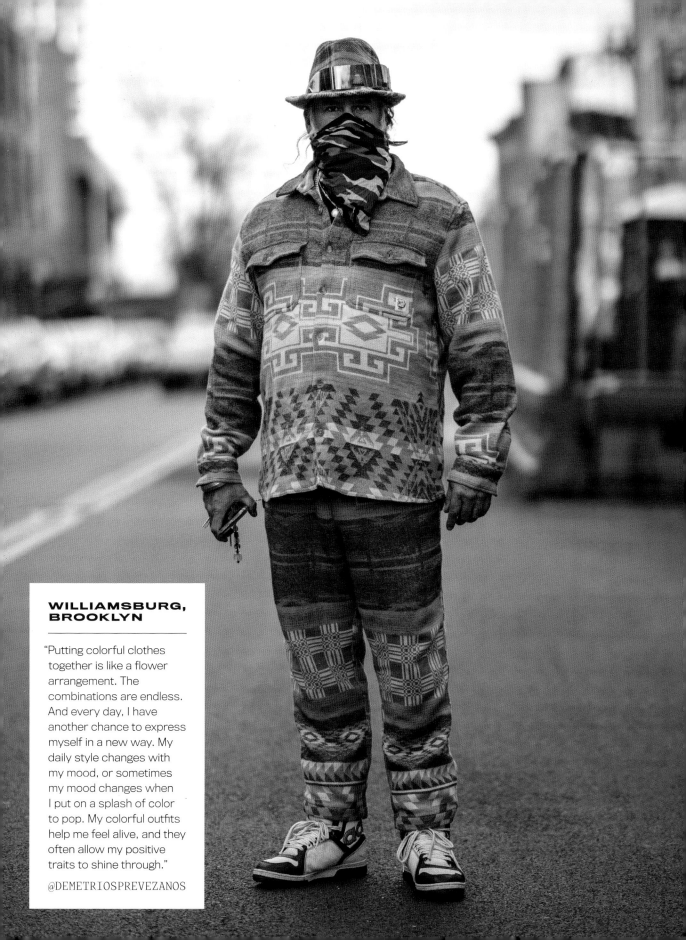

WILLIAMSBURG, BROOKLYN

"Putting colorful clothes together is like a flower arrangement. The combinations are endless. And every day, I have another chance to express myself in a new way. My daily style changes with my mood, or sometimes my mood changes when I put on a splash of color to pop. My colorful outfits help me feel alive, and they often allow my positive traits to shine through."

@DEMETRIOSPREVEZANOS

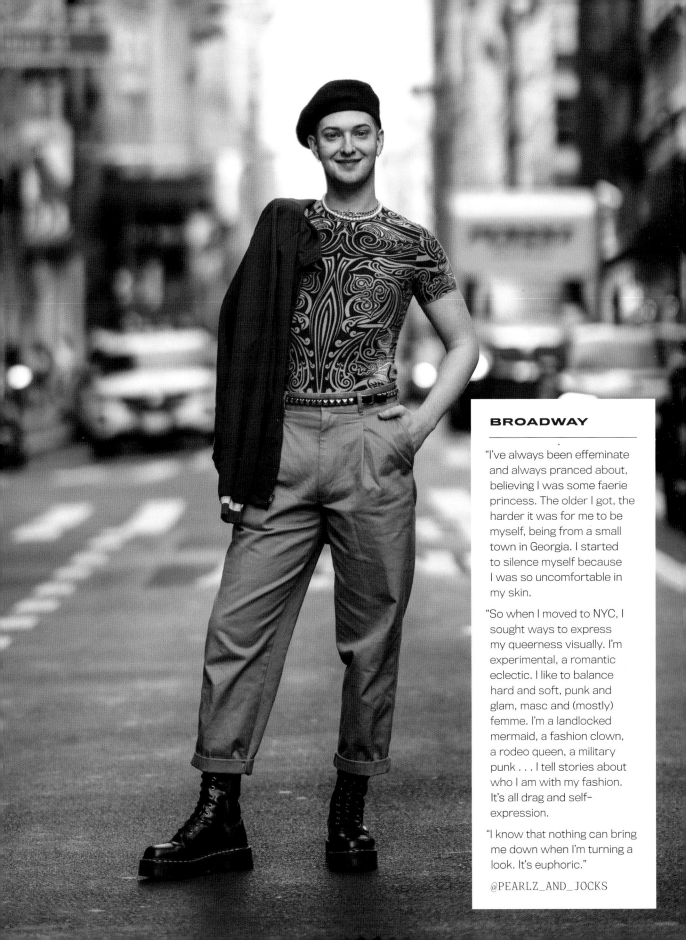

BROADWAY

"I've always been effeminate and always pranced about, believing I was some faerie princess. The older I got, the harder it was for me to be myself, being from a small town in Georgia. I started to silence myself because I was so uncomfortable in my skin.

"So when I moved to NYC, I sought ways to express my queerness visually. I'm experimental, a romantic eclectic. I like to balance hard and soft, punk and glam, masc and (mostly) femme. I'm a landlocked mermaid, a fashion clown, a rodeo queen, a military punk . . . I tell stories about who I am with my fashion. It's all drag and self-expression.

"I know that nothing can bring me down when I'm turning a look. It's euphoric."

@PEARLZ_AND_JOCKS

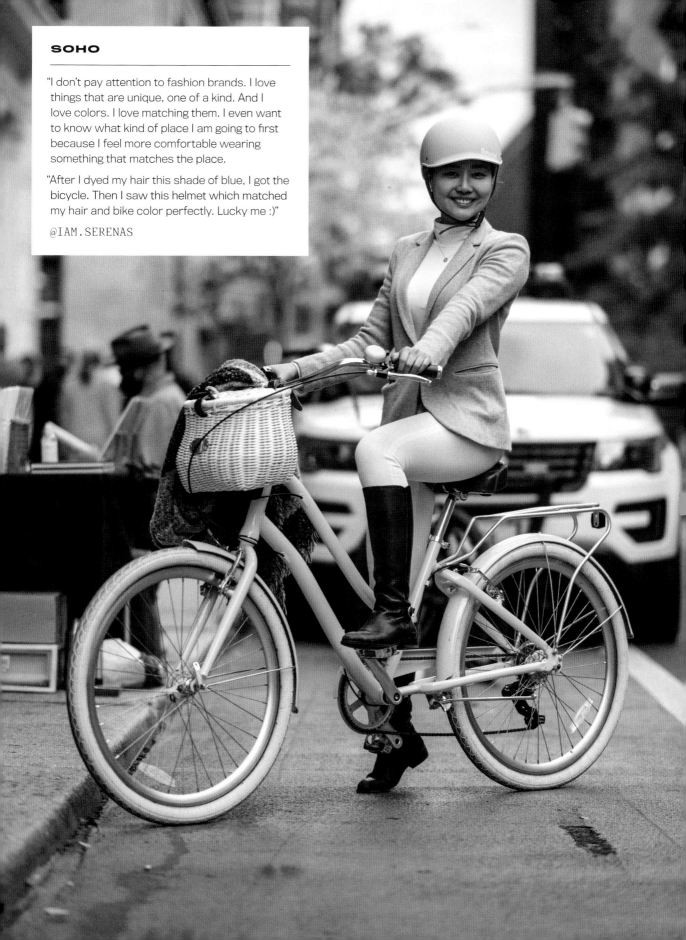

SOHO

"I don't pay attention to fashion brands. I love things that are unique, one of a kind. And I love colors. I love matching them. I even want to know what kind of place I am going to first because I feel more comfortable wearing something that matches the place.

"After I dyed my hair this shade of blue, I got the bicycle. Then I saw this helmet which matched my hair and bike color perfectly. Lucky me :)"

@IAM.SERENAS

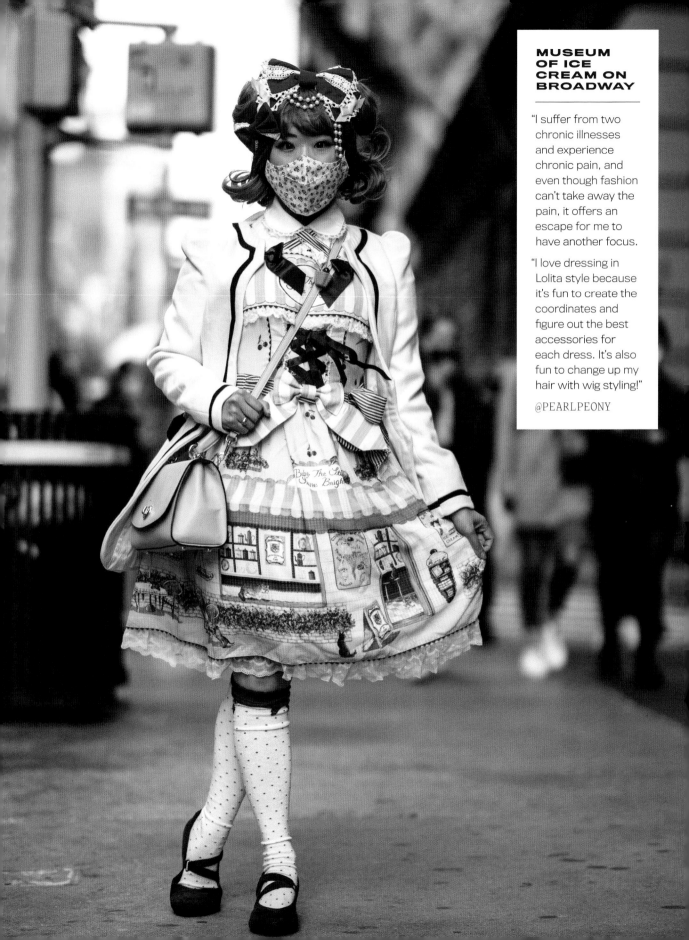

MUSEUM OF ICE CREAM ON BROADWAY

"I suffer from two chronic illnesses and experience chronic pain, and even though fashion can't take away the pain, it offers an escape for me to have another focus.

"I love dressing in Lolita style because it's fun to create the coordinates and figure out the best accessories for each dress. It's also fun to change up my hair with wig styling!"

@PEARLPEONY

"My style is an extension of my power. I want people to
know that it's okay and possible to be masculine and
feminine at the same time."

—LUCAS HESS

"I'm communicating the type of person I want to be on any
given day. My style switches up quite often and showcases
my growth as a person."

@REL_THEKID

"I'm a soft, beautiful woman, but I'm also strong and not to
be messed with. I don't want to wear anything that couldn't
be accessorized with an axe.

"If the pandemic has taught me anything about style, it's that
I don't need a time or place to wear my most ridiculous
outfit. What I used to wear to the club I'm wearing to the
grocery store now. I feel confident in my outfit, and that's all
that matters.

"The three of us have our own unique styles, but we always
try to look unified when we walk the streets together. It
reflects our friendship."

@PERI.TARO

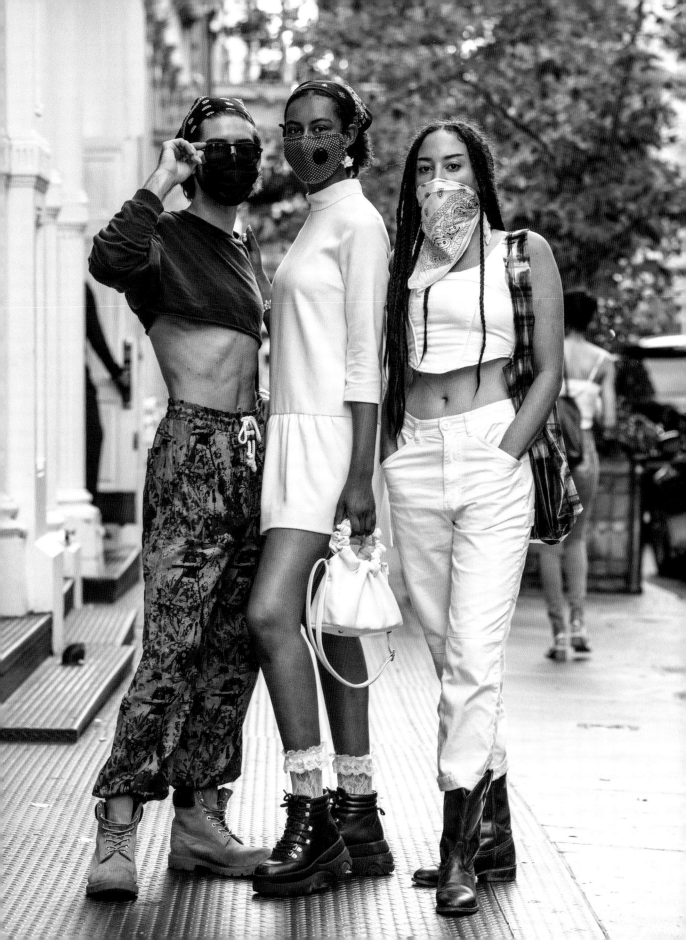

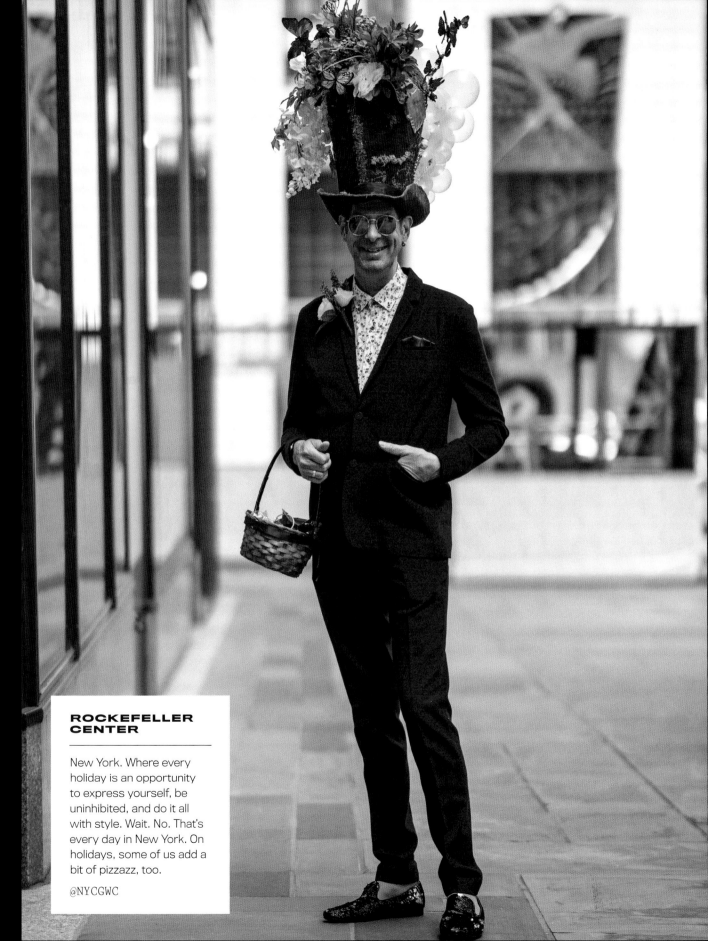

ROCKEFELLER CENTER

New York. Where every
holiday is an opportunity
to express yourself, be
uninhibited, and do it all
with style. Wait. No. That's
every day in New York. On
holidays, some of us add a
bit of pizzazz, too.

@NYCGWC

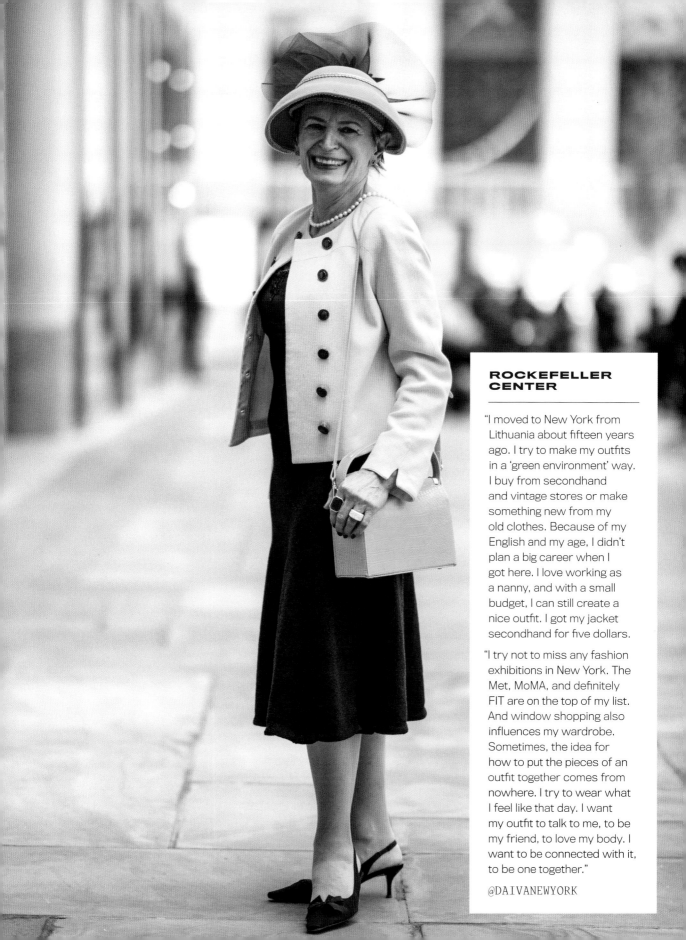

ROCKEFELLER CENTER

"I moved to New York from Lithuania about fifteen years ago. I try to make my outfits in a 'green environment' way. I buy from secondhand and vintage stores or make something new from my old clothes. Because of my English and my age, I didn't plan a big career when I got here. I love working as a nanny, and with a small budget, I can still create a nice outfit. I got my jacket secondhand for five dollars.

"I try not to miss any fashion exhibitions in New York. The Met, MoMA, and definitely FIT are on the top of my list. And window shopping also influences my wardrobe. Sometimes, the idea for how to put the pieces of an outfit together comes from nowhere. I try to wear what I feel like that day. I want my outfit to talk to me, to be my friend, to love my body. I want to be connected with it, to be one together."

@DAIVANEWYORK

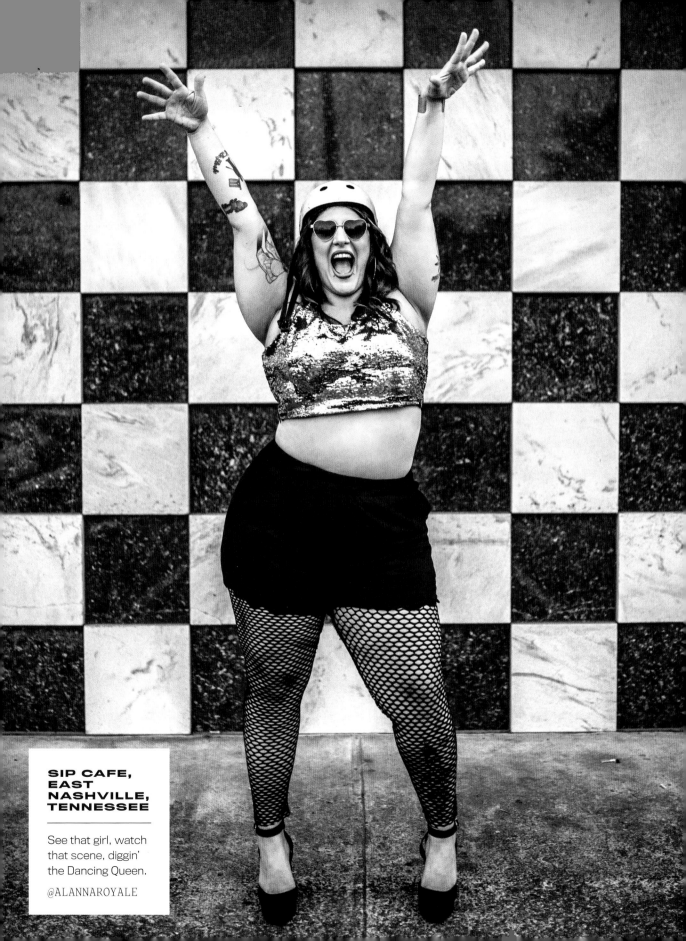

SIP CAFE, EAST NASHVILLE, TENNESSEE

See that girl, watch that scene, diggin' the Dancing Queen.

@ALANNAROYALE

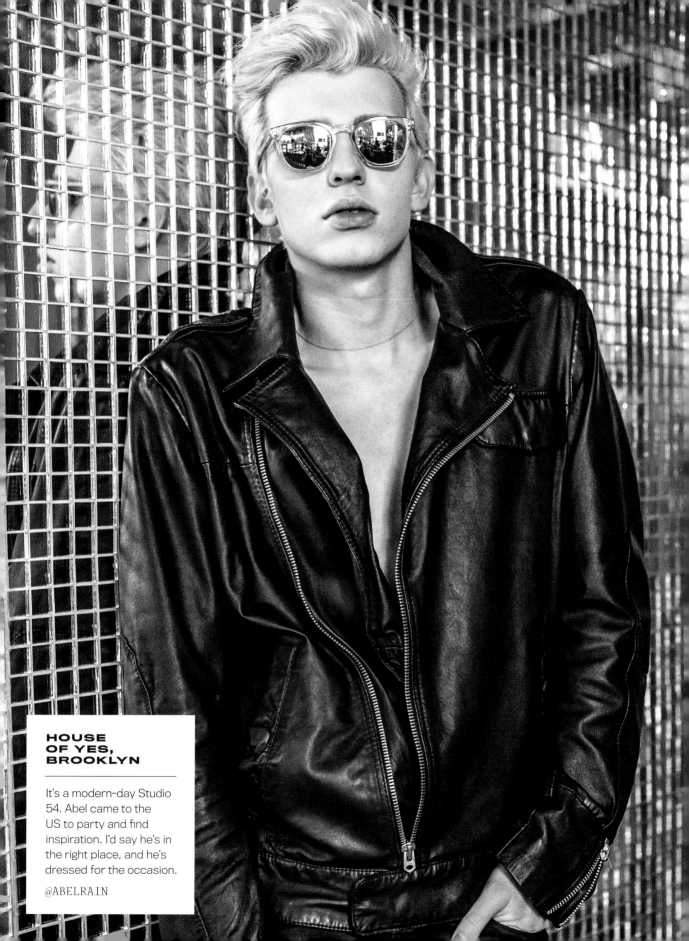

HOUSE OF YES, BROOKLYN

It's a modern-day Studio 54. Abel came to the US to party and find inspiration. I'd say he's in the right place, and he's dressed for the occasion.

@ABELRAIN

NOLITA

"Mike is always up for anything and has such a happy spirit. He was more than willing to wear these matching outfits to help us celebrate the Kentucky Derby. And even though the event was quite different this year, we were still in a festive mood. We've done this type of complementary styling in the past. He actually thinks it's super fun to coordinate, which thrills me. I've never been with anyone that cares about me the way Mike does.

"My style: I typically wear things that bring me joy and delight. I'm not afraid to look different. And even though Mike and I put this ensemble together for the race, I don't save a special dress just for an important occasion. I wear it to the grocery store. It makes my day better and probably brightens the day of others as well."

@FAERIEGLAMOUR with @REDHDDSTPCHLD74

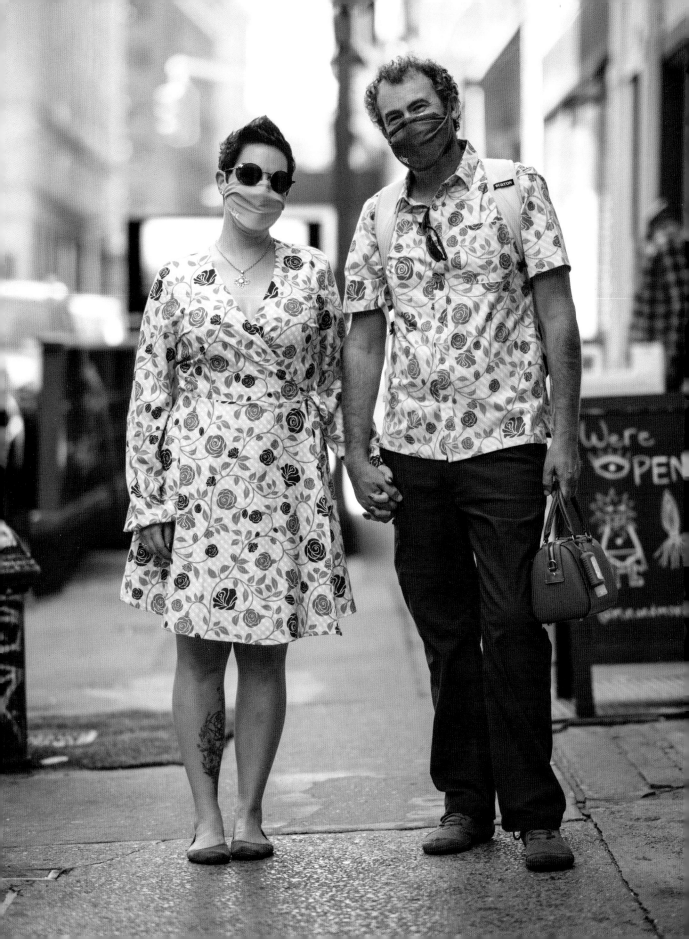

RIGHT
UPPER WEST SIDE

New York's very own Mary Poppins. Every moment with style icon Tziporah Salamon is unique and extraordinary, filled with unexpected joy. She seems to appear out of nowhere, and there's also a sense that at any moment, if Tzippy wants to, she could raise an umbrella and float away. Spit-spot!

@TZIPORAHSALAMON

BELOW LEFT
PRINCE STREET

Who wears a taffeta outfit while bike riding?

BELOW RIGHT
GRAMERCY PARK

Those that are truly comfortable being authentic and unique are the ones everyone wants to be like.

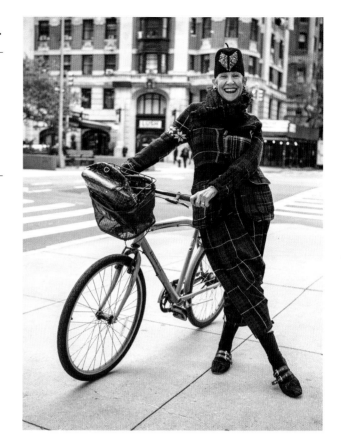

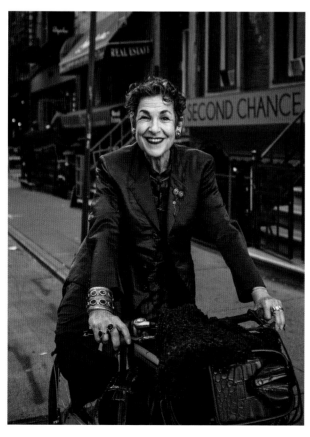

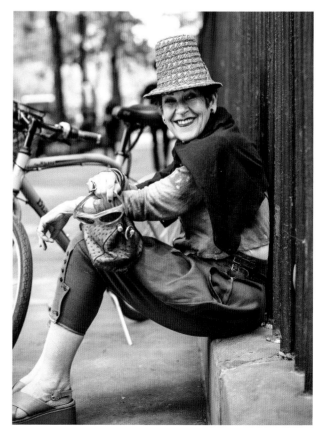

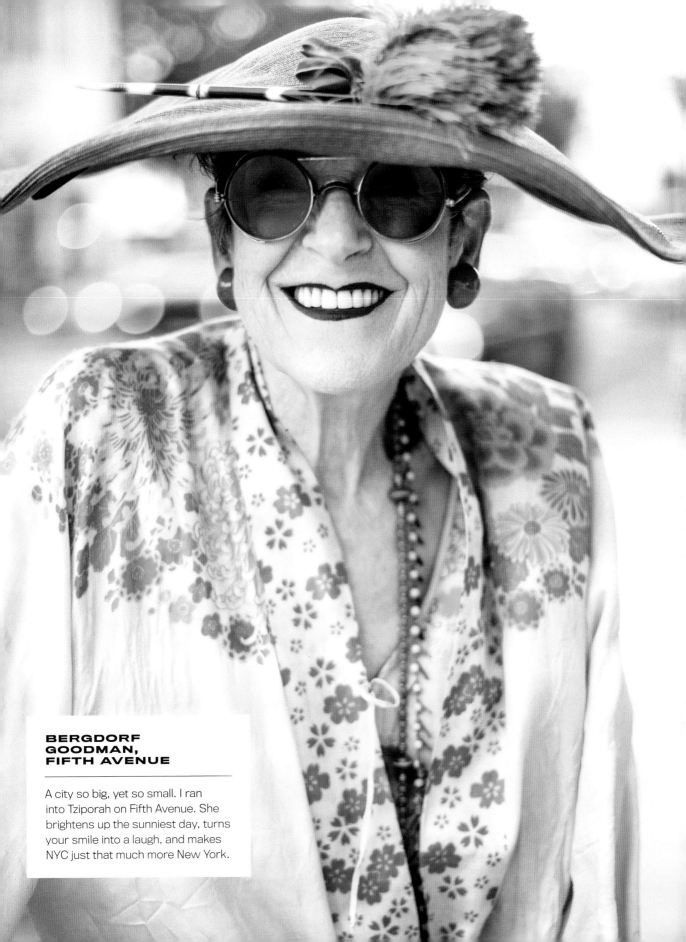

BERGDORF GOODMAN, FIFTH AVENUE

A city so big, yet so small. I ran into Tziporah on Fifth Avenue. She brightens up the sunniest day, turns your smile into a laugh, and makes NYC just that much more New York.

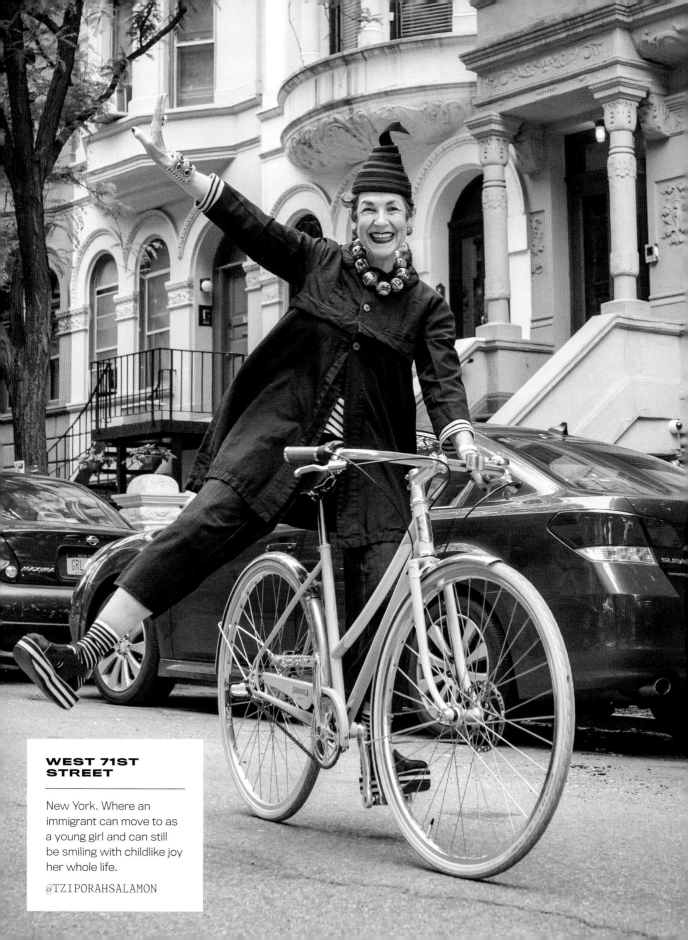

WEST 71ST
STREET

New York. Where an
immigrant can move to as
a young girl and can still
be smiling with childlike joy
her whole life.

@TZIPORAHSALAMON

BROOKLYN BRIDGE

"My style is my art form.

"I create outfits that make me happy. To me, dressing is an incredibly creative endeavor that I take very seriously.

"I paint works of art with my clothes and accessories. The difference is that I wear these works of art on my body.

"I am doing my part to elevate the role of dressing, and hopefully raising the bar and setting it high."

RIVERSIDE PARK

@TZIPORAHSALAMON always makes me feel like something special is about to happen. Like she could start pedaling and she and her Shinola bike could fly off to a magical place. Oh, that's right, we're already in New York. That's pretty magical.

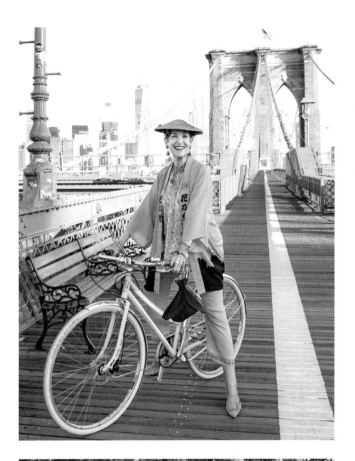

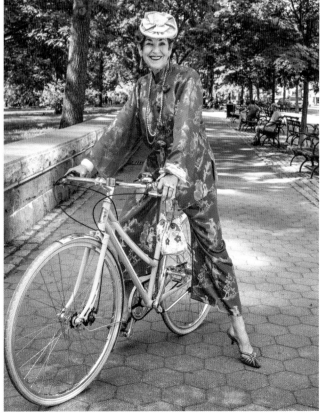

59TH STREET–COLUMBUS CIRCLE

"The pandemic has actually given me more freedom to express my style. Since I'm at home and don't see my coworkers in person every day, I can try new things and not worry if it doesn't work out. I've started experimenting more with different hair and nail colors. So far, my hair has been blond, blue, purple, silver, pink, and gray. There's this disconnect that has given me a sense of power to put out a more gender-fluid statement.

"So when I first saw the IVY PARK/Adidas tracksuit I'm wearing, I instantly thought I want to wear this on the first day it's warm and have the hair and nails to match. I want people to notice me and think, 'Oh, I bet he's fun!'"

@ZGENT

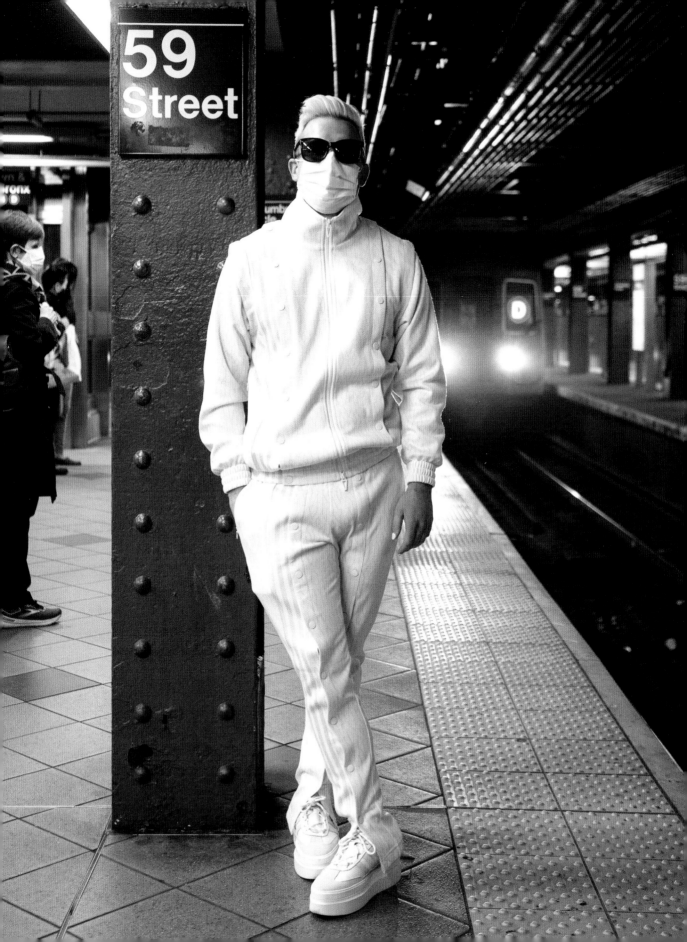

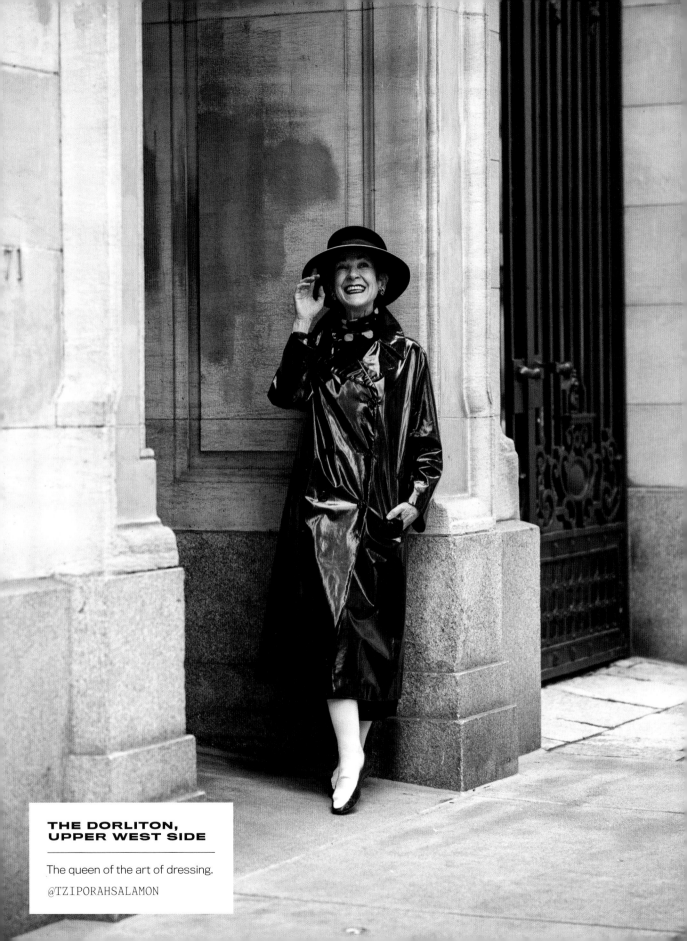

**THE DORLITON,
UPPER WEST SIDE**

The queen of the art of dressing.

@TZIPORAHSALAMON

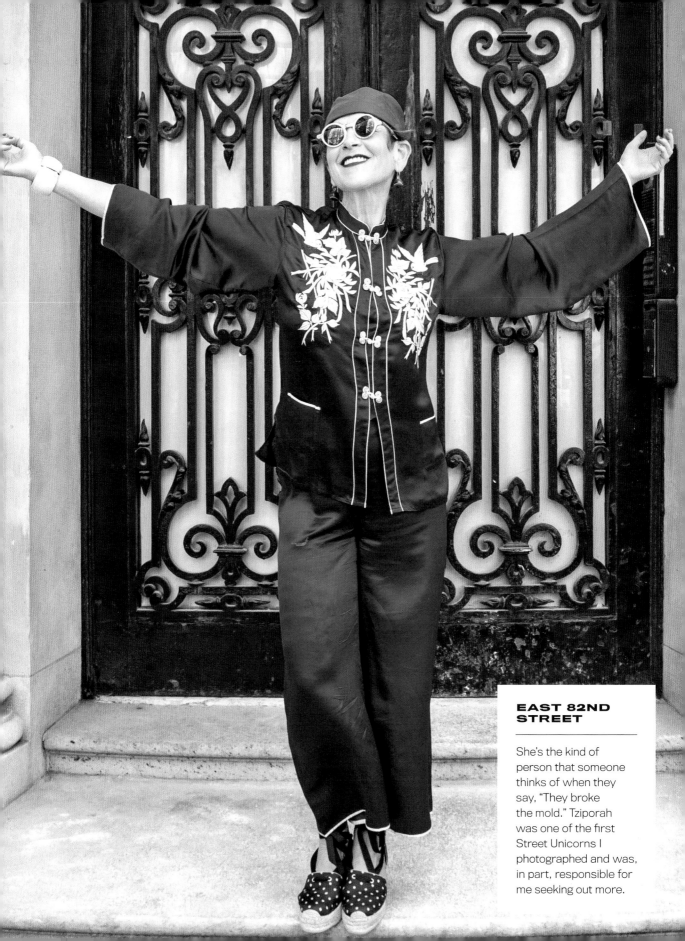

EAST 82ND STREET

She's the kind of person that someone thinks of when they say, "They broke the mold." Tziporah was one of the first Street Unicorns I photographed and was, in part, responsible for me seeking out more.

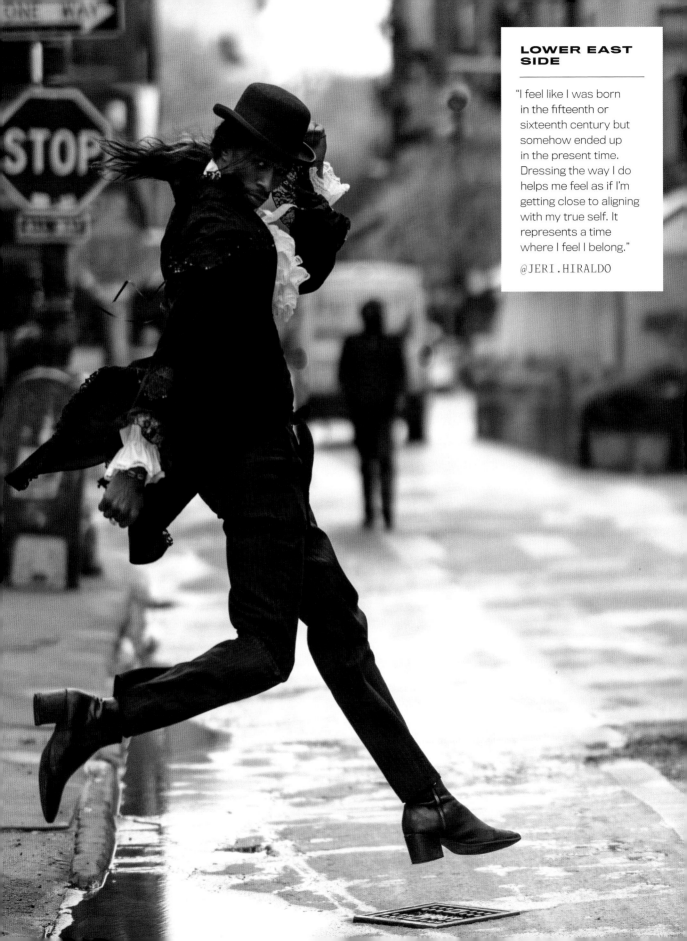

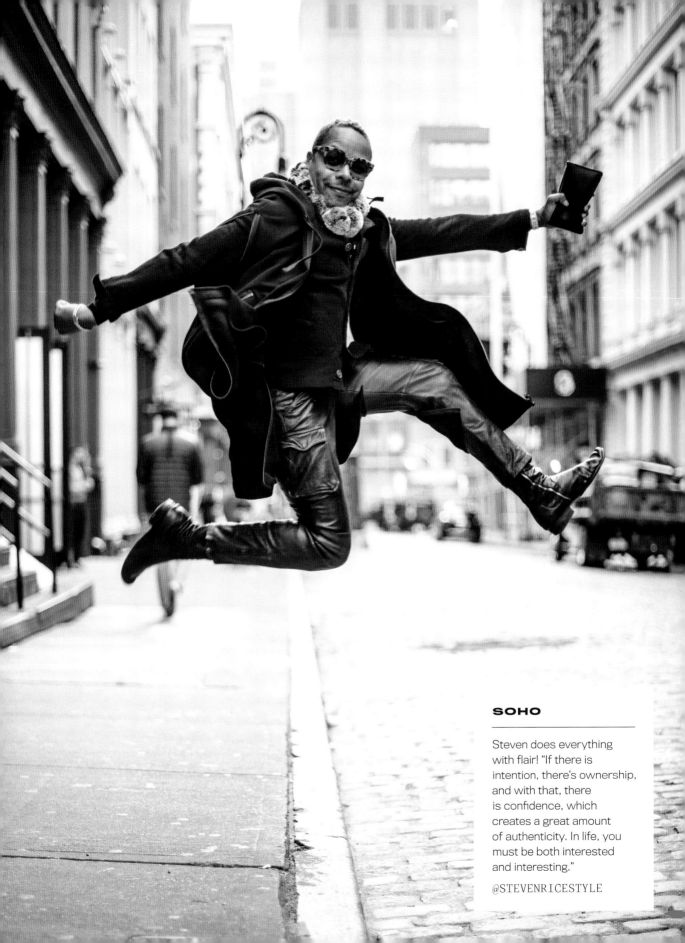

SOHO

Steven does everything with flair! "If there is intention, there's ownership, and with that, there is confidence, which creates a great amount of authenticity. In life, you must be both interested and interesting."

@STEVENRICESTYLE

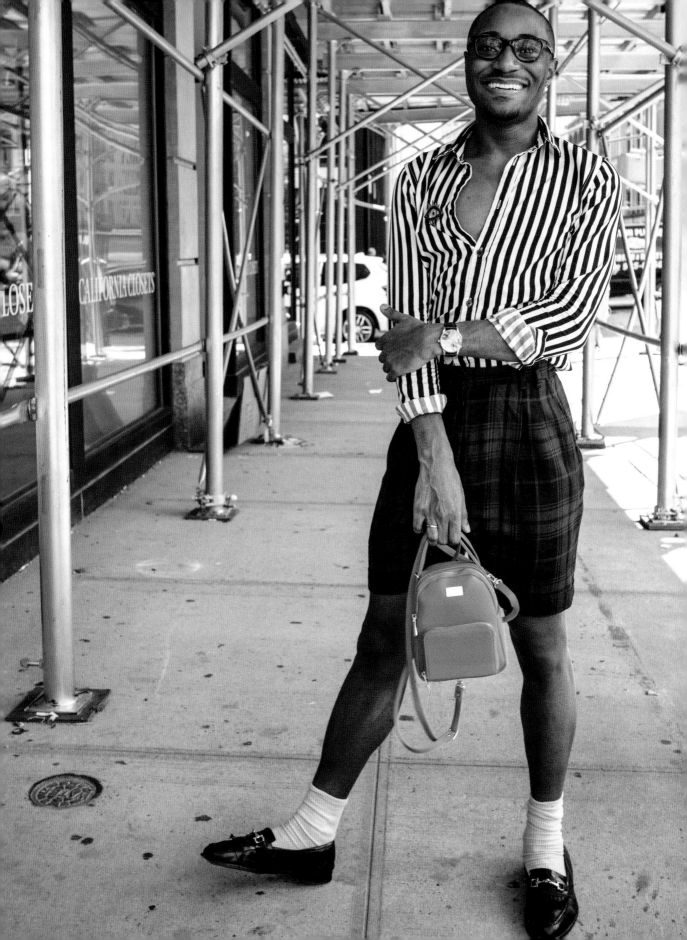

OPPOSITE PAGE

TRIBECA

POWER CLASH! Brandon wants us to consider bringing unlikely elements together to create something new and fresh. It's a way to gently challenge the world to grow and accept each other for being the most authentic version of ourselves. It's also to inspire others to strive to achieve it.

@SIRBRANDONNICHOLAS

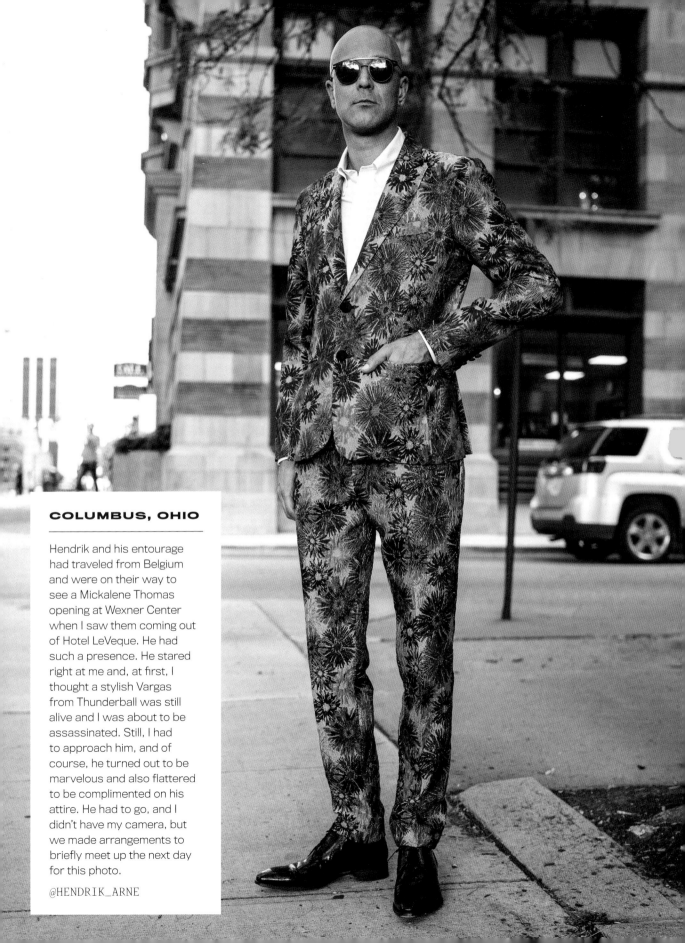

COLUMBUS, OHIO

Hendrik and his entourage
had traveled from Belgium
and were on their way to
see a Mickalene Thomas
opening at Wexner Center
when I saw them coming out
of Hotel LeVeque. He had
such a presence. He stared
right at me and, at first, I
thought a stylish Vargas
from Thunderball was still
alive and I was about to be
assassinated. Still, I had
to approach him, and of
course, he turned out to be
marvelous and also flattered
to be complimented on his
attire. He had to go, and I
didn't have my camera, but
we made arrangements to
briefly meet up the next day
for this photo.

@HENDRIK_ARNE

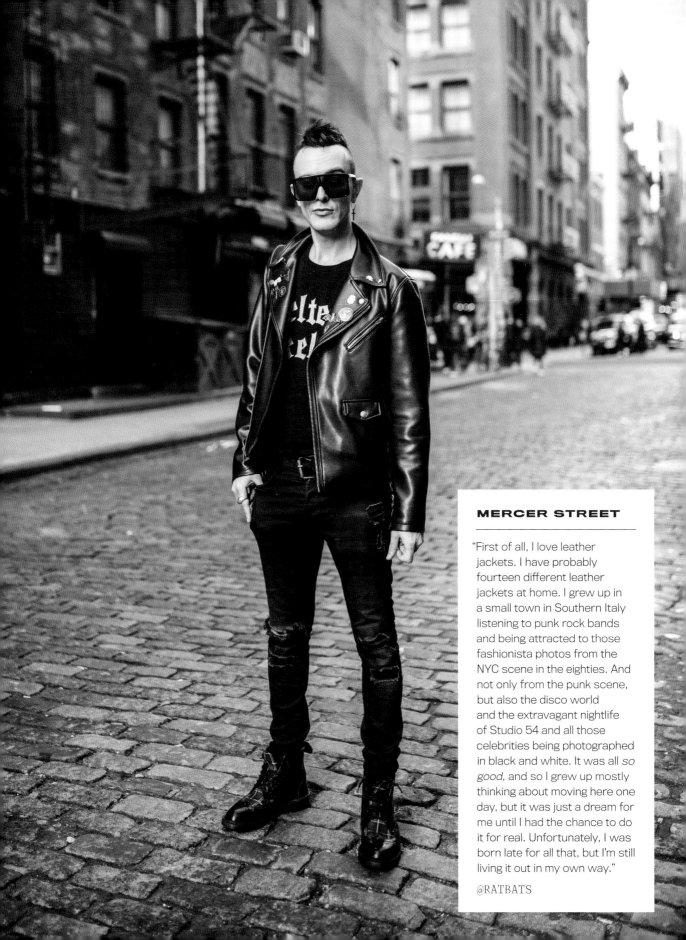

MERCER STREET

"First of all, I love leather jackets. I have probably fourteen different leather jackets at home. I grew up in a small town in Southern Italy listening to punk rock bands and being attracted to those fashionista photos from the NYC scene in the eighties. And not only from the punk scene, but also the disco world and the extravagant nightlife of Studio 54 and all those celebrities being photographed in black and white. It was all *so good*, and so I grew up mostly thinking about moving here one day, but it was just a dream for me until I had the chance to do it for real. Unfortunately, I was born late for all that, but I'm still living it out in my own way."

@RATBATS

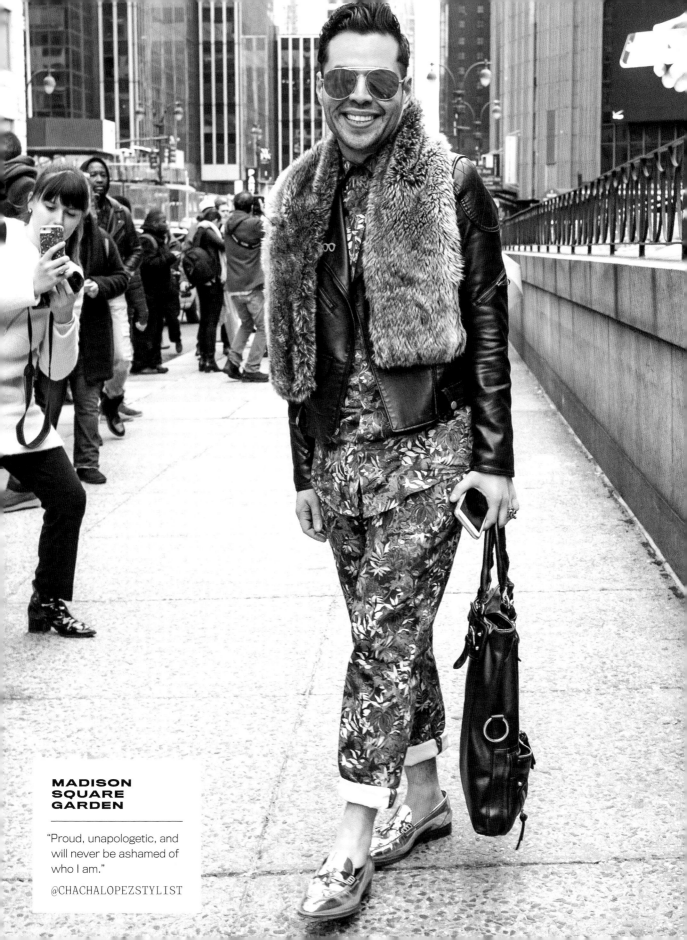

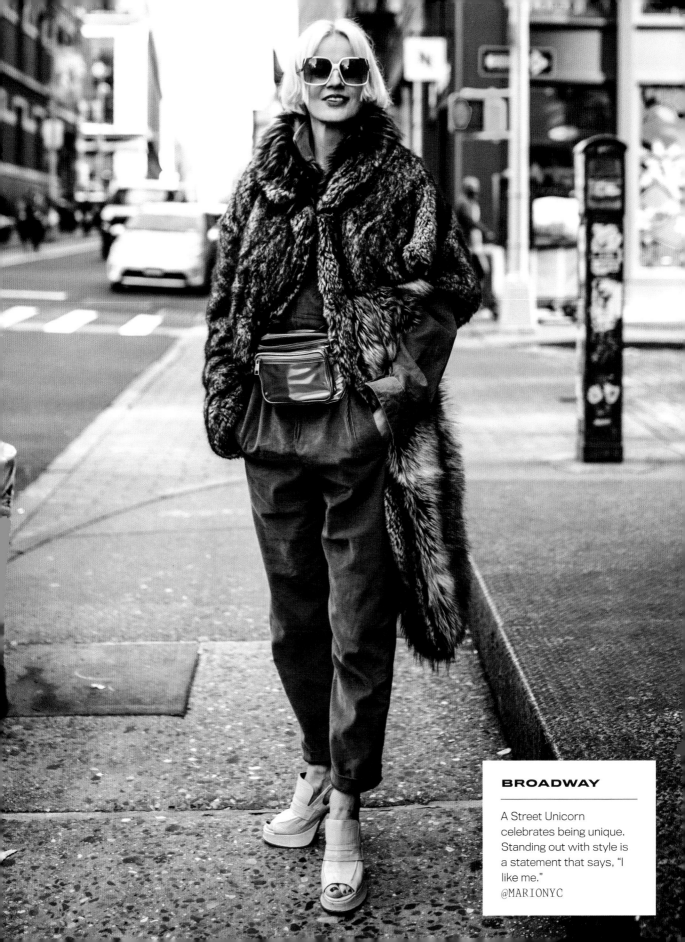

BROADWAY

A Street Unicorn celebrates being unique. Standing out with style is a statement that says, "I like me."
@MARIONYC

SPRING STREET

"I'm ashamed to admit that I conformed to the boundaries of growing up in small-town, conservative Kansas. There were unspoken confines on how people should act, dress, and even how people should think or what they should believe. I didn't know what I wanted out of life, but I quickly realized I wasn't going to find it there. I applied to the Fashion Institute of Technology, and when I got the letter of acceptance, there was absolutely no looking back.

"Moving to New York was the first time I learned to truly express myself through the art of dress. And now I feel unstoppable. When I put on an outfit that I know is a little bit far out (which is honestly most days), it gives me a bit of adrenaline. I've learned to thrive off of knowing that my outfit will turn a few heads. Whether it makes people think, 'Why would anyone think it's okay to leave the house in that?' or 'Whoa, that's a really cool look,' or 'I would've never thought to wear those pieces together,' I get a thrill from knowing that my art form—fashion—made people feel something."

@LYNDSAY JAEGER

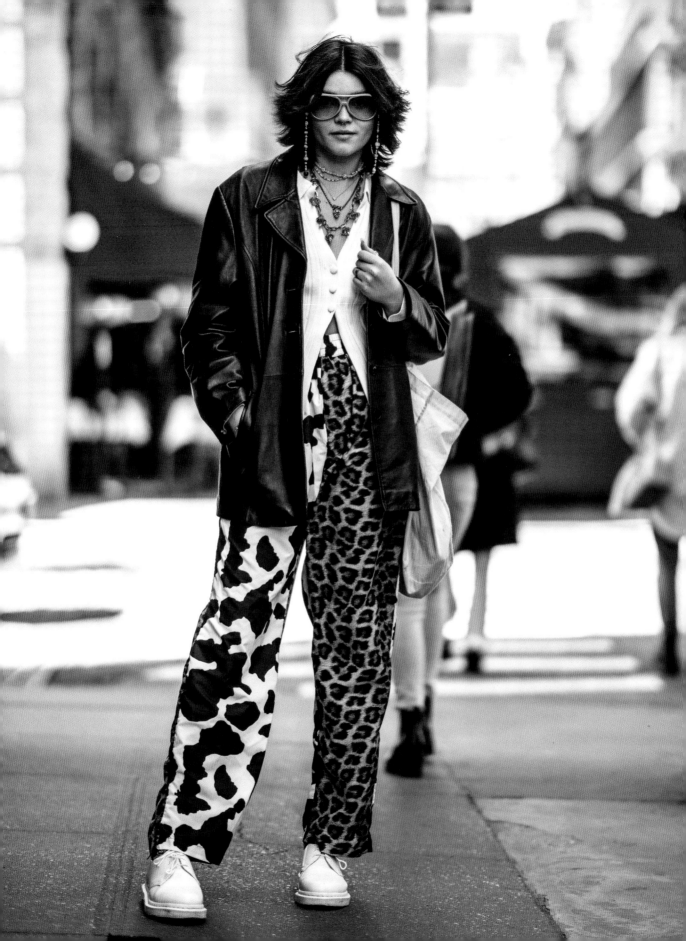

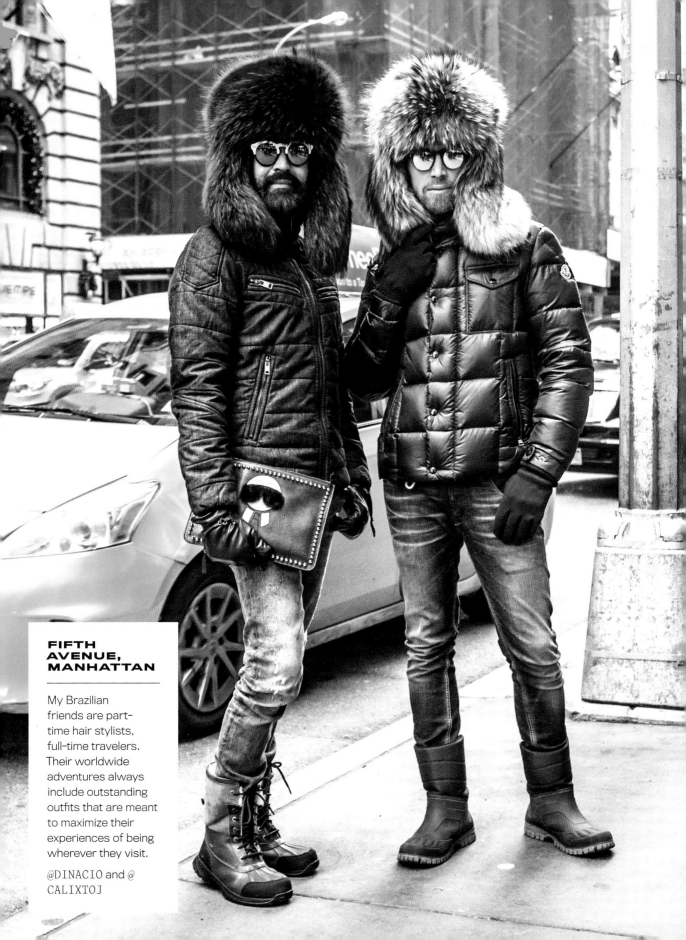

FIFTH AVENUE, MANHATTAN

My Brazilian friends are part-time hair stylists, full-time travelers. Their worldwide adventures always include outstanding outfits that are meant to maximize their experiences of being wherever they visit.

@DINACIO and @CALIXTOJ

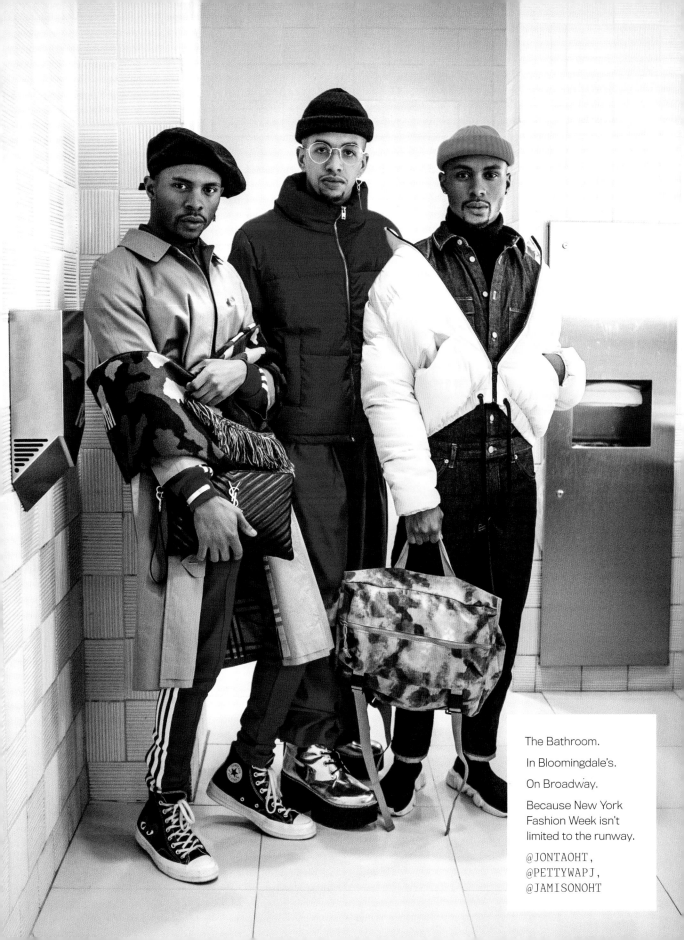

The Bathroom.

In Bloomingdale's.

On Broadway.

Because New York
Fashion Week isn't
limited to the runway.

@JONTAOHT,
@PETTYWAPJ,
@JAMISONOHT

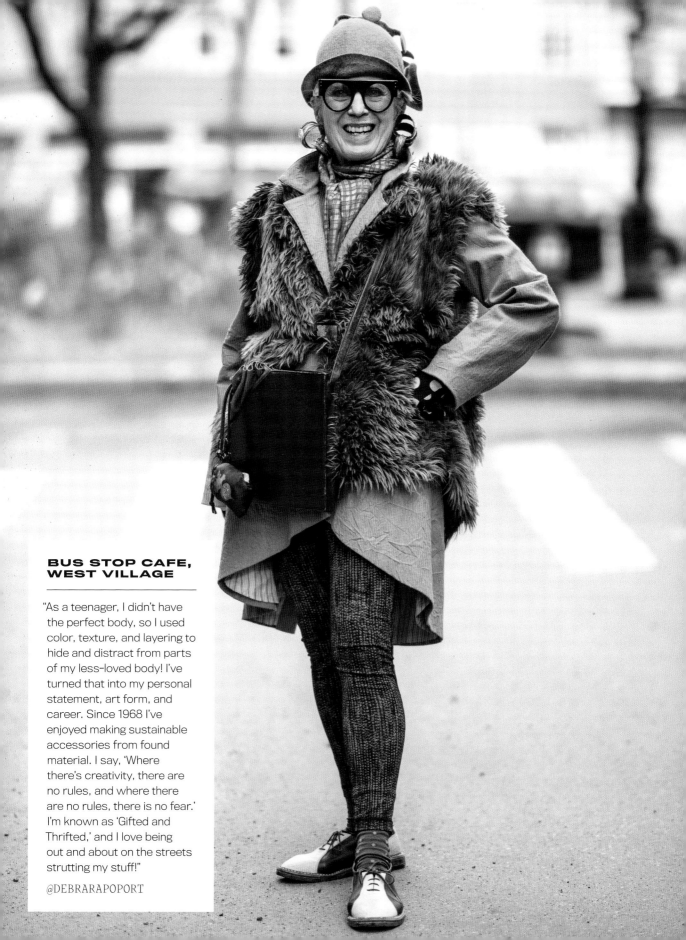

BUS STOP CAFE, WEST VILLAGE

"As a teenager, I didn't have the perfect body, so I used color, texture, and layering to hide and distract from parts of my less-loved body! I've turned that into my personal statement, art form, and career. Since 1968 I've enjoyed making sustainable accessories from found material. I say, 'Where there's creativity, there are no rules, and where there are no rules, there is no fear.' I'm known as 'Gifted and Thrifted,' and I love being out and about on the streets strutting my stuff!"

@DEBRARAPOPORT

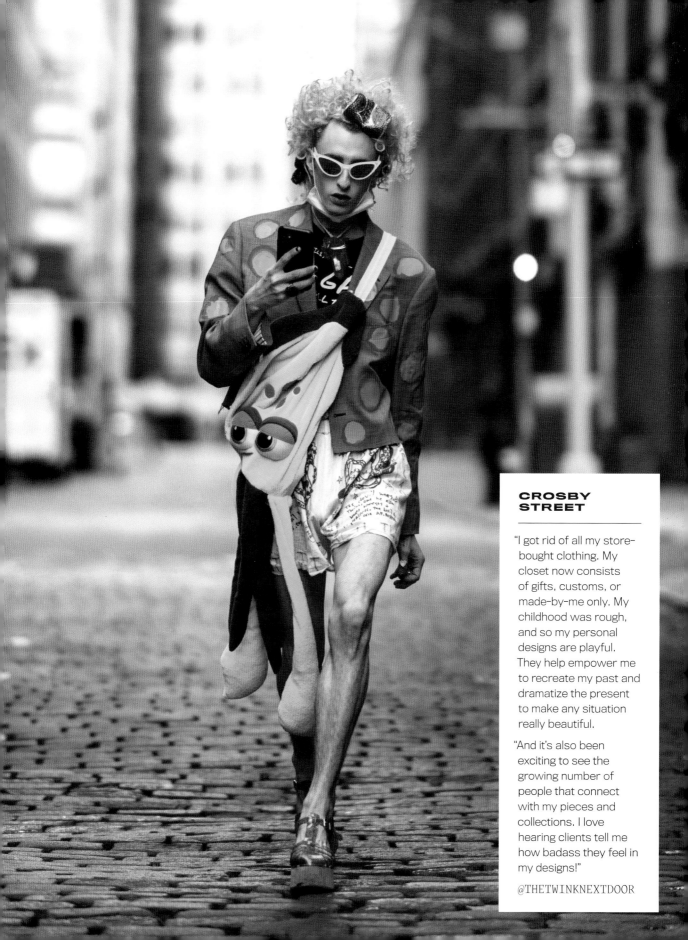

CROSBY STREET

"I got rid of all my store-bought clothing. My closet now consists of gifts, customs, or made-by-me only. My childhood was rough, and so my personal designs are playful. They help empower me to recreate my past and dramatize the present to make any situation really beautiful.

"And it's also been exciting to see the growing number of people that connect with my pieces and collections. I love hearing clients tell me how badass they feel in my designs!"

@THETWINKNEXTDOOR

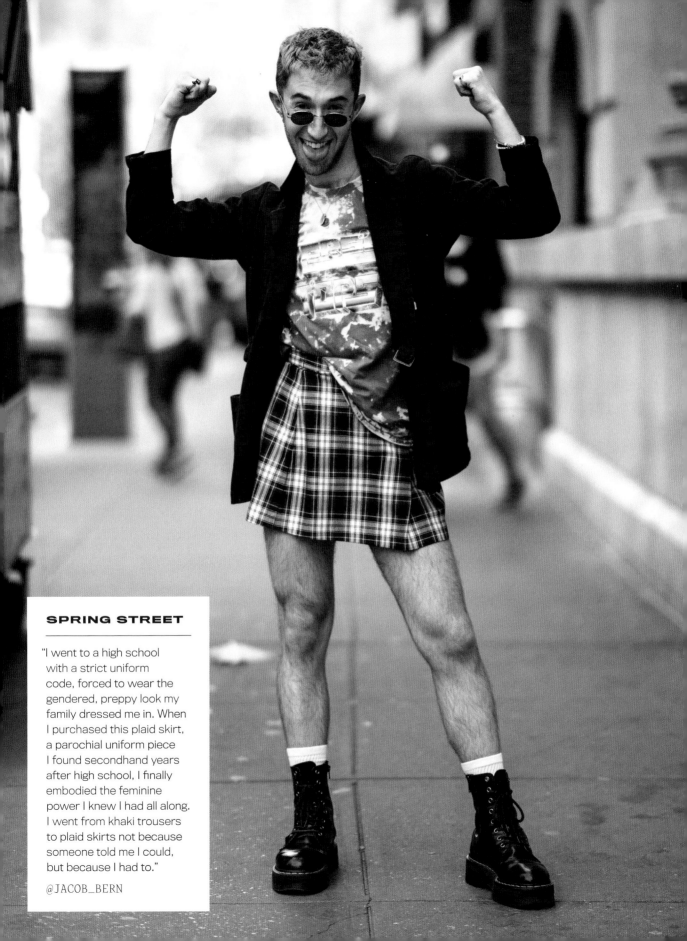

SPRING STREET

"I went to a high school with a strict uniform code, forced to wear the gendered, preppy look my family dressed me in. When I purchased this plaid skirt, a parochial uniform piece I found secondhand years after high school, I finally embodied the feminine power I knew I had all along. I went from khaki trousers to plaid skirts not because someone told me I could, but because I had to."

@JACOB_BERN

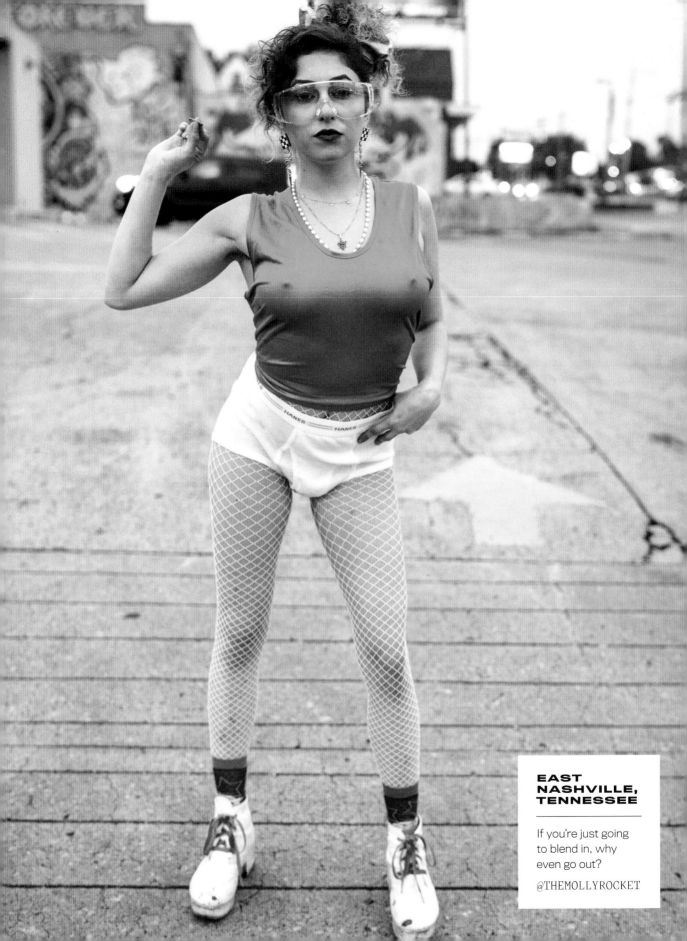

**EAST
NASHVILLE,
TENNESSEE**

If you're just going
to blend in, why
even go out?

@THEMOLLYROCKET

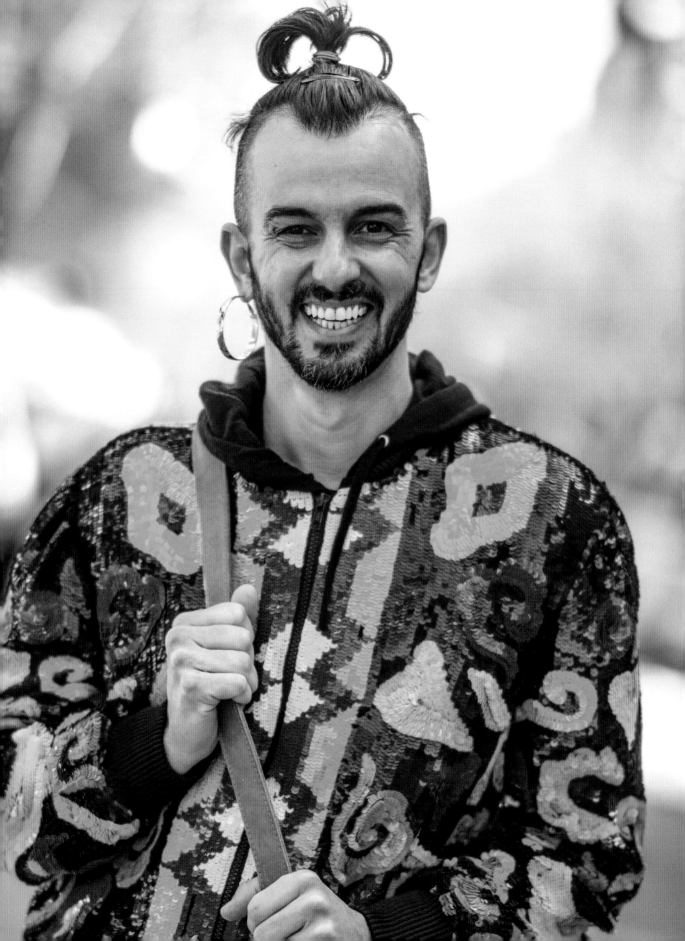

NOLITA

"Creating looks has always been an act of antiestablishment
for me. I grew up in a very, very conservative small town in
the south of Brazil where I was the one queer kid everyone
gossiped about—and I wanted to give them something to
talk about. While I couldn't get away with all the crazy ideas
I had in mind, my favorite sister—Manuela—loved letting me
play fashion designer for her.

"Together, we made the seamstresses in my hometown
crazy with our ideas and mixing of fabrics, but my sis
always looked impeccable. When I left home at thirteen, it
was my time to fully express myself through my clothing. I
moved to a bigger city alone, started working really early,
and spent most of my money in vintage stores (*brechós*,
as we say in Portuguese, were the discovery of a lifetime).
Dressing up became a form of play. Each piece of clothing
was part of my armor. The more colors, the more powerful
I felt. I also never really understood why people gendered
clothing. How boring that is! And I want to have fun! I want
people to know I don't follow rules, especially when it
comes to gender.

"A few years ago, I got a job with a very traditional institution
in NYC. I was very passionate about the job, and because
of that, I worked really hard to fit within the 'traditional
office style.' After two years, I felt lost and didn't really
know who I was anymore—beige chino pants and Banana
Republic shirts killed my vibe! So I quit and promised
myself to never again fall into that trap. More than ever, I
play dress up as a form of protest. Let's break the cis-tem,
babe! One sequin at a time."

@TH_EICHNER

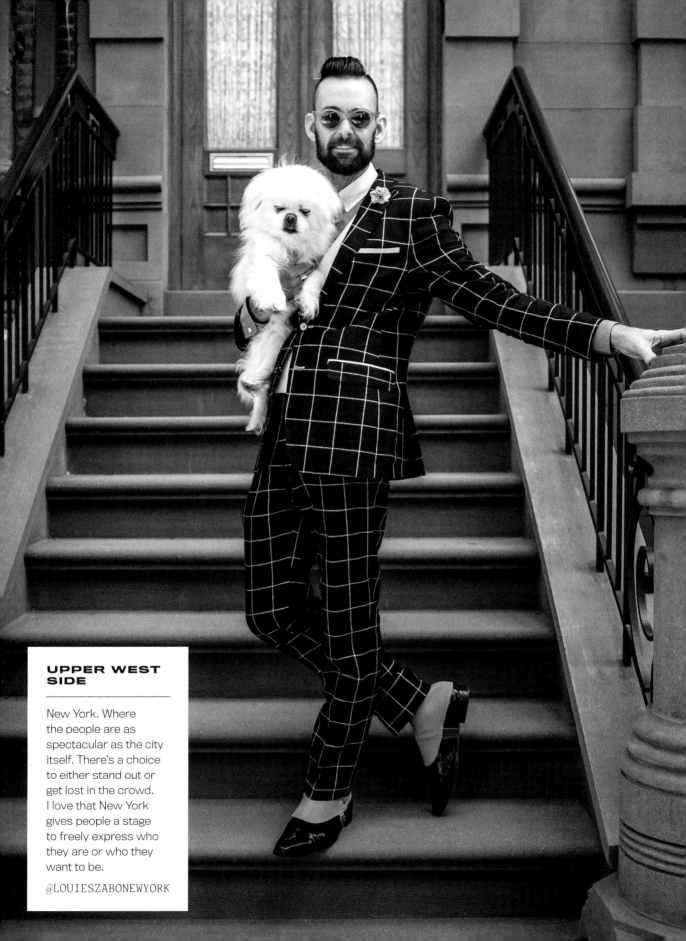

UPPER WEST SIDE

New York. Where the people are as spectacular as the city itself. There's a choice to either stand out or get lost in the crowd. I love that New York gives people a stage to freely express who they are or who they want to be.

@LOUIESZABONEWYORK

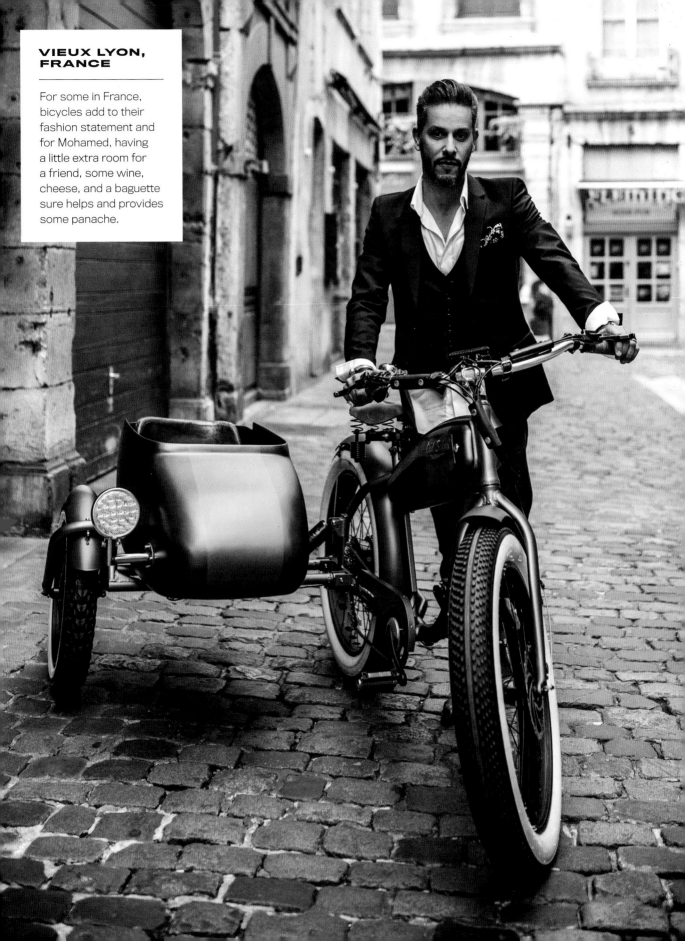

For some in France, bicycles add to their fashion statement and for Mohamed, having a little extra room for a friend, some wine, cheese, and a baguette sure helps and provides some panache.

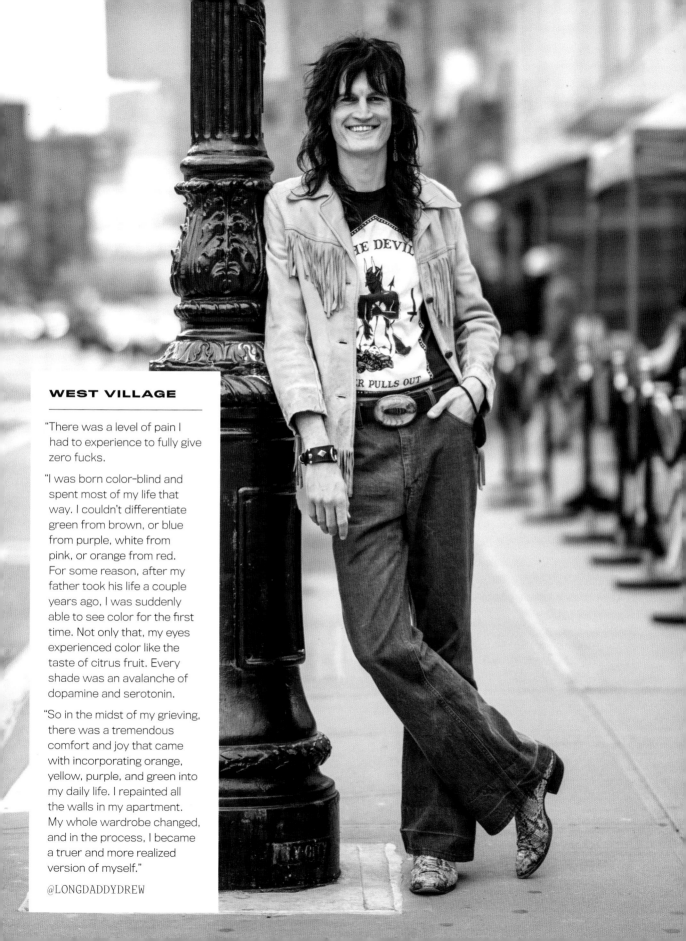

WEST VILLAGE

"There was a level of pain I had to experience to fully give zero fucks.

"I was born color-blind and spent most of my life that way. I couldn't differentiate green from brown, or blue from purple, white from pink, or orange from red. For some reason, after my father took his life a couple years ago, I was suddenly able to see color for the first time. Not only that, my eyes experienced color like the taste of citrus fruit. Every shade was an avalanche of dopamine and serotonin.

"So in the midst of my grieving, there was a tremendous comfort and joy that came with incorporating orange, yellow, purple, and green into my daily life. I repainted all the walls in my apartment. My whole wardrobe changed, and in the process, I became a truer and more realized version of myself."

@LONGDADDYDREW

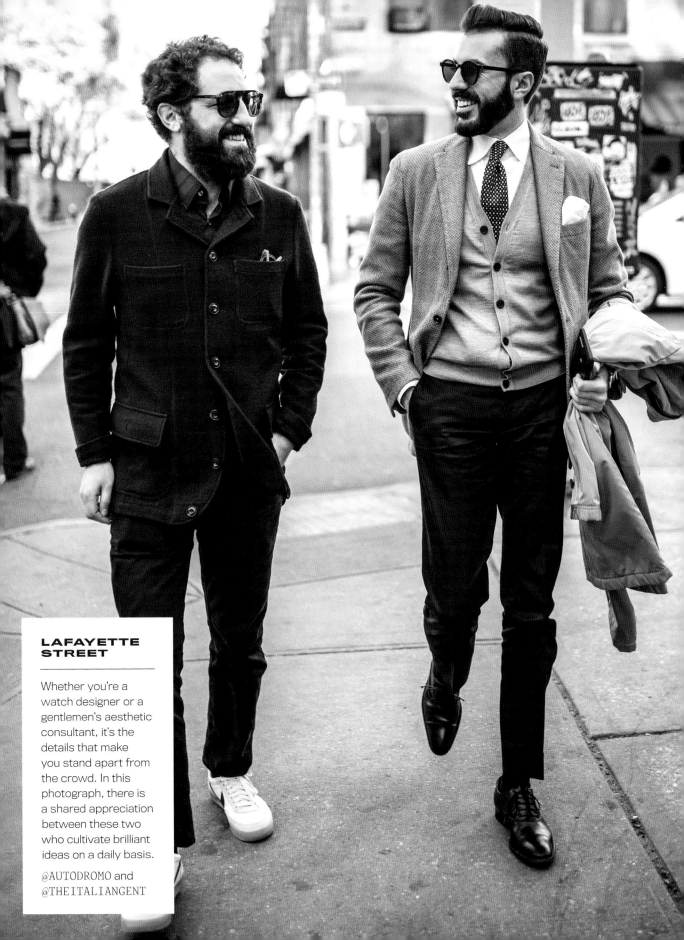

LAFAYETTE STREET

Whether you're a watch designer or a gentlemen's aesthetic consultant, it's the details that make you stand apart from the crowd. In this photograph, there is a shared appreciation between these two who cultivate brilliant ideas on a daily basis.

@AUTODROMO and @THEITALIANGENT

PARIS, FRANCE

Italians in Paris. Enjoying a moment outside the Centre Pompidou by some French graffiti, which I later realized is conveniently worded *Exprime Toi*, or Express Yourself. They both did beautifully.

@MERTZAFERKARA and @GABRIBOL

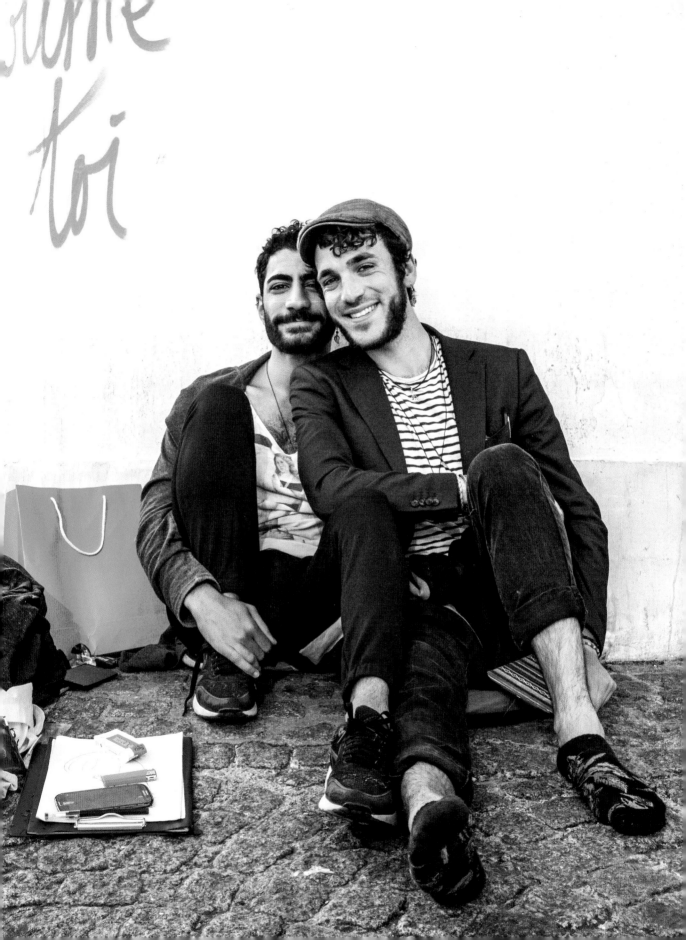

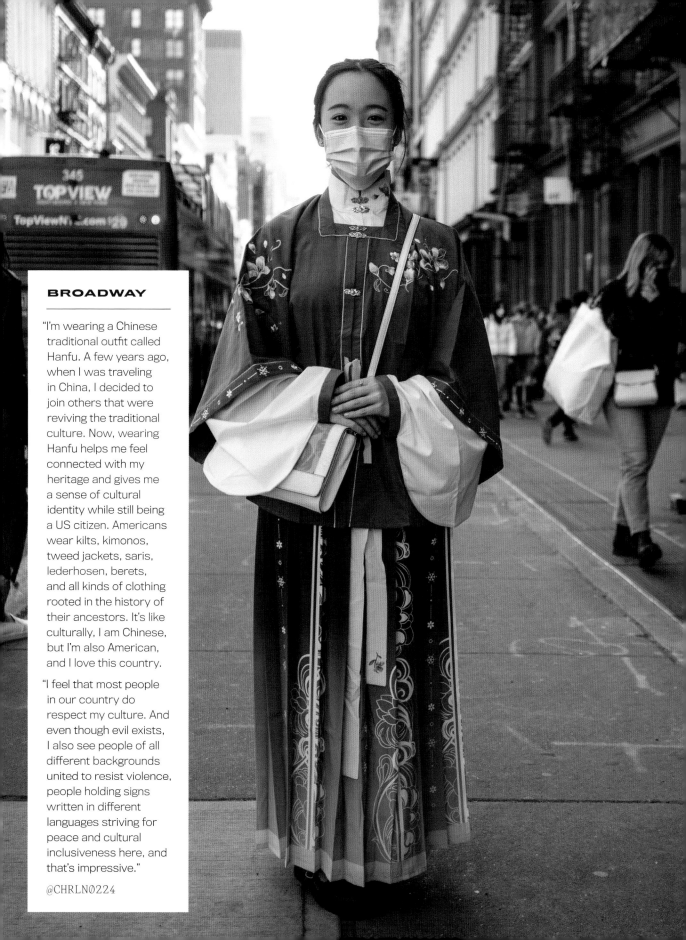

BROADWAY

"I'm wearing a Chinese traditional outfit called Hanfu. A few years ago, when I was traveling in China, I decided to join others that were reviving the traditional culture. Now, wearing Hanfu helps me feel connected with my heritage and gives me a sense of cultural identity while still being a US citizen. Americans wear kilts, kimonos, tweed jackets, saris, lederhosen, berets, and all kinds of clothing rooted in the history of their ancestors. It's like culturally, I am Chinese, but I'm also American, and I love this country.

"I feel that most people in our country do respect my culture. And even though evil exists, I also see people of all different backgrounds united to resist violence, people holding signs written in different languages striving for peace and cultural inclusiveness here, and that's impressive."

@CHRLN0224

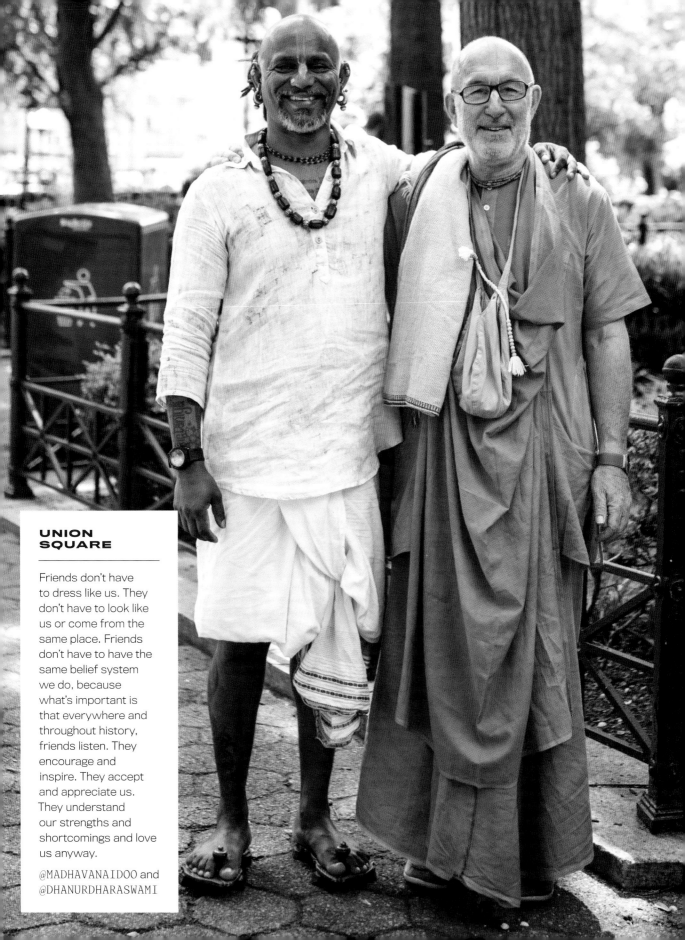

UNION SQUARE

Friends don't have to dress like us. They don't have to look like us or come from the same place. Friends don't have to have the same belief system we do, because what's important is that everywhere and throughout history, friends listen. They encourage and inspire. They accept and appreciate us. They understand our strengths and shortcomings and love us anyway.

@MADHAVANAIDOO and @DHANURDHARASWAMI

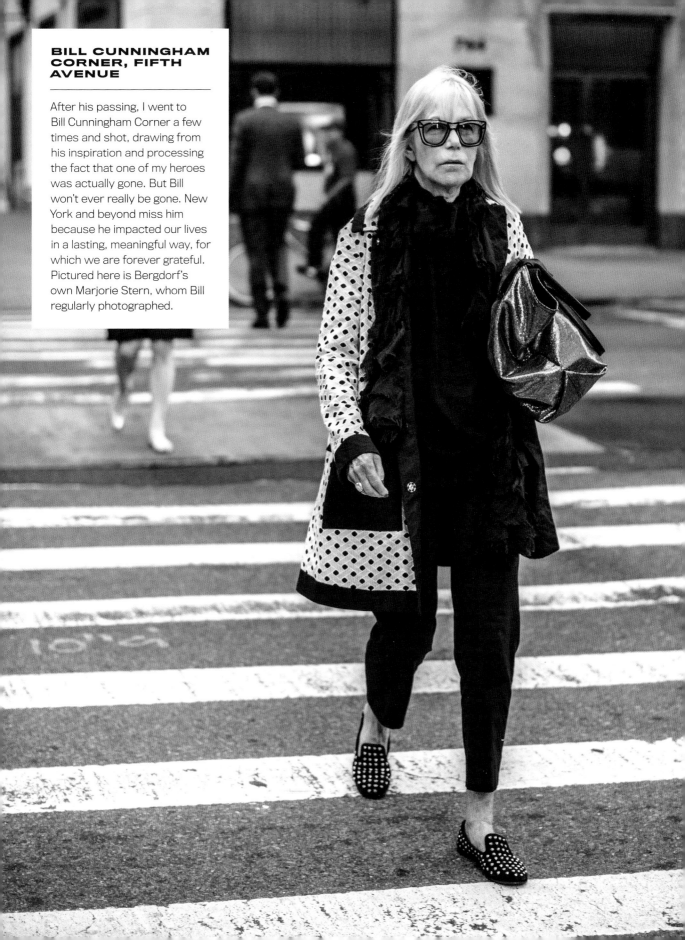

BILL CUNNINGHAM CORNER, FIFTH AVENUE

After his passing, I went to Bill Cunningham Corner a few times and shot, drawing from his inspiration and processing the fact that one of my heroes was actually gone. But Bill won't ever really be gone. New York and beyond miss him because he impacted our lives in a lasting, meaningful way, for which we are forever grateful. Pictured here is Bergdorf's own Marjorie Stern, whom Bill regularly photographed.

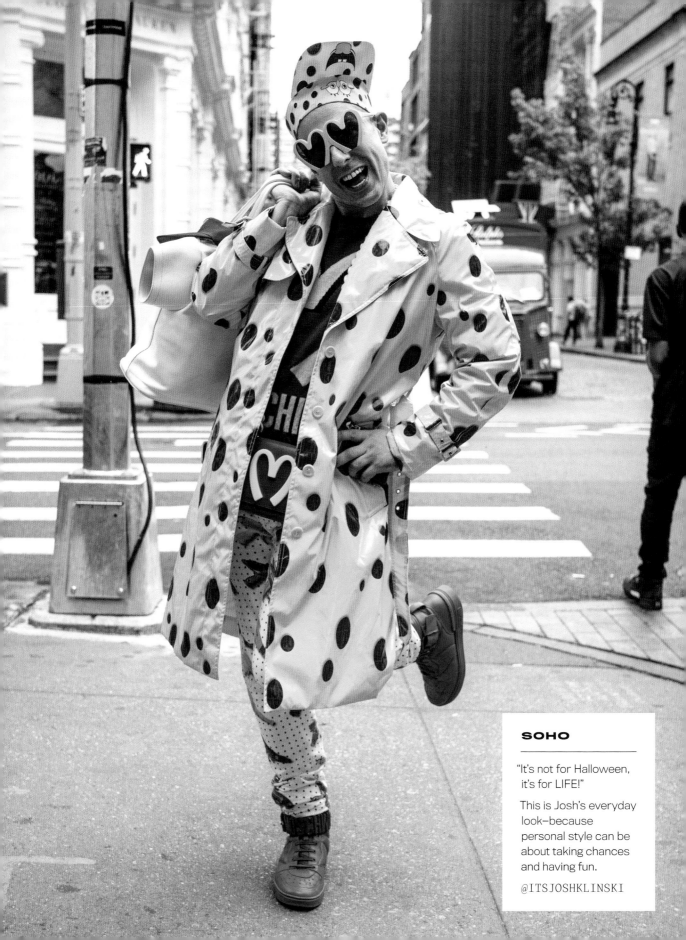

SOHO

"It's not for Halloween, it's for LIFE!"

This is Josh's everyday look—because personal style can be about taking chances and having fun.

@ITSJOSHKLINSKI

SHOREDITCH, LONDON

"I see life in full color. It gives me joy and vitalizes me with immense energy. Also, being a man of color, I carry a vibrant cultural heritage. I believe in the therapeutic power of color, and working as a stylist, art director, fashion choreographer, and creative consultant, it is my vision to bring more colors into the world of fashion, celebrating life, joy, and all aspects of human emotions.

"I am not here to break rules. I am here to push all boundaries, if possible, or to remove those boundaries that restrict personal growth and stifle creativity in the first place."

@MANRUTT

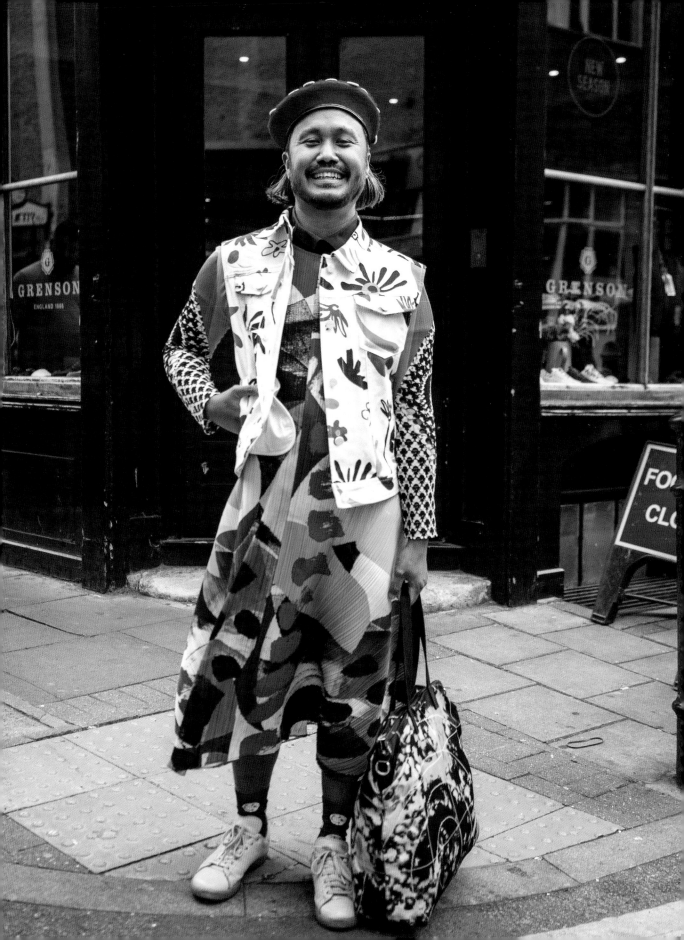

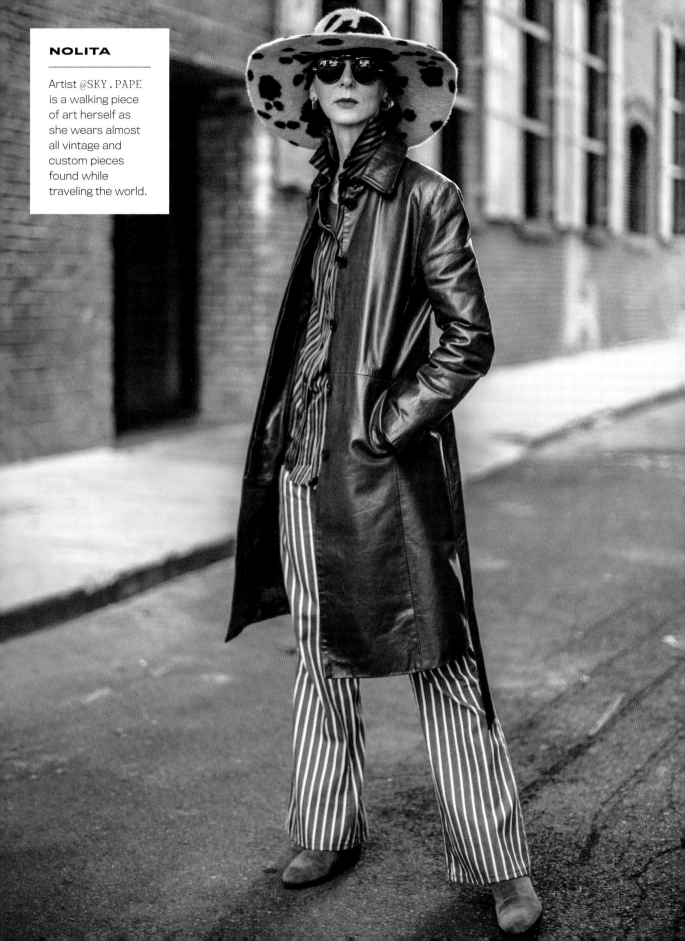

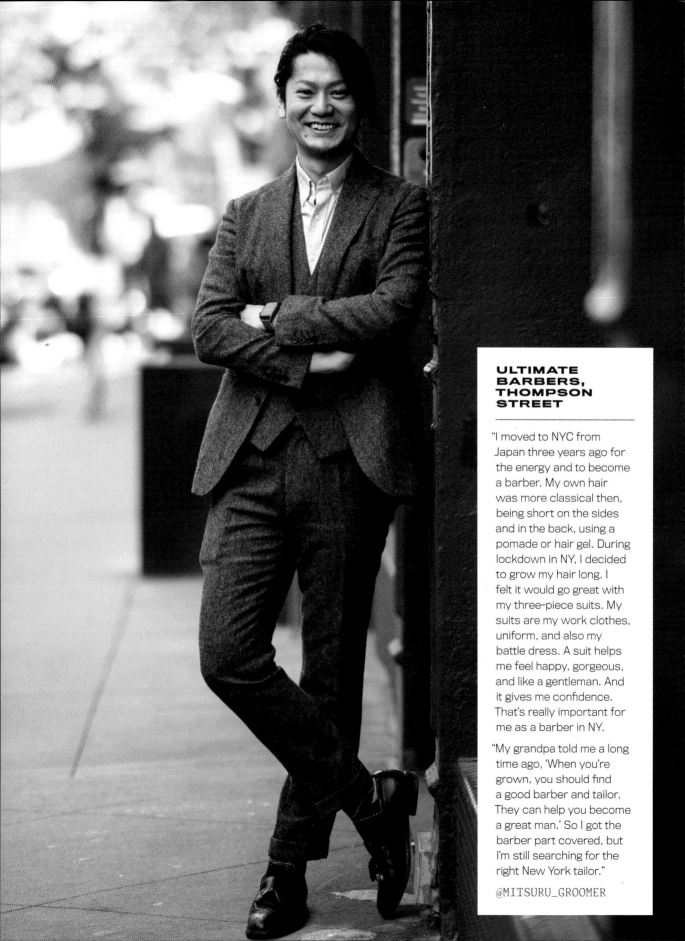

ULTIMATE BARBERS, THOMPSON STREET

"I moved to NYC from Japan three years ago for the energy and to become a barber. My own hair was more classical then, being short on the sides and in the back, using a pomade or hair gel. During lockdown in NY, I decided to grow my hair long. I felt it would go great with my three-piece suits. My suits are my work clothes, uniform, and also my battle dress. A suit helps me feel happy, gorgeous, and like a gentleman. And it gives me confidence. That's really important for me as a barber in NY.

"My grandpa told me a long time ago, 'When you're grown, you should find a good barber and tailor. They can help you become a great man.' So I got the barber part covered, but I'm still searching for the right New York tailor."

@MITSURU_GROOMER

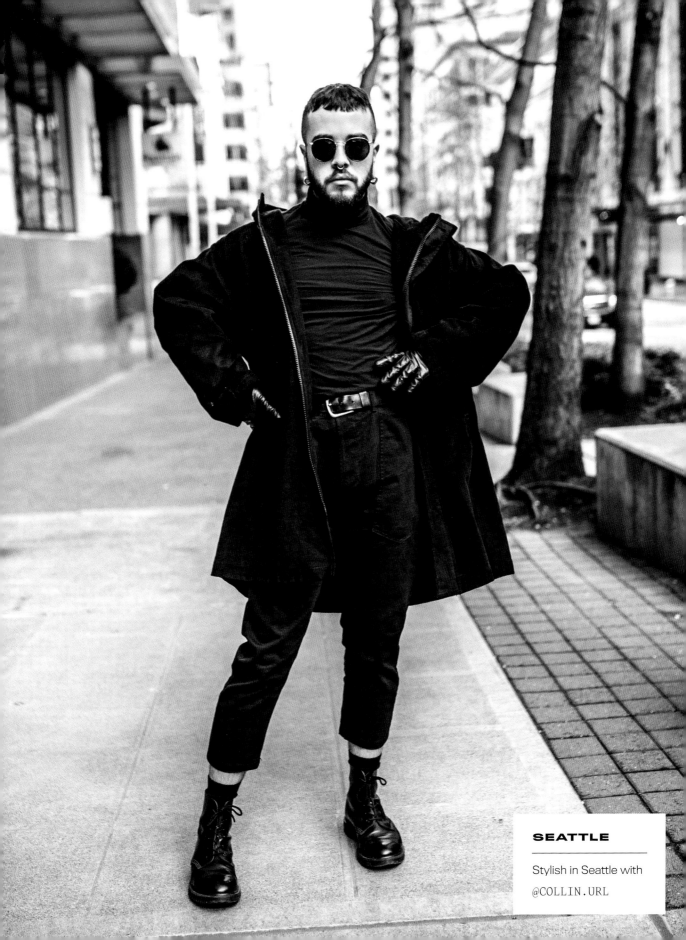

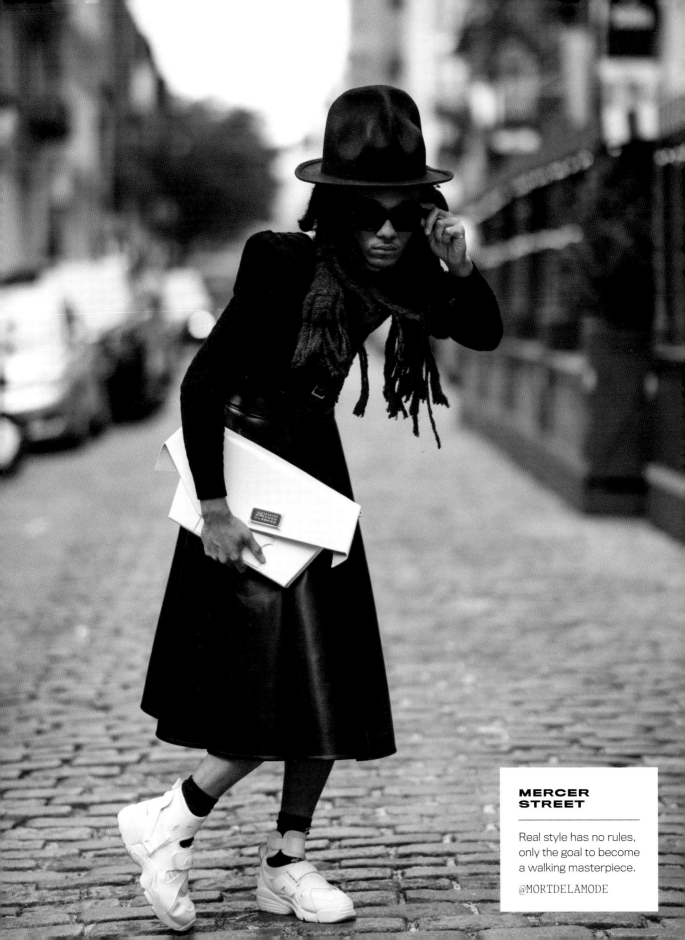

MERCER STREET

Real style has no rules, only the goal to become a walking masterpiece.

@MORTDELAMODE

COLUMBUS CIRCLE

"I like to mix and match decades of fashion to show the world an abstract style. There have been so many times that I flip through fashion magazines, and I am in awe of the creativity that goes behind high-fashion shoots. Although the clothing that they are featuring is astronomically priced, I appreciate the creative styling techniques. The only way that I have been able to affordably recreate the same looks is through vintage and unique clothing."

As I looked at all the buttons Melissa had on her jacket, I asked her about the Black Girl Magic one. She explained:

"Black Girl Magic is the resilience that Black girls have. The ability to push through racism and stereotypes of Black women is the magic potion we all have. The confidence it takes to be a Black woman is no different than being an athlete. People will forever doubt you, and you have to nod your head and smile through the doubt. People expect you not to convey your emotions because of their fear of the 'angry Black woman.' You have to strategically display your emotions to be taken seriously. Black Girl Magic allows you to do all this without losing yourself in the process. It gives hope and confidence that cannot be bought or sold. The reason that most old white men fear it is because it is the one thing they can't steal. People should be inspired by Black Girl Magic because it teaches and empowers ALL women, but especially girls of color. It should be looked at as a platform for overcoming oppression."

@IAMTHECARTERPROJEKT

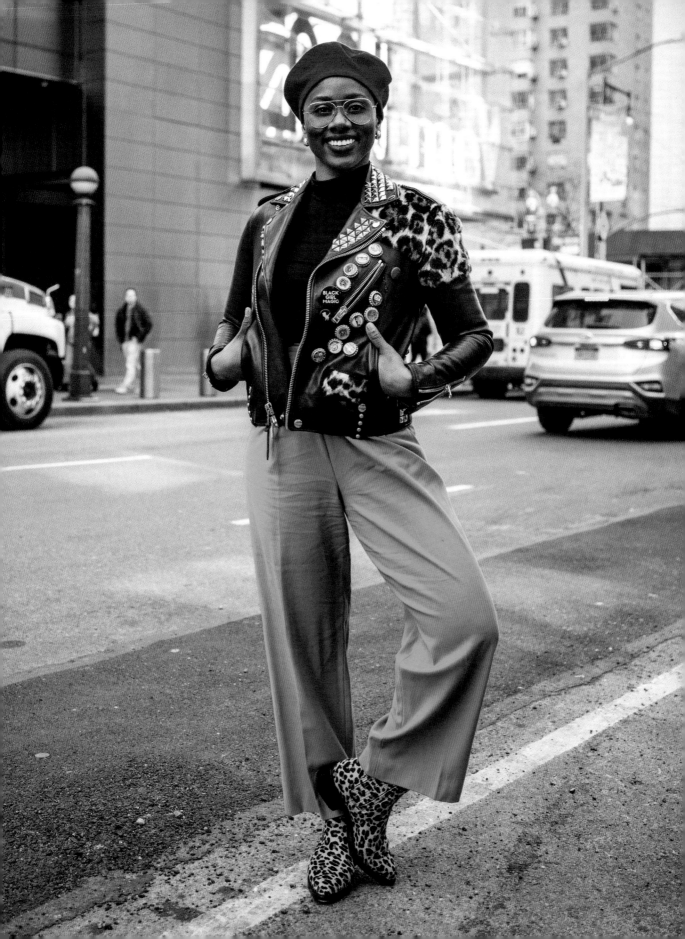

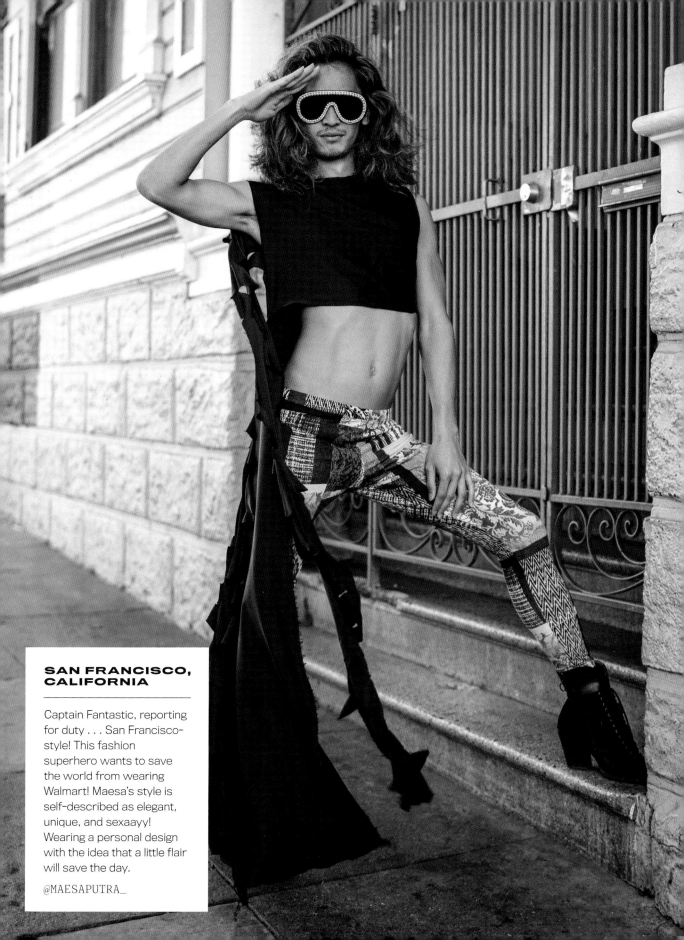

SAN FRANCISCO, CALIFORNIA

Captain Fantastic, reporting for duty . . . San Francisco-style! This fashion superhero wants to save the world from wearing Walmart! Maesa's style is self-described as elegant, unique, and sexaayy! Wearing a personal design with the idea that a little flair will save the day.

@MAESAPUTRA_

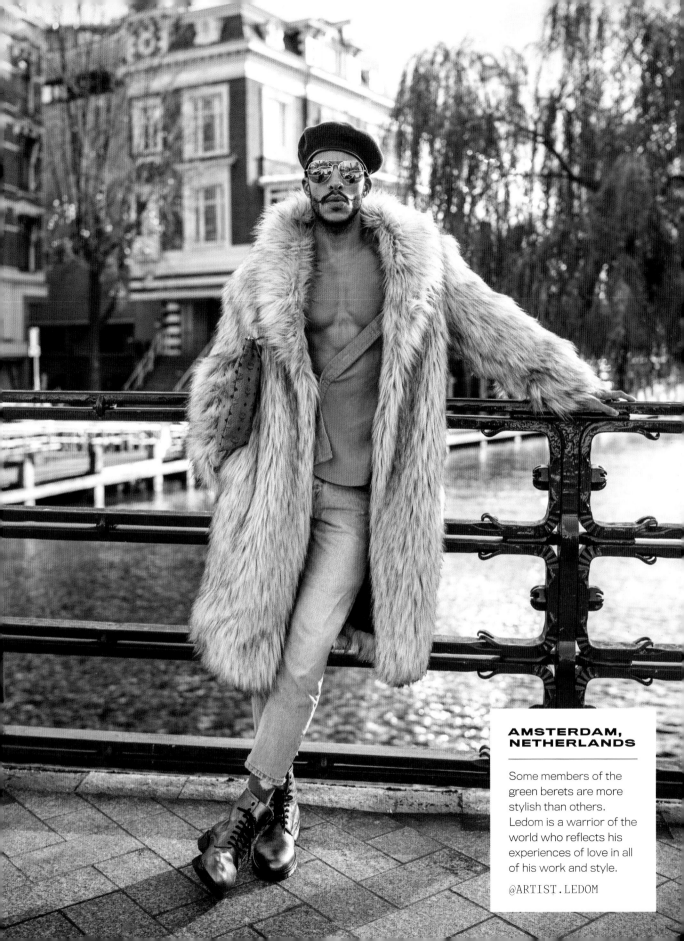

AMSTERDAM, NETHERLANDS

Some members of the green berets are more stylish than others. Ledom is a warrior of the world who reflects his experiences of love in all of his work and style.

@ARTIST.LEDOM

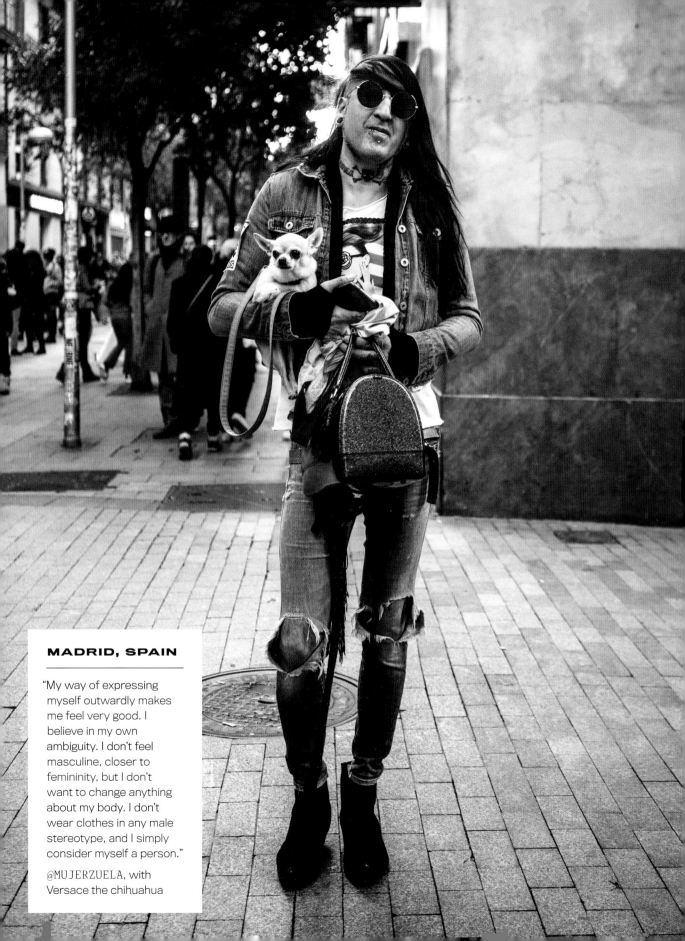

MADRID, SPAIN

"My way of expressing
myself outwardly makes
me feel very good. I
believe in my own
ambiguity. I don't feel
masculine, closer to
femininity, but I don't
want to change anything
about my body. I don't
wear clothes in any male
stereotype, and I simply
consider myself a person."

@MUJERZUELA, with
Versace the chihuahua

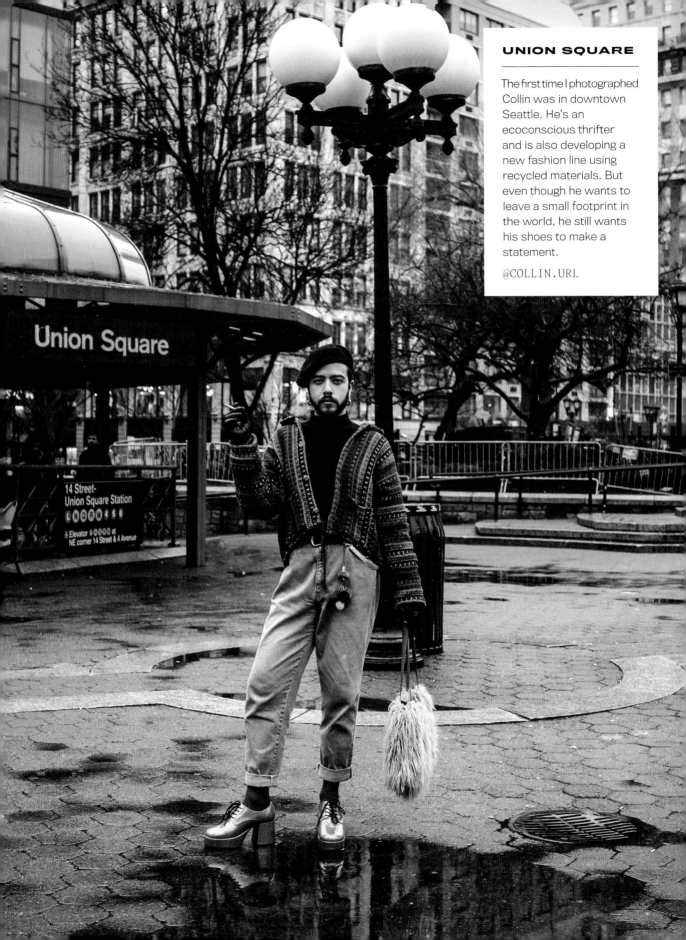

UNION SQUARE

The first time I photographed Collin was in downtown Seattle. He's an ecoconscious thrifter and is also developing a new fashion line using recycled materials. But even though he wants to leave a small footprint in the world, he still wants his shoes to make a statement.

@COLLIN.URL

MUMBAI, MAHARASHTRA, INDIA

How do you wear charisma? Well, when your clothes echo your personality and you've got so much damn dazzle and pizzazz, you're on the right track. Clothes are our accessories to who we are. Chosen carefully, they can put an exclamation point on your presence! To that point, may I present the singular Suresh.

@ANCHORMAN_SURESH

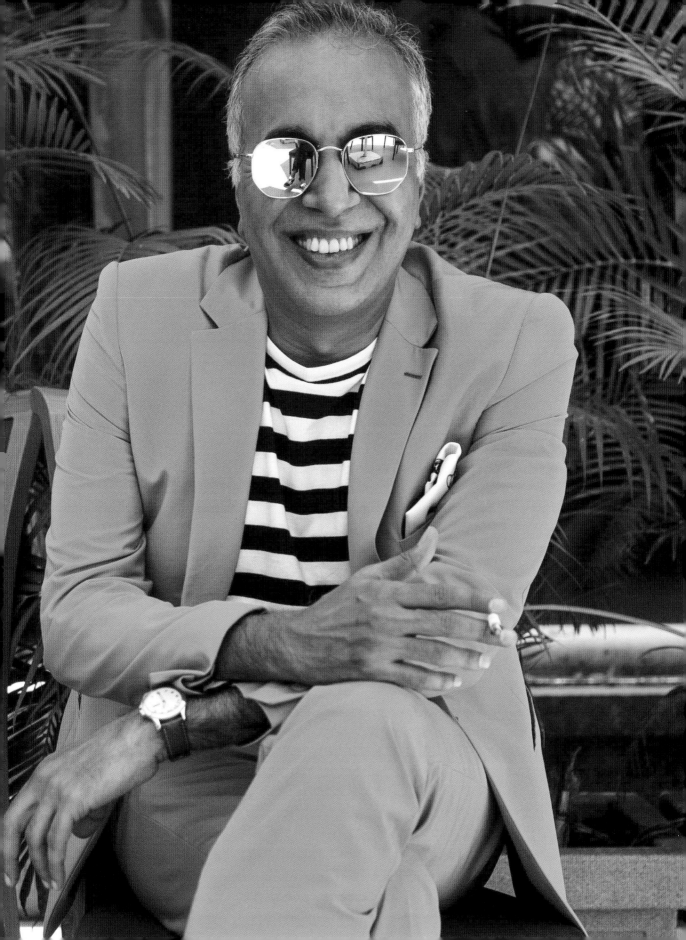

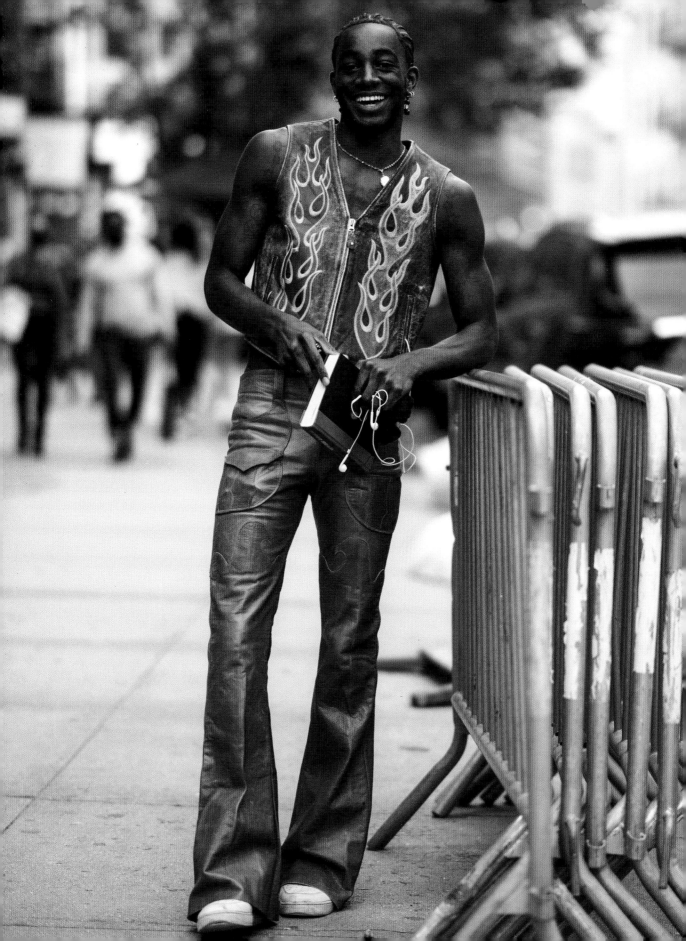

LAFAYETTE STREET

"I've always been a person who's been more on the quiet side. My clothes are the translation of my self-expression and love for the world.

"Growing up, I could never really find myself in new trends or clothes that were deemed as popular, so I started shopping on eBay. I found myself wrapped in the world of vintage clothing, and I began to find myself and learn new things about me. I had to risk being out of the ordinary and overcome the opinions of others, but trusting and following myself has been the biggest lesson that my clothes have taught me."

@SAVEMUSA

SOHO

"I suffer from extreme anxiety and social issues, but expressing who I am through my style is always worth the risk. It helps me stay grounded and focused.

"I try to remember that despite all my fears, there are so many other people who want to put themselves out there but can't or aren't ready to. The aspect of knowing the value of what I'm doing and presenting it to the world makes it all worth it, even if I only inspire one other person."

@THETWINKNEXTDOOR

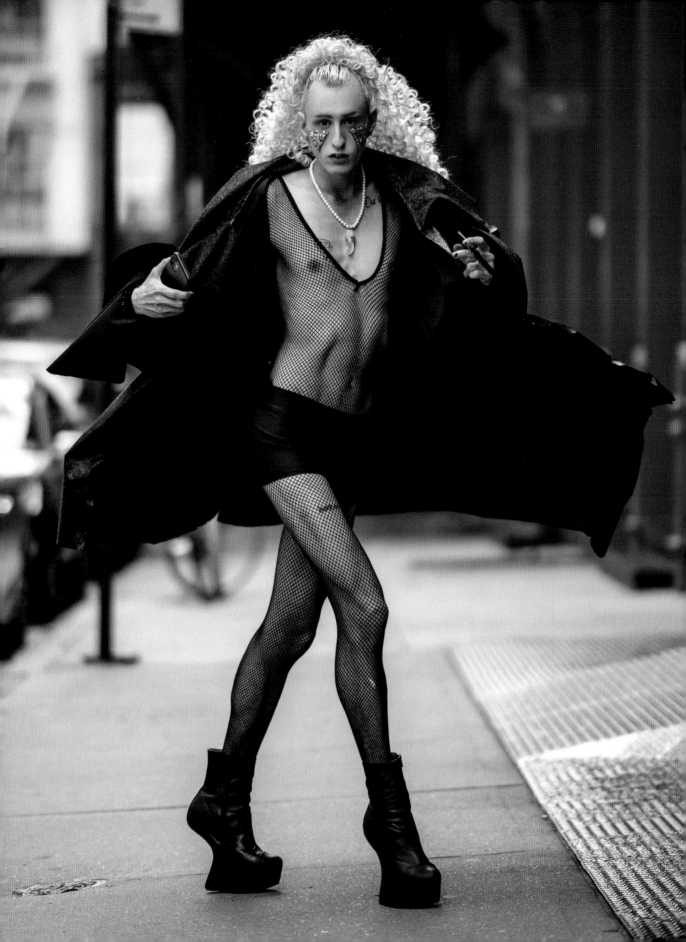

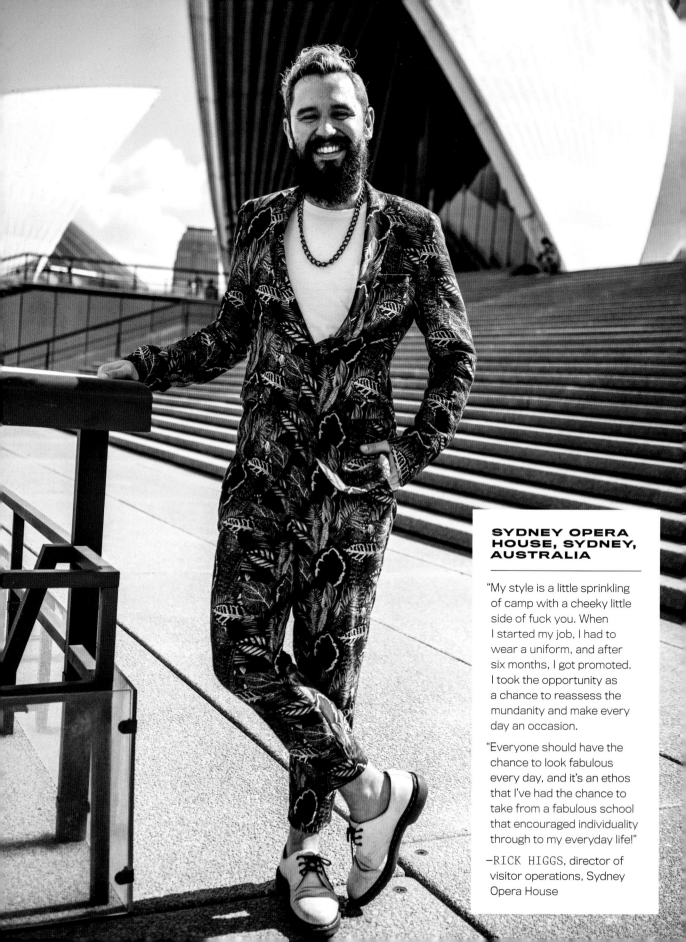

SYDNEY OPERA HOUSE, SYDNEY, AUSTRALIA

"My style is a little sprinkling of camp with a cheeky little side of fuck you. When I started my job, I had to wear a uniform, and after six months, I got promoted. I took the opportunity as a chance to reassess the mundanity and make every day an occasion.

"Everyone should have the chance to look fabulous every day, and it's an ethos that I've had the chance to take from a fabulous school that encouraged individuality through to my everyday life!"

—RICK HIGGS, director of visitor operations, Sydney Opera House

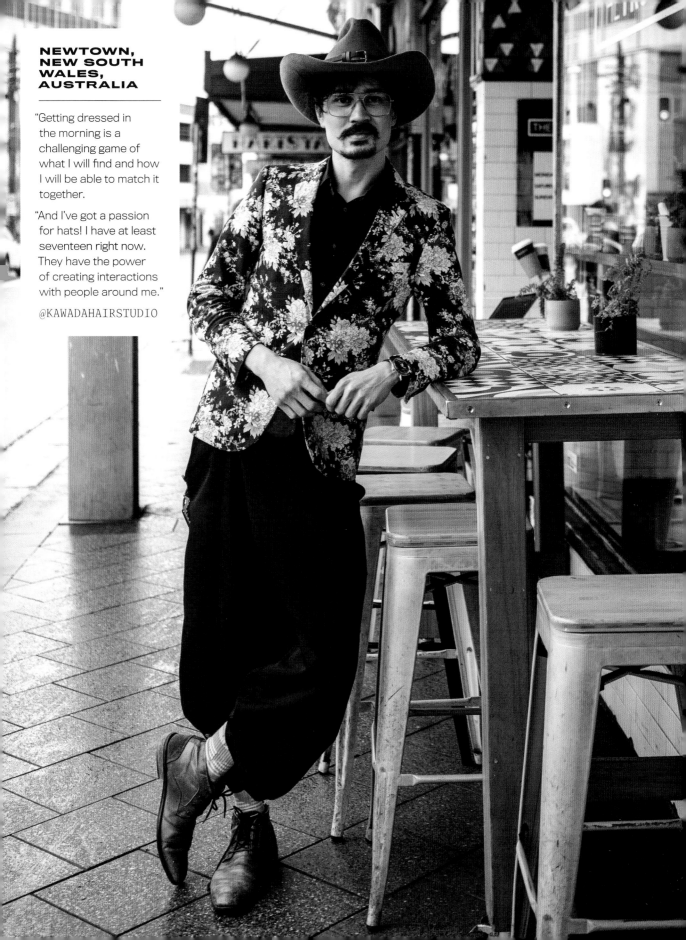

NEWTOWN, NEW SOUTH WALES, AUSTRALIA

"Getting dressed in the morning is a challenging game of what I will find and how I will be able to match it together.

"And I've got a passion for hats! I have at least seventeen right now. They have the power of creating interactions with people around me."

@KAWADAHAIRSTUDIO

SOHO

New York will come to your emotional rescue. Ravendano says, "It's the best place to find out who I really am, while having the time of my life. You can come here alone, but never feel alone as long as you get out into the city. I have a chance to say what I'm really feeling and thinking because most everyone here does–they're very direct." He's only here on extended vacation from Peru, but he hopes to one day call NYC home. When he does, he'll be bringing this rock star style with him.

@RAVENDANORAVENDANO

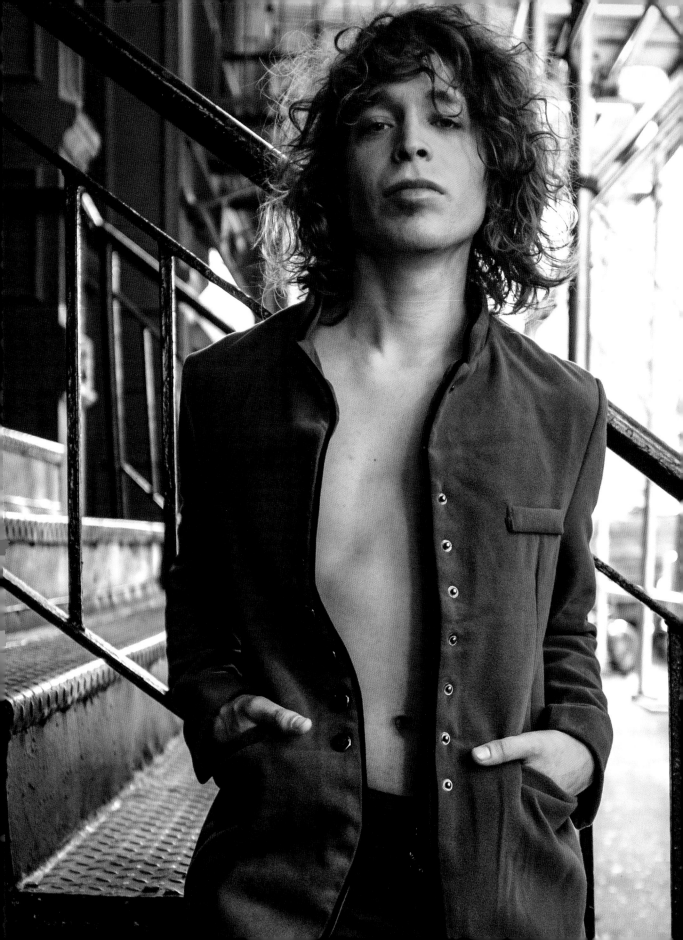

FIFTH AVENUE

The Lederers. Doing their part to improve the standard of style.

Melissa is smart, confident, and has exquisite taste. She's creative and always moving forward, and, of course, she's stylish as hell.

With style, gravitas, and overflowing with joie de vivre, it's no wonder Jeff frequently made it into the pages of Bill Cunningham's column.

@MBKLEDERER and @JLLEDERER

BOTTOM AND OPPOSITE PAGE

Suiting up. It isn't just for men.

Some people might be intimidated by a stylish woman in a suit and may even want to criticize her. I'd say the critics are fearful, insecure, repressed, and simply unadventurous.

@MBKLEDERER

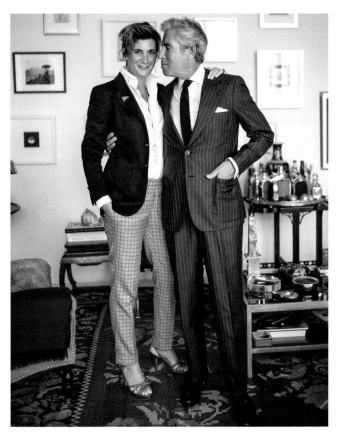

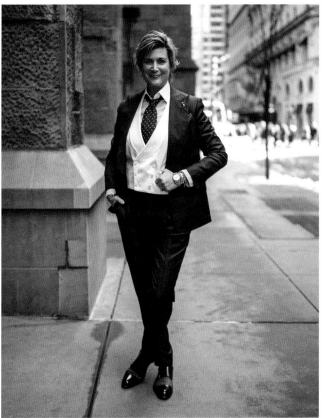

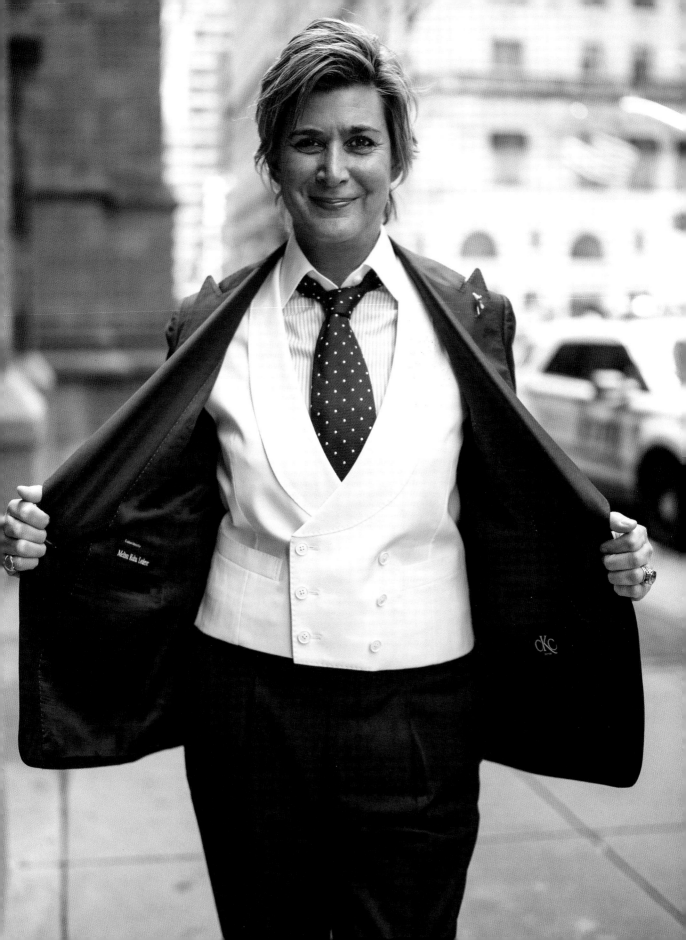

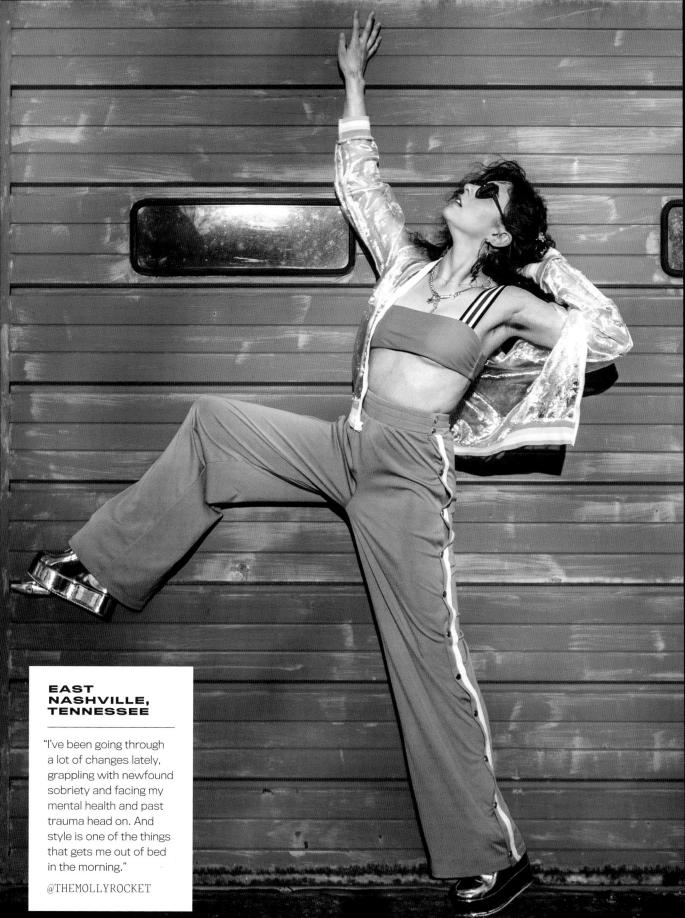

EAST NASHVILLE, TENNESSEE

"I've been going through a lot of changes lately, grappling with newfound sobriety and facing my mental health and past trauma head on. And style is one of the things that gets me out of bed in the morning."

@THEMOLLYROCKET

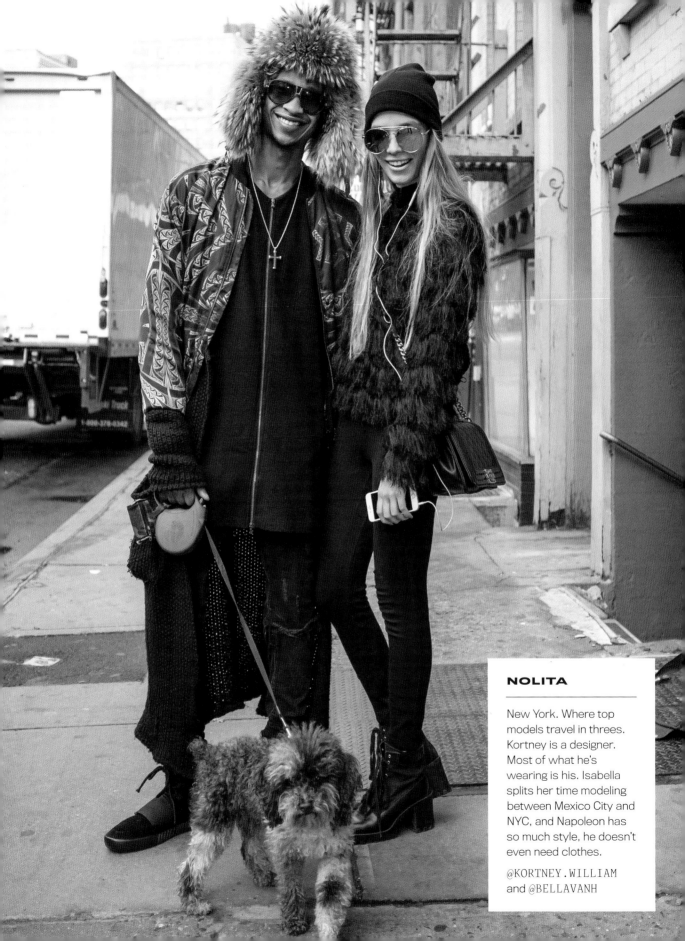

NOLITA

New York. Where top models travel in threes. Kortney is a designer. Most of what he's wearing is his. Isabella splits her time modeling between Mexico City and NYC, and Napoleon has so much style, he doesn't even need clothes.

@KORTNEY.WILLIAM
and @BELLAVANH

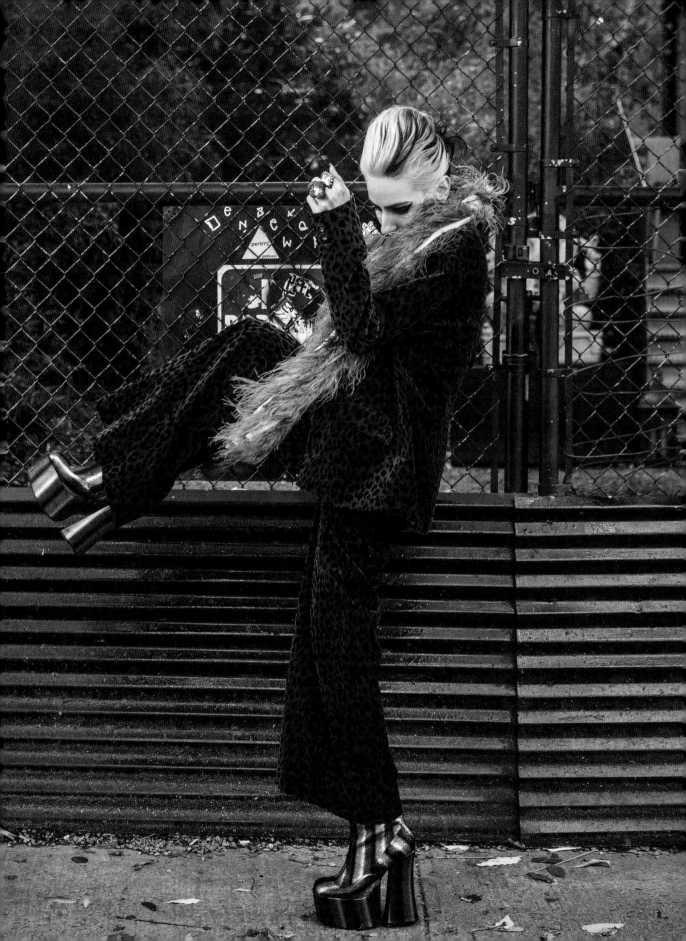

CROSBY STREET

"I like to say that I talk to clothing. I dress the way that the clothes want to be seen, which is why my style varies every day. Each morning, my mood determines what I hear and wear.

"And I hope that my style inspires people to be themselves. That doesn't mean that I wanna inspire people to just dress up. I wanna inspire people to not be scared of life and things they can't control. Fuck it and be you. You're the one thing you don't have to be scared of."

@SOFAUSTI

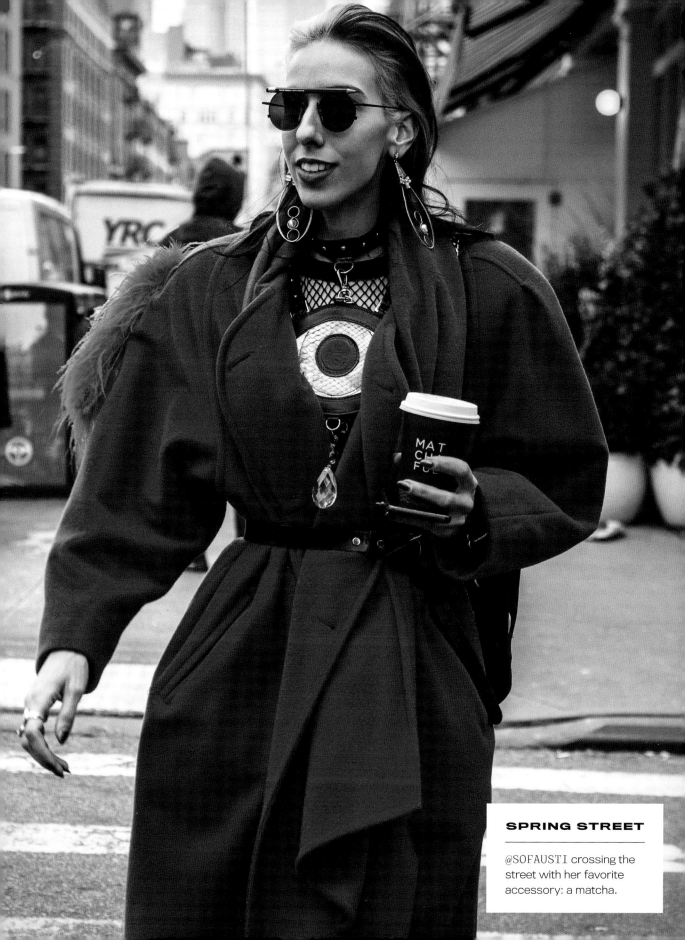

SPRING STREET

@SOFAUSTI crossing the street with her favorite accessory: a matcha.

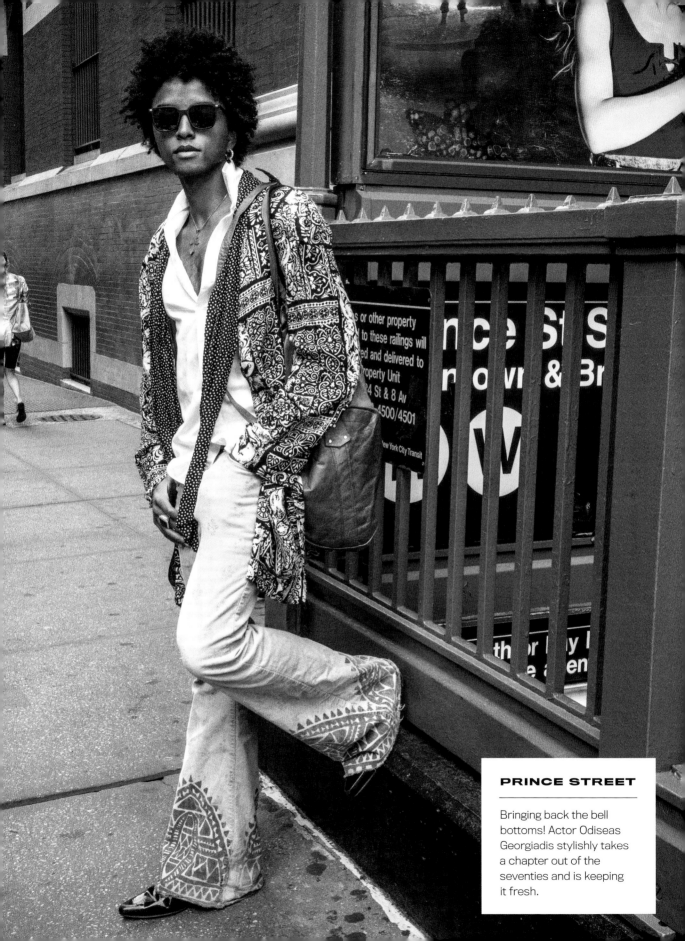

PRINCE STREET

Bringing back the bell bottoms! Actor Odiseas Georgiadis stylishly takes a chapter out of the seventies and is keeping it fresh.

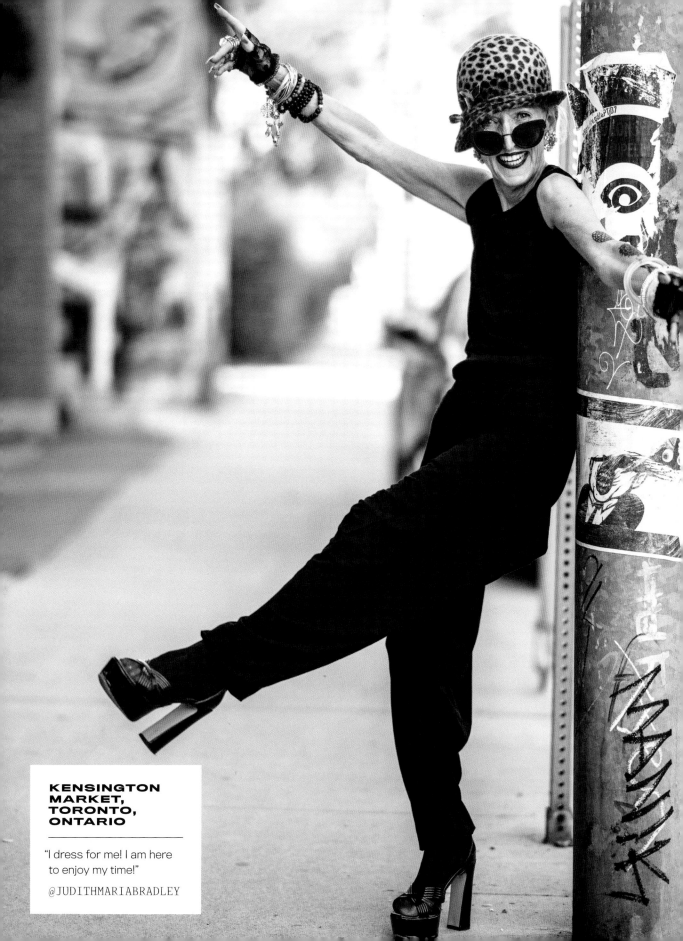

KENSINGTON
MARKET,
TORONTO,
ONTARIO

"I dress for me! I am here
to enjoy my time!"

@JUDITHMARIABRADLEY

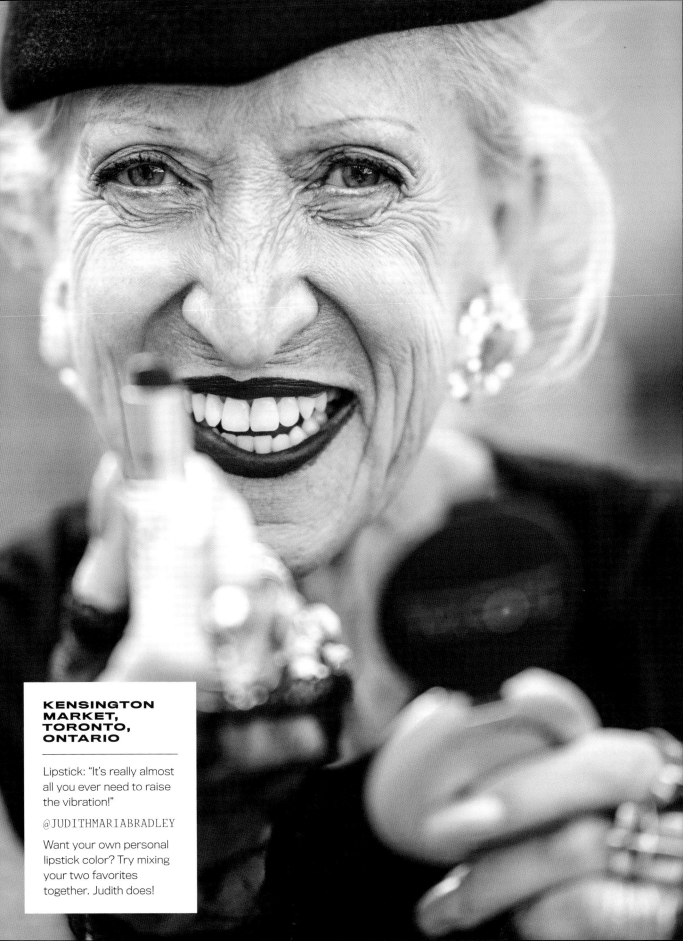

**KENSINGTON
MARKET,
TORONTO,
ONTARIO**

Lipstick: "It's really almost all you ever need to raise the vibration!"

@JUDITHMARIABRADLEY

Want your own personal lipstick color? Try mixing your two favorites together. Judith does!

"I grew up in Orem, Utah. I was a very active member of the LDS church. I'm still quite religious, actually! But after I came out of the closet, it became a little bit more difficult to practice as strictly. And even though I attended Brigham Young University (BYU), I was NOT scared to get dressed up. I'll have you know that I wore a dress TWICE while going there just 'cause I was like, 'Damn, I look goooood.' BYU is a private religious school with rules that are aligned with the teachings of the LDS faith. But I didn't care. I wanted to get dressed up. So I would.

"I moved to New York in the beginning of January. So I'm like a newborn here. To say that things are . . . different . . . is putting it lightly. But WOW, it's wonderful. One reason is that clothing is SO much more expressive here. People are BOLD. And I LIIIIIVE for it. There are a lot more people who are artistic, and I have to really step up my game to stand out. So the kind of brand I try and go for is like thrift store runway. I take a lot of inspiration from elite runway shows and things similar to that. I want my outfits to sort of be like an art show. I want people to stare 'cause it means I've done something new. They haven't seen it before. It got their attention. There is truly NOTHING like putting an outfit together, putting on some headphones and STRUTTING down the streets to a song like 'Phenomenal Woman' by Laura Mvula. Granted, not EVERY DAY is like that. Sometimes I don't have time or energy to go all out. But I try to as much as possible.

"What I want most from the way I dress is to give people the permission to free themselves from their fears. I want to set up a space where others can be happy as well! I've found that when I do something bold but the motivation is just to love and liberate myself, people usually don't have a problem. Even in Utah! It's hard to get mad at someone when they are filled with love.

"So long story short. My outfits say one thing. I love myself so much. I'm working and learning to love myself more. And I give myself permission to create and be my most powerful me!"

@JOSEPHTSWAIN

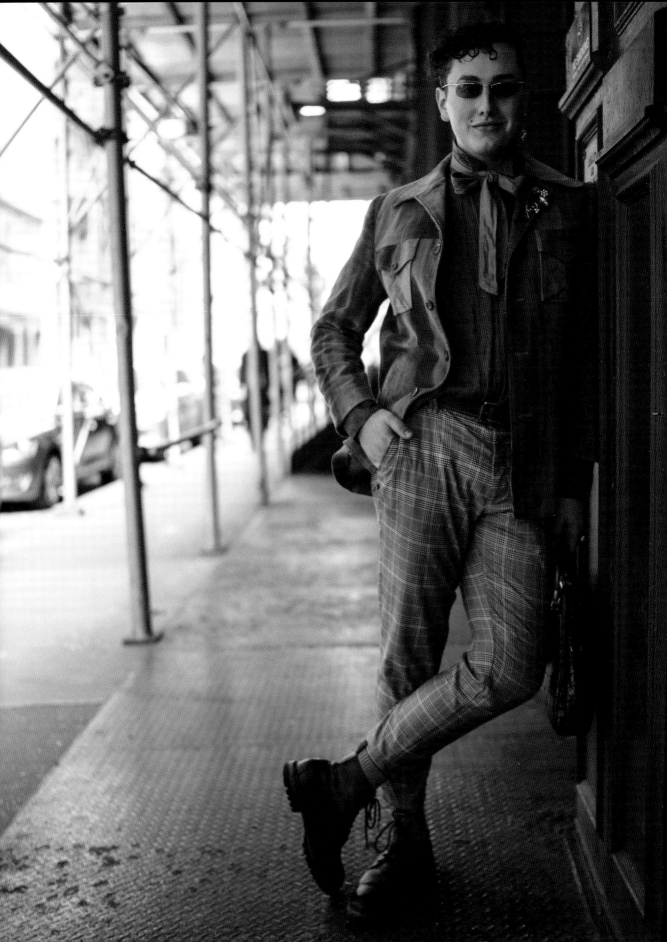

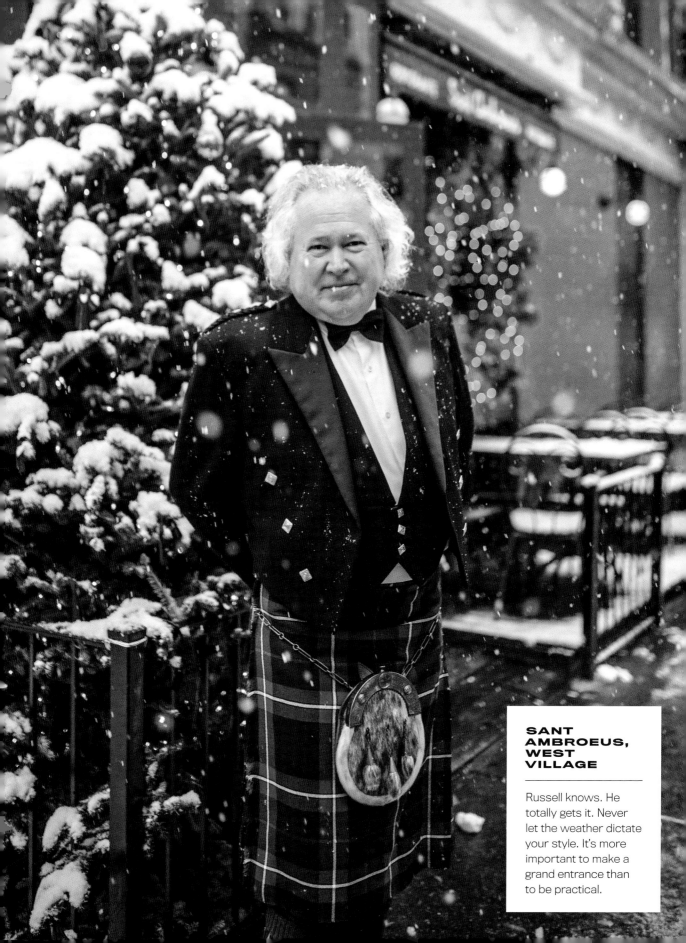

SANT AMBROEUS, WEST VILLAGE

Russell knows. He totally gets it. Never let the weather dictate your style. It's more important to make a grand entrance than to be practical.

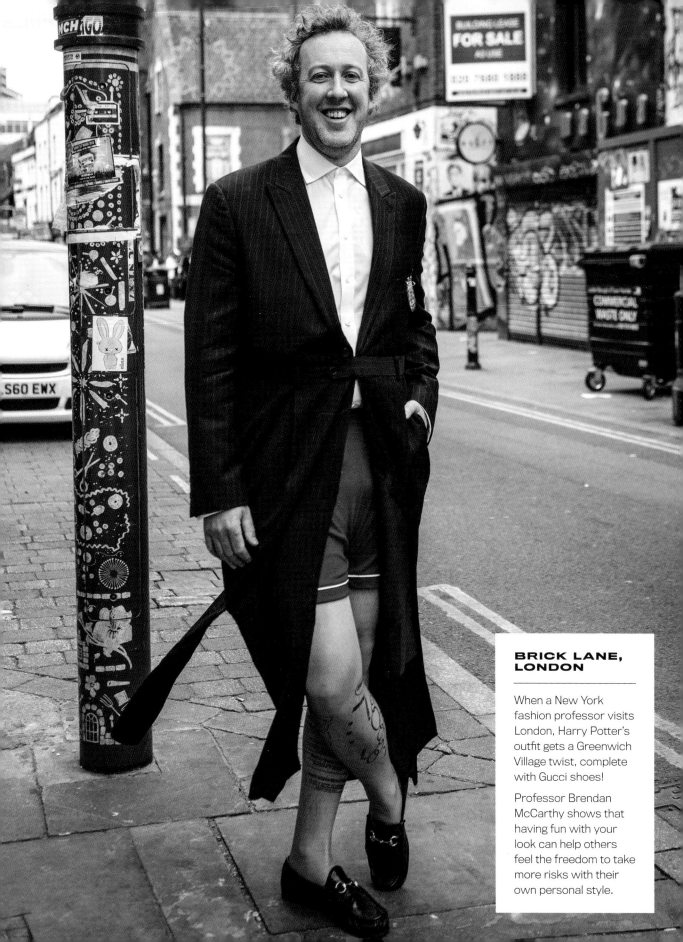

BRICK LANE, LONDON

When a New York fashion professor visits London, Harry Potter's outfit gets a Greenwich Village twist, complete with Gucci shoes!

Professor Brendan McCarthy shows that having fun with your look can help others feel the freedom to take more risks with their own personal style.

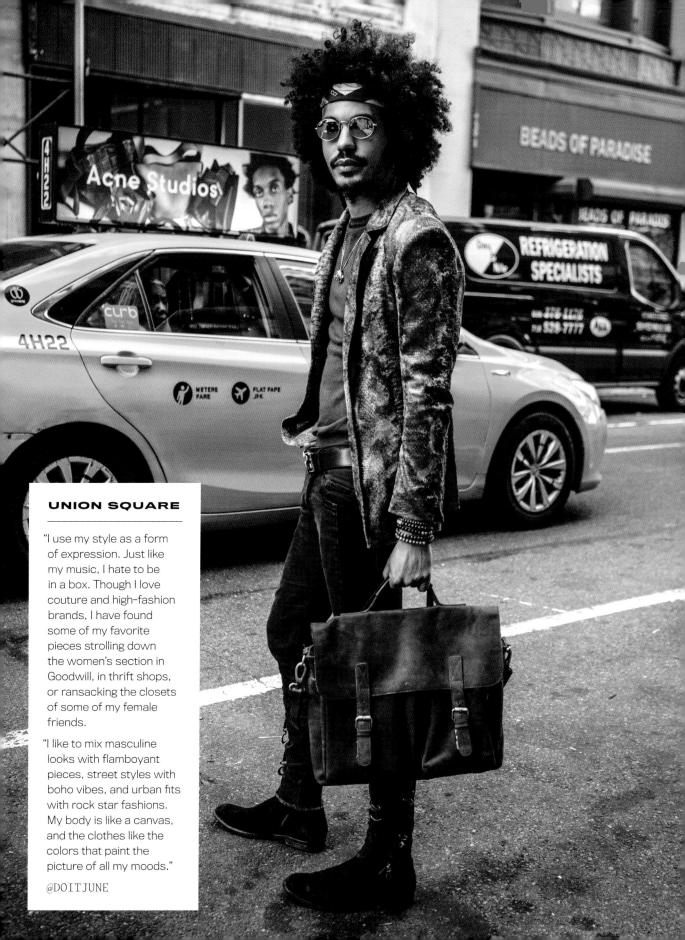

UNION SQUARE

"I use my style as a form of expression. Just like my music, I hate to be in a box. Though I love couture and high-fashion brands, I have found some of my favorite pieces strolling down the women's section in Goodwill, in thrift shops, or ransacking the closets of some of my female friends.

"I like to mix masculine looks with flamboyant pieces, street styles with boho vibes, and urban fits with rock star fashions. My body is like a canvas, and the clothes like the colors that paint the picture of all my moods."

@DOITJUNE

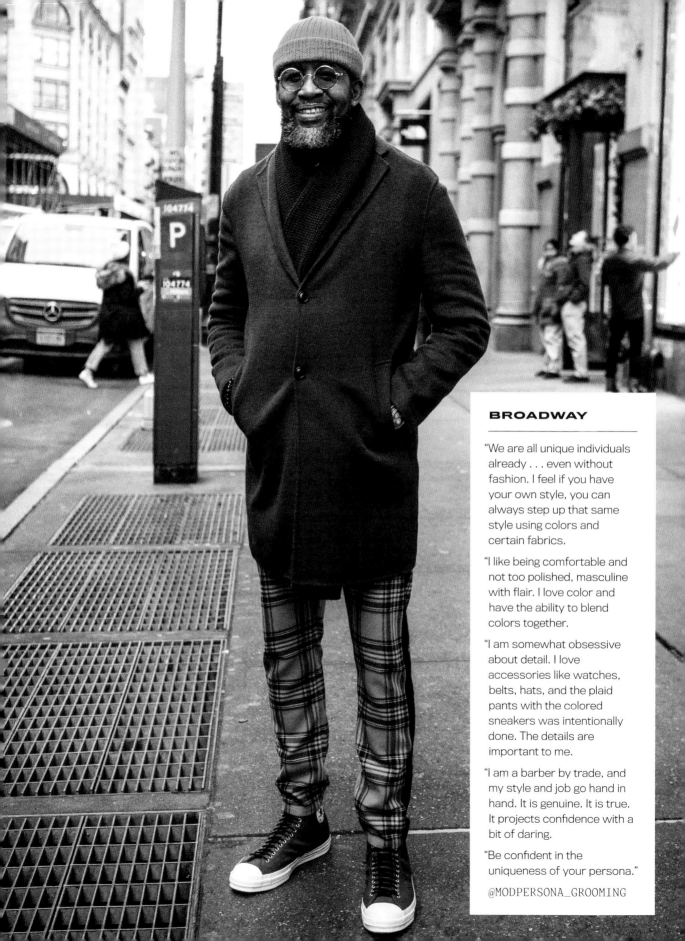

BROADWAY

"We are all unique individuals already . . . even without fashion. I feel if you have your own style, you can always step up that same style using colors and certain fabrics.

"I like being comfortable and not too polished, masculine with flair. I love color and have the ability to blend colors together.

"I am somewhat obsessive about detail. I love accessories like watches, belts, hats, and the plaid pants with the colored sneakers was intentionally done. The details are important to me.

"I am a barber by trade, and my style and job go hand in hand. It is genuine. It is true. It projects confidence with a bit of daring.

"Be confident in the uniqueness of your persona."

@MODPERSONA_GROOMING

PIZZA BEACH, LOWER EAST SIDE

"Any article of clothing I choose is just because the piece speaks to me. I never question it. I don't think a whole lot about whether something is feminine or masculine, especially because those are such vapid terms.

"It's like noticing a beautiful painting in a gallery. You can know absolutely nothing about the context or intention of the artist and still have this heavy impact just from the work 'speaking to you.' That's what I let the clothes do, and then I let them do the talking for me. It can express so much about my mood.

"And I only pick pieces that resonate with me regardless of price or age. I'm not going to wear something just because it's popular or made by a high-end designer. It's all about my intuition, and a secondhand shirt can have more value to me than a brand-new Prada jacket if it connects with me.

"I would tell anyone to wear something that is honestly them regardless of superficial constraints. Wear it because you believe it to speak about what's underneath rather than wearing it because someone told you to."

@OPTIONAMUSIC

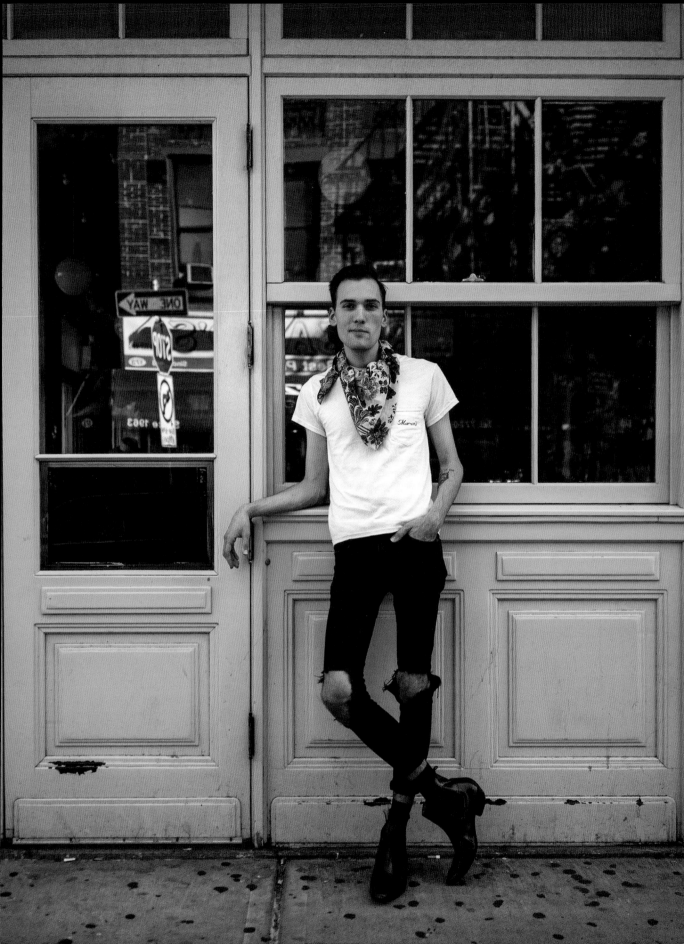

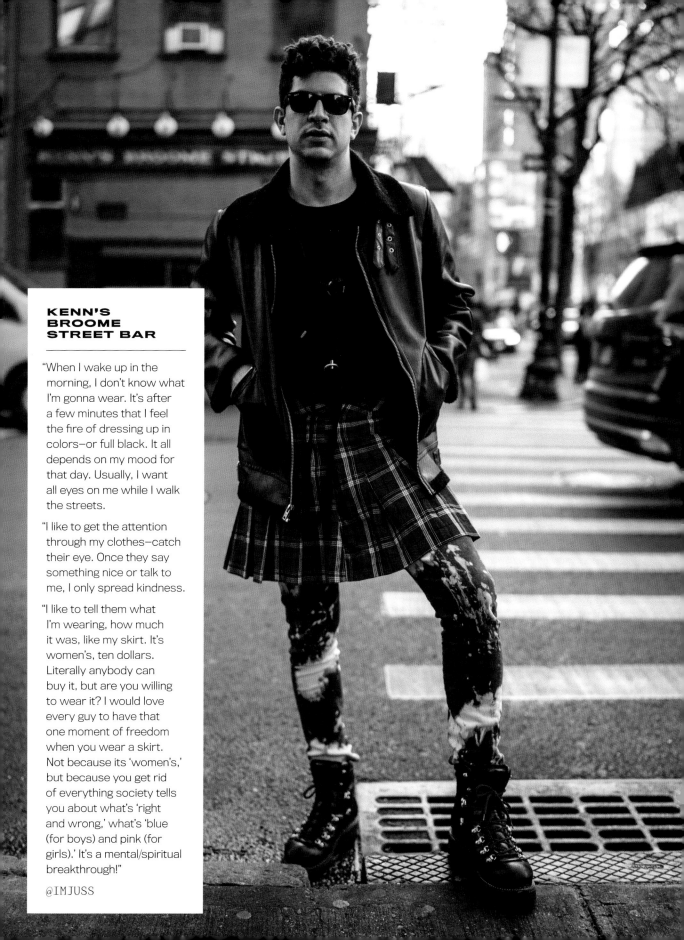

KENN'S BROOME STREET BAR

"When I wake up in the morning, I don't know what I'm gonna wear. It's after a few minutes that I feel the fire of dressing up in colors—or full black. It all depends on my mood for that day. Usually, I want all eyes on me while I walk the streets.

"I like to get the attention through my clothes—catch their eye. Once they say something nice or talk to me, I only spread kindness.

"I like to tell them what I'm wearing, how much it was, like my skirt. It's women's, ten dollars. Literally anybody can buy it, but are you willing to wear it? I would love every guy to have that one moment of freedom when you wear a skirt. Not because its 'women's,' but because you get rid of everything society tells you about what's 'right and wrong,' what's 'blue (for boys) and pink (for girls).' It's a mental/spiritual breakthrough!"

@IMJUSS

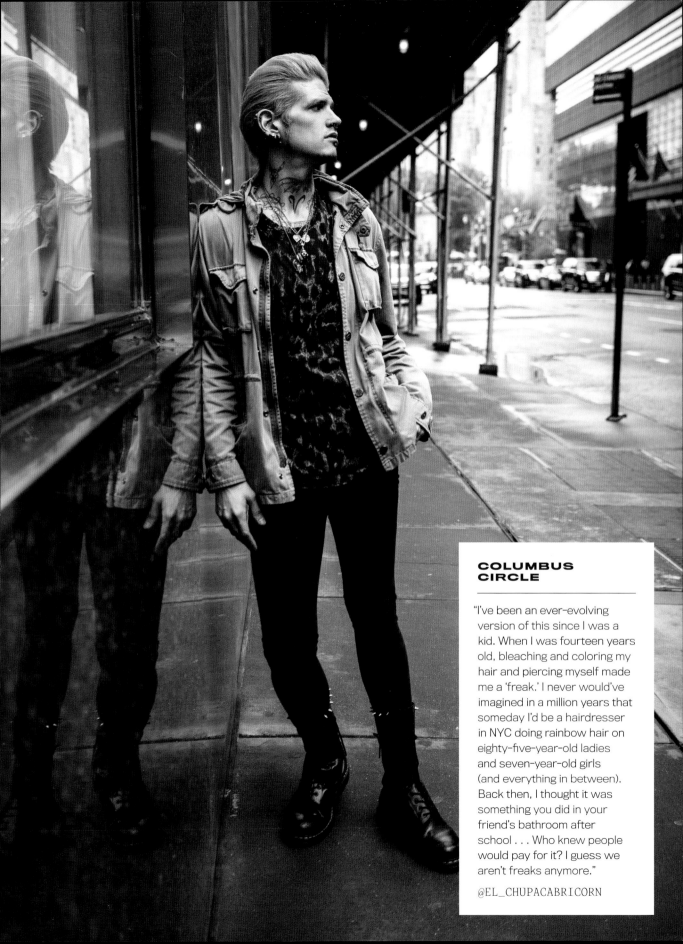

COLUMBUS CIRCLE

"I've been an ever-evolving version of this since I was a kid. When I was fourteen years old, bleaching and coloring my hair and piercing myself made me a 'freak.' I never would've imagined in a million years that someday I'd be a hairdresser in NYC doing rainbow hair on eighty-five-year-old ladies and seven-year-old girls (and everything in between). Back then, I thought it was something you did in your friend's bathroom after school . . . Who knew people would pay for it? I guess we aren't freaks anymore."

@EL_CHUPACABRICORN

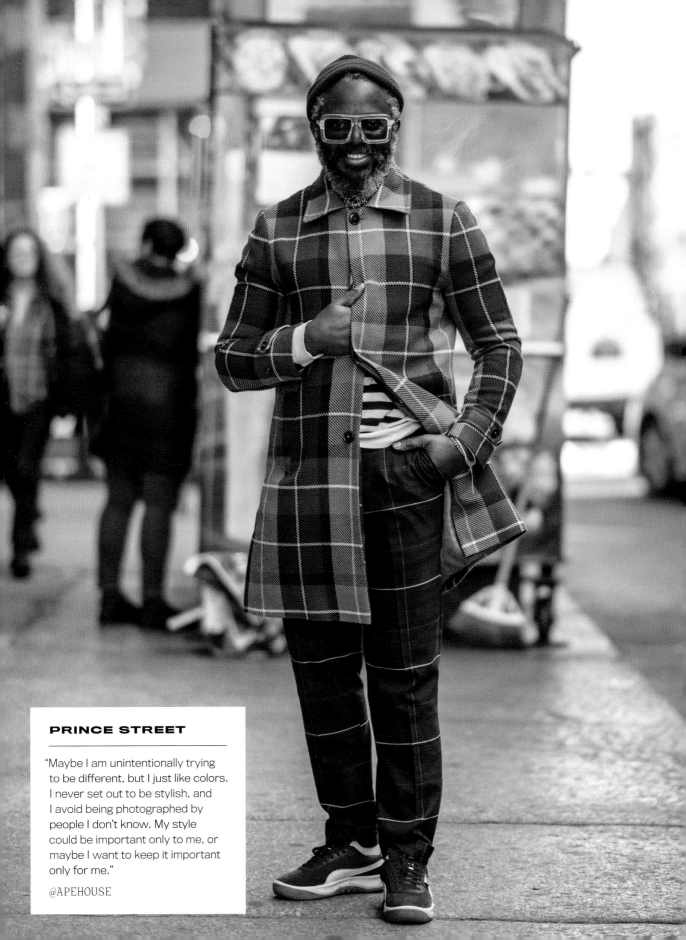

PRINCE STREET

"Maybe I am unintentionally trying
to be different, but I just like colors.
I never set out to be stylish, and
I avoid being photographed by
people I don't know. My style
could be important only to me, or
maybe I want to keep it important
only for me."

@APEHOUSE

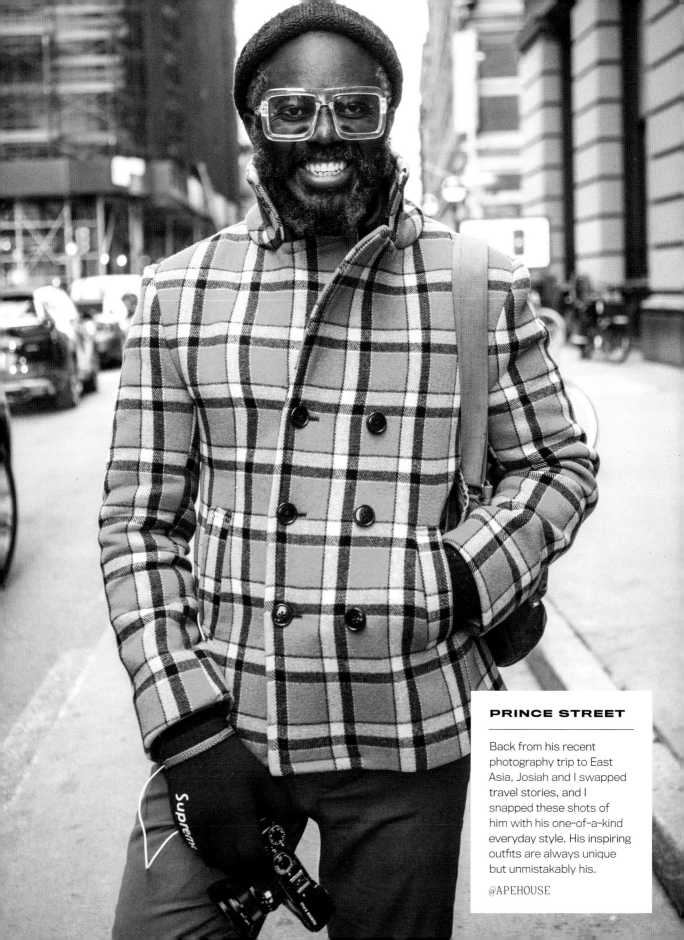

PRINCE STREET

Back from his recent photography trip to East Asia, Josiah and I swapped travel stories, and I snapped these shots of him with his one-of-a-kind everyday style. His inspiring outfits are always unique but unmistakably his.

@APEHOUSE

SLOANE SQUARE, LONDON

"My style makes me comfortable and puts me in my zone—a happy mood. Sometimes, when I'm unable to wear what I truly want to wear for whatever reason, maybe I'm away on holiday and didn't pack enough stuff or whatever, I feel like a fish out of water.

"My father used to say, 'Dress the way you want to be addressed. We don't get a second chance to make a first impression.'"

@STACREST

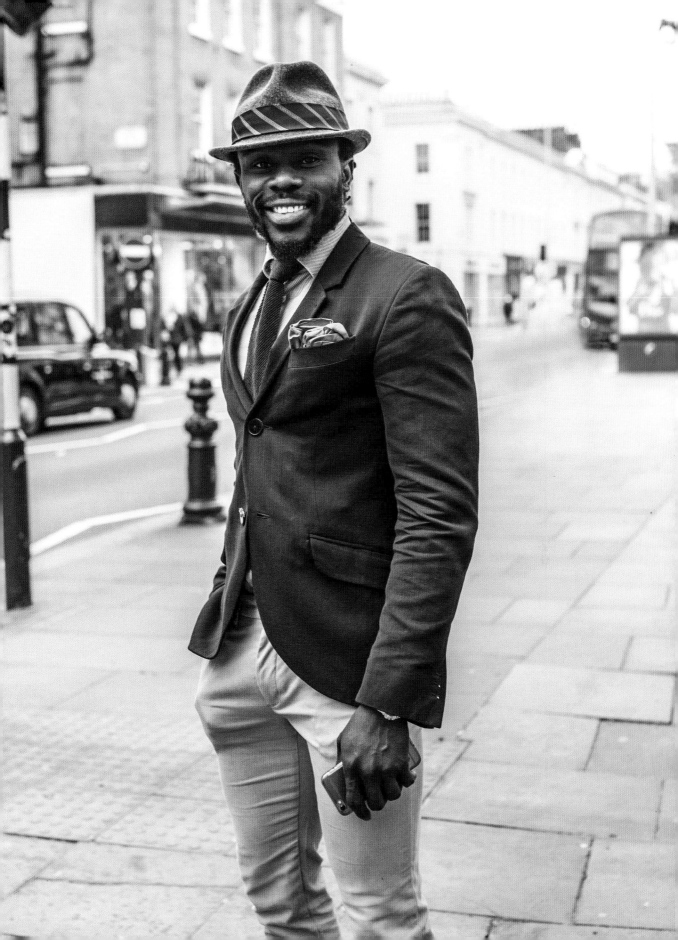

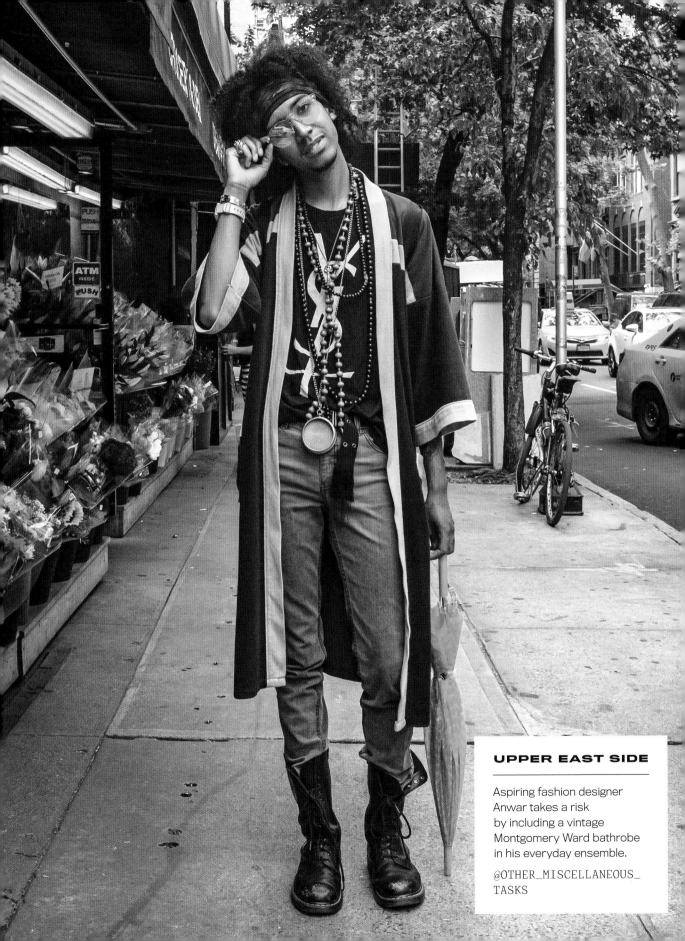

UPPER EAST SIDE

Aspiring fashion designer Anwar takes a risk by including a vintage Montgomery Ward bathrobe in his everyday ensemble.

@OTHER_MISCELLANEOUS_TASKS

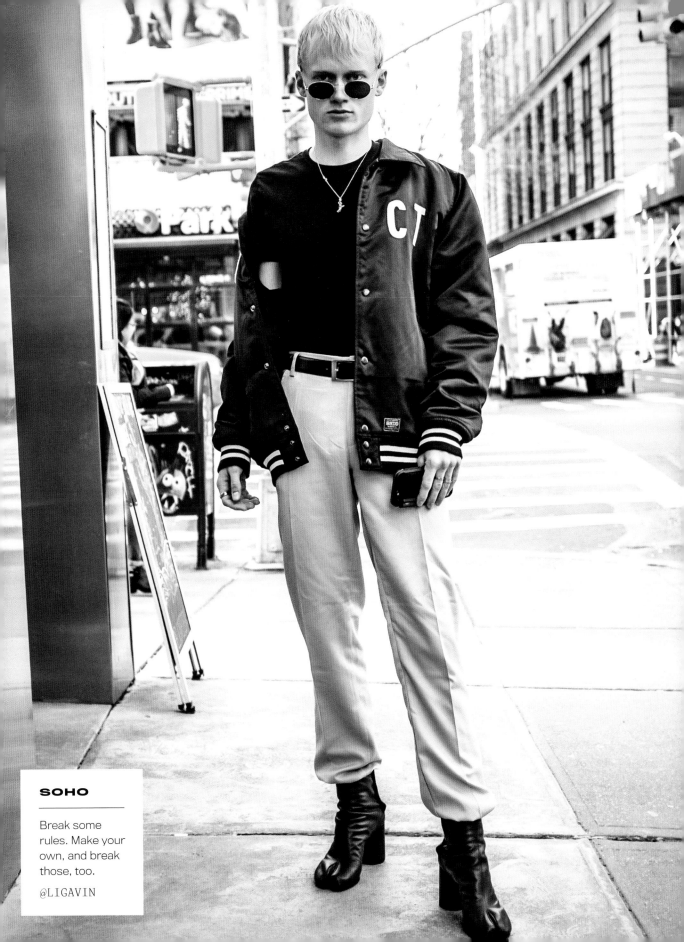

SOHO

Break some
rules. Make your
own, and break
those, too.

@LIGAVIN

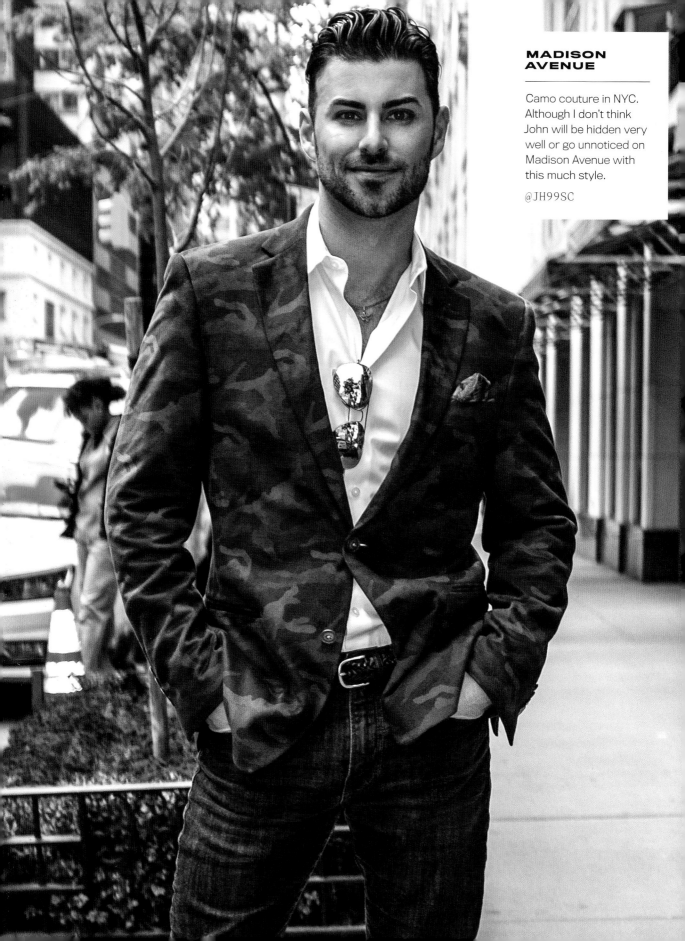

MADISON AVENUE

Camo couture in NYC. Although I don't think John will be hidden very well or go unnoticed on Madison Avenue with this much style.

@JH99SC

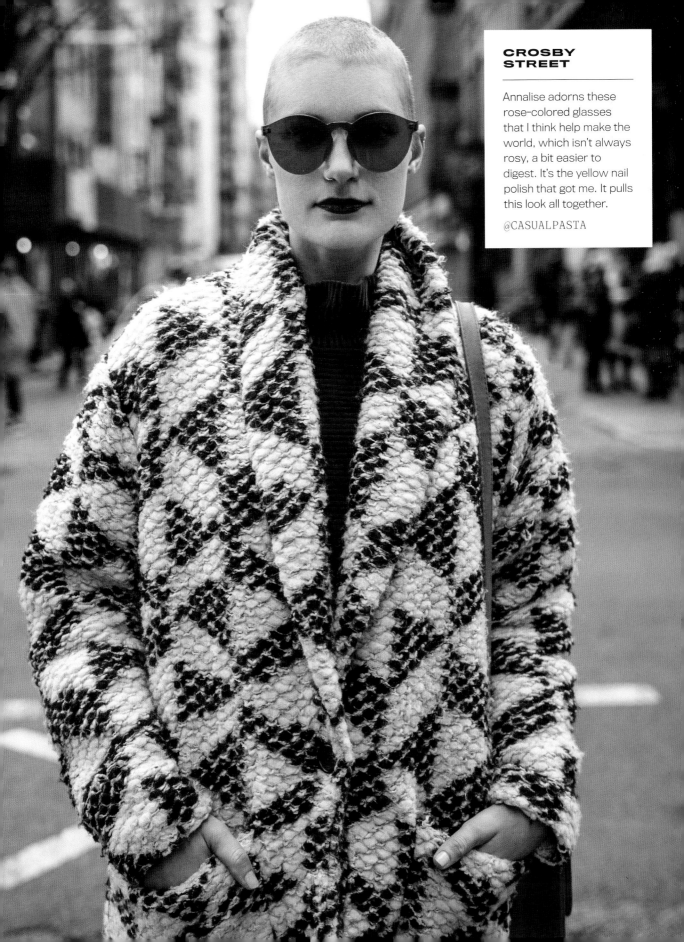

CROSBY STREET

Annalise adorns these rose-colored glasses that I think help make the world, which isn't always rosy, a bit easier to digest. It's the yellow nail polish that got me. It pulls this look all together.

@CASUALPASTA

HOWARD STREET

"I've always been drawn to color in a highly emotional way. Bright colors are the antidote to darkness. As a sufferer of anxiety and depression—in stark contrast to what my look and general demeanor might suggest—I immerse myself in it to stay positive and optimistic.

"What's most important to me is being true to myself. And I will continue to do so for as long as I live, accompanied by my wonderful friend—fashion—who brightens up each and every day and never lets me down."

@THESCARLETBOB

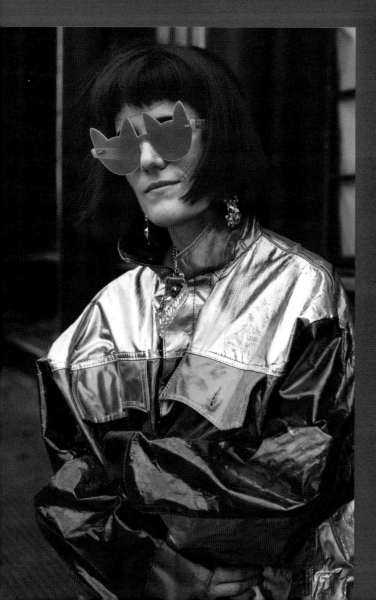

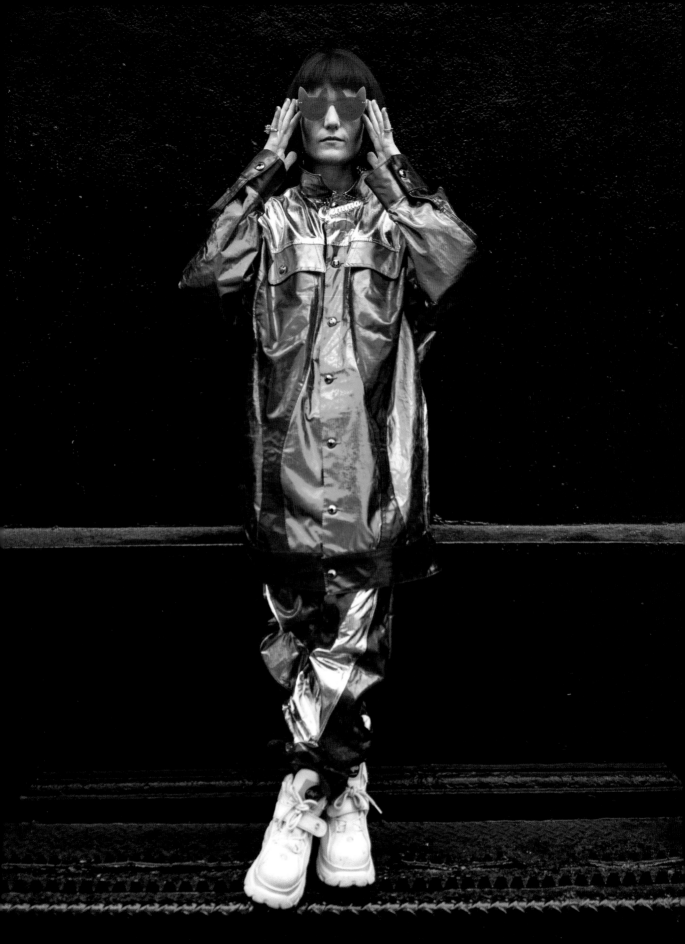

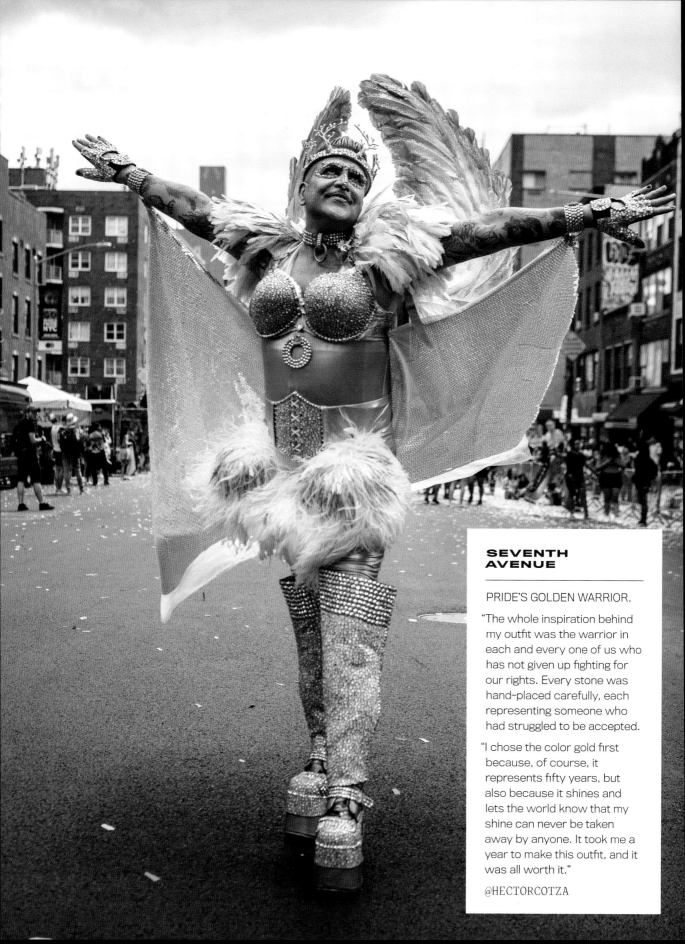

SEVENTH AVENUE

PRIDE'S GOLDEN WARRIOR.

"The whole inspiration behind my outfit was the warrior in each and every one of us who has not given up fighting for our rights. Every stone was hand-placed carefully, each representing someone who had struggled to be accepted.

"I chose the color gold first because, of course, it represents fifty years, but also because it shines and lets the world know that my shine can never be taken away by anyone. It took me a year to make this outfit, and it was all worth it."

@HECTORCOTZA

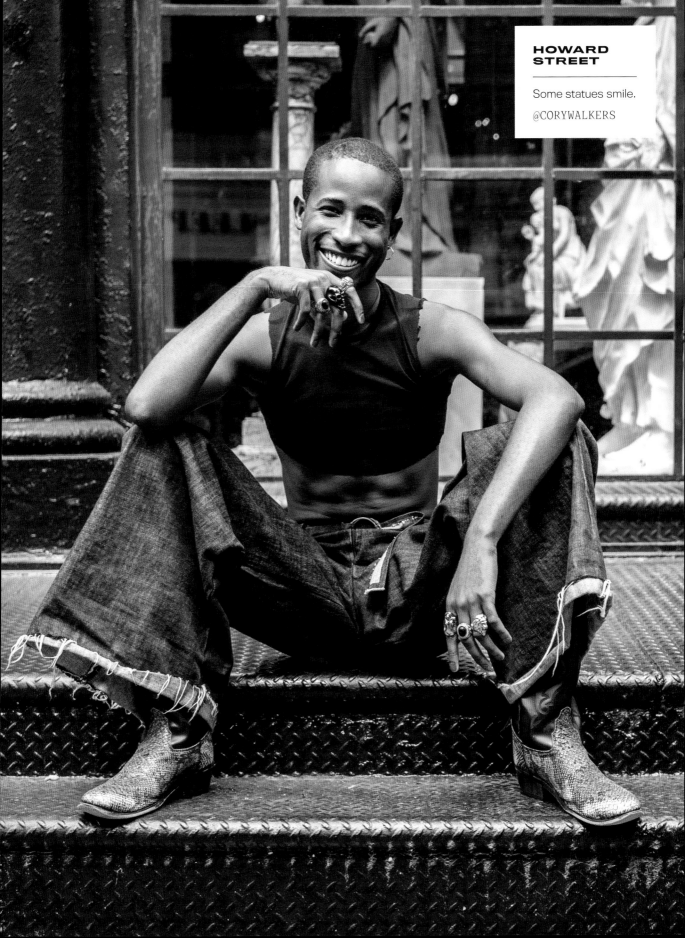

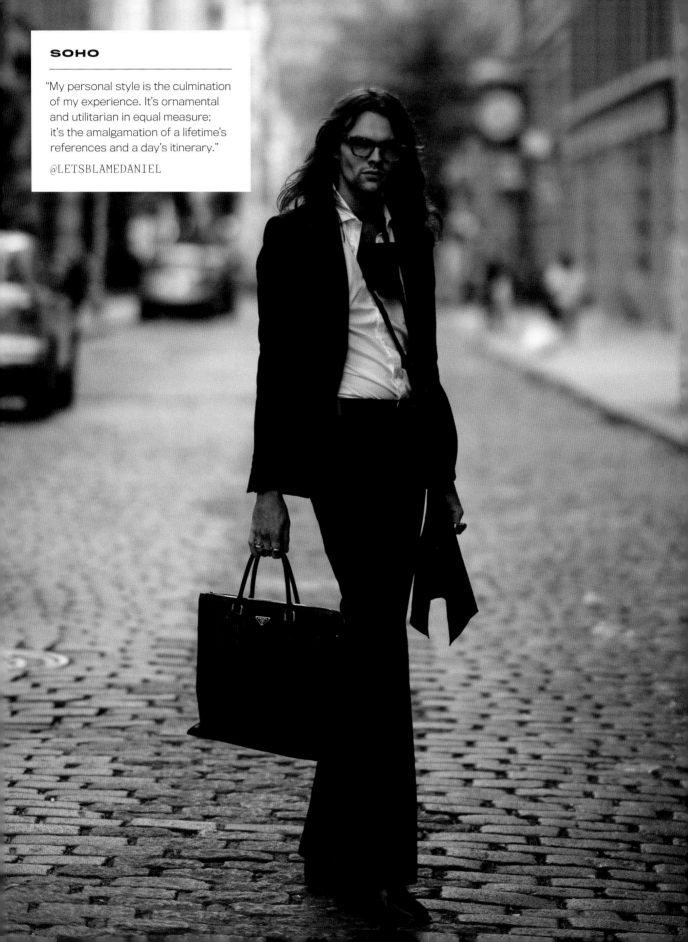

SOHO

"My personal style is the culmination of my experience. It's ornamental and utilitarian in equal measure; it's the amalgamation of a lifetime's references and a day's itinerary."

@LETSBLAMEDANIEL

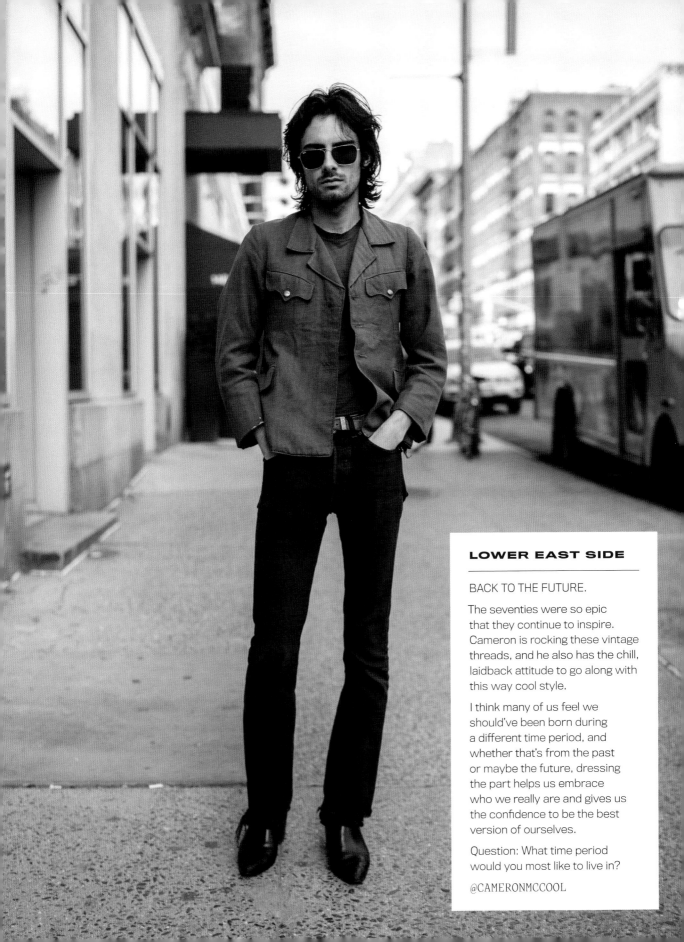

LOWER EAST SIDE

BACK TO THE FUTURE.

The seventies were so epic that they continue to inspire. Cameron is rocking these vintage threads, and he also has the chill, laidback attitude to go along with this way cool style.

I think many of us feel we should've been born during a different time period, and whether that's from the past or maybe the future, dressing the part helps us embrace who we really are and gives us the confidence to be the best version of ourselves.

Question: What time period would you most like to live in?

@CAMERONMCCOOL

NEWTOWN, NEW SOUTH WALES

"I've always been interested in the way style alters the way people treat each other and how we think of ourselves.

"I started wearing three-piece suits in my late teens while long-term unemployed. Like a lot of people without much money back then, buying interesting clothes in thrift stores was one of my only possible indulgences.

"I got my first few suits for fifteen to twenty dollars each and still have most of them. I even wore a fifties-style suit I bought from the Salvation Army to wear to my corporate job twenty years later, and no one had any idea it was secondhand (and older than me). I used to wear them all the time while unemployed—it was a nice way of making everything feel like an occasion, like every day had the potential to be life-changing or revelatory. And it did change how people treated me; whenever I did the groceries at 2 a.m. in my suit, I could shoplift as much as I wanted. But if I went to the same store with the same security guard and wore jeans, he'd follow me constantly.

"I also remember being shocked and amused that I got shouted at really abusively by some surfers driving by because I was once walking along the highway wearing a blue pinstripe three-piece with a bright red Mohawk. It's fun to confound expectations like that and push your own comfort zones, but now that I have my own shop—which I love and cherish and have great respect for—I feel like I'd be letting the place down if I didn't dress for the occasion."

@IXEX

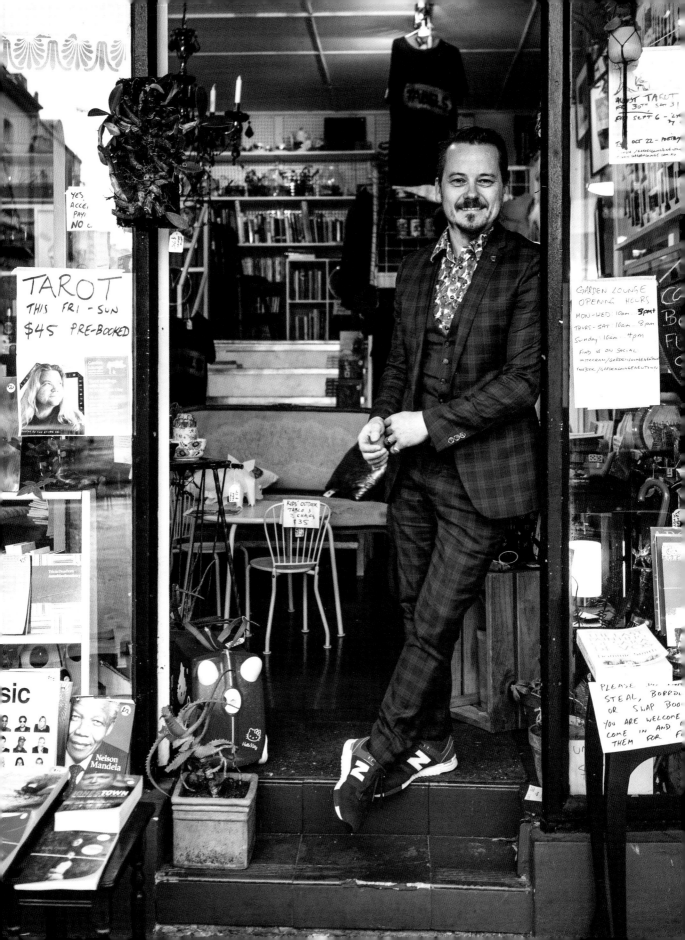

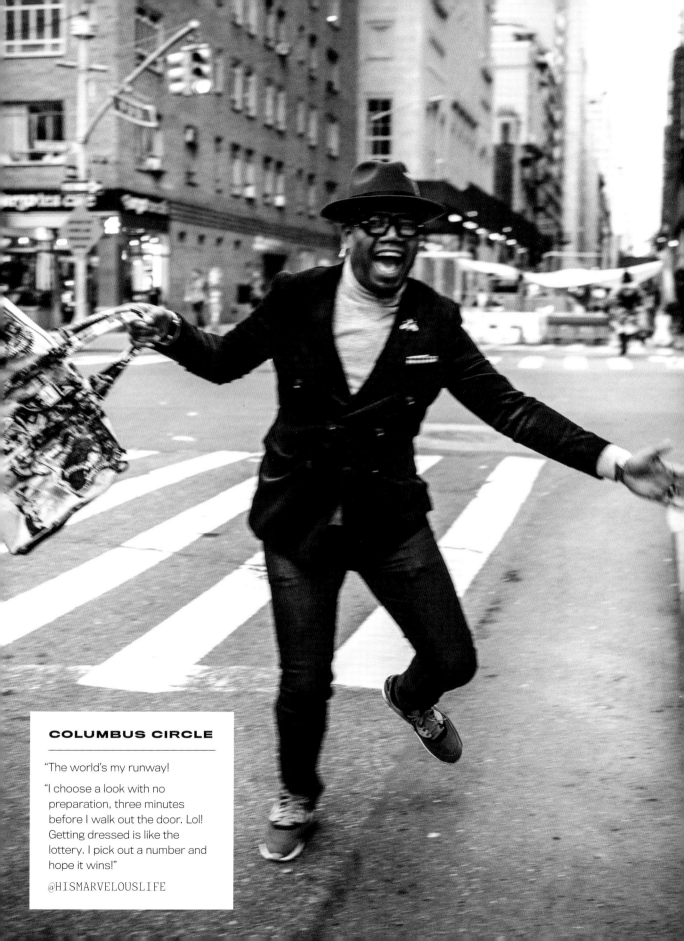

COLUMBUS CIRCLE

"The world's my runway!

"I choose a look with no preparation, three minutes before I walk out the door. Lol! Getting dressed is like the lottery. I pick out a number and hope it wins!"

@HISMARVELOUSLIFE

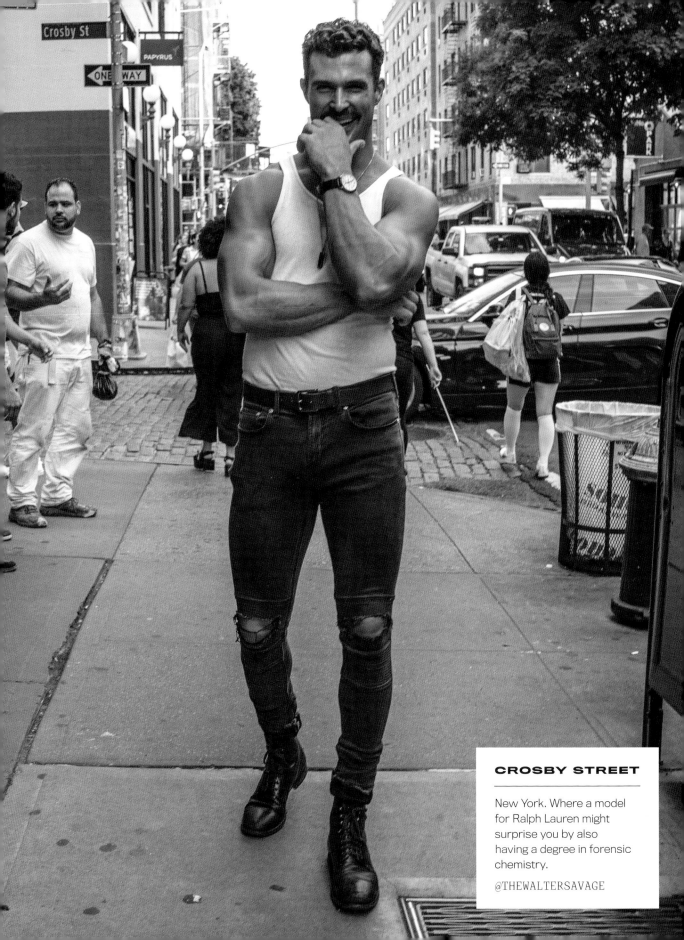

CROSBY STREET

New York. Where a model for Ralph Lauren might surprise you by also having a degree in forensic chemistry.

@THEWALTERSAVAGE

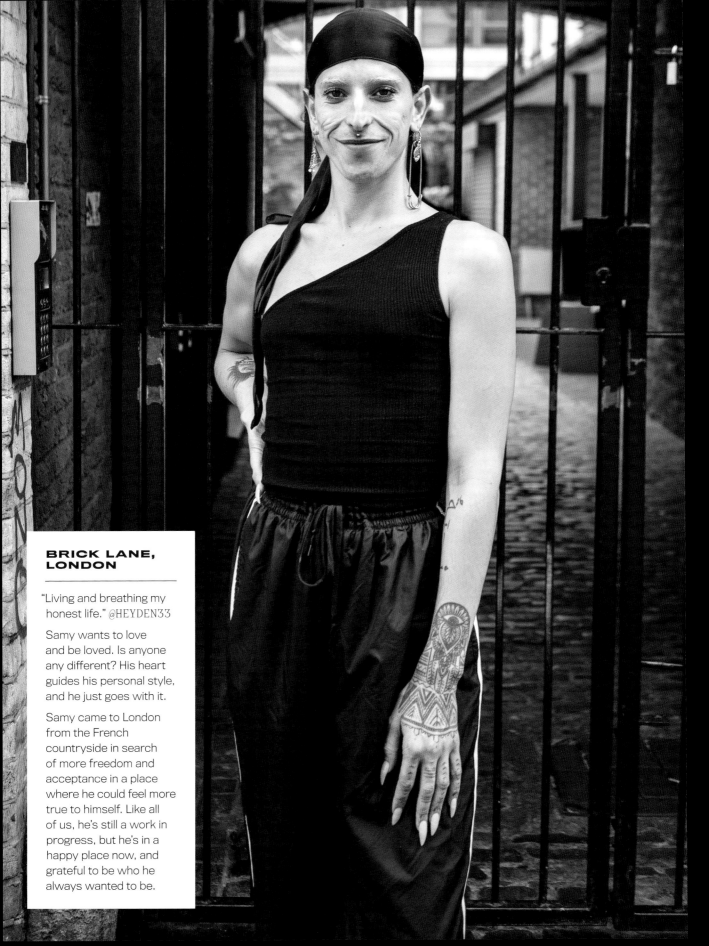

BRICK LANE, LONDON

"Living and breathing my honest life." @HEYDEN33

Samy wants to love and be loved. Is anyone any different? His heart guides his personal style, and he just goes with it.

Samy came to London from the French countryside in search of more freedom and acceptance in a place where he could feel more true to himself. Like all of us, he's still a work in progress, but he's in a happy place now, and grateful to be who he always wanted to be.

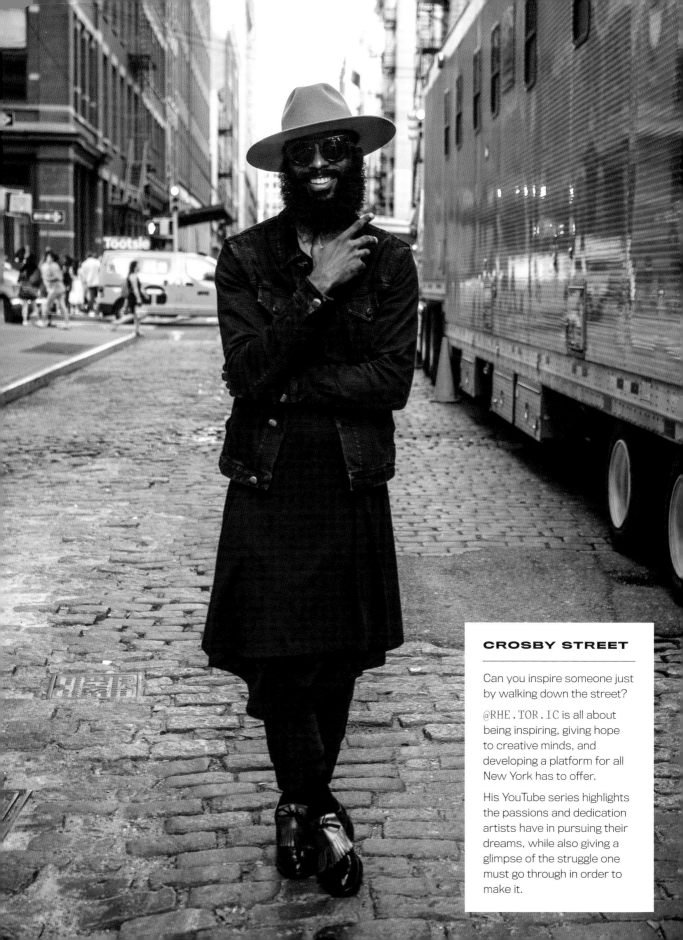

CROSBY STREET

Can you inspire someone just by walking down the street?

@RHE.TOR.IC is all about being inspiring, giving hope to creative minds, and developing a platform for all New York has to offer.

His YouTube series highlights the passions and dedication artists have in pursuing their dreams, while also giving a glimpse of the struggle one must go through in order to make it.

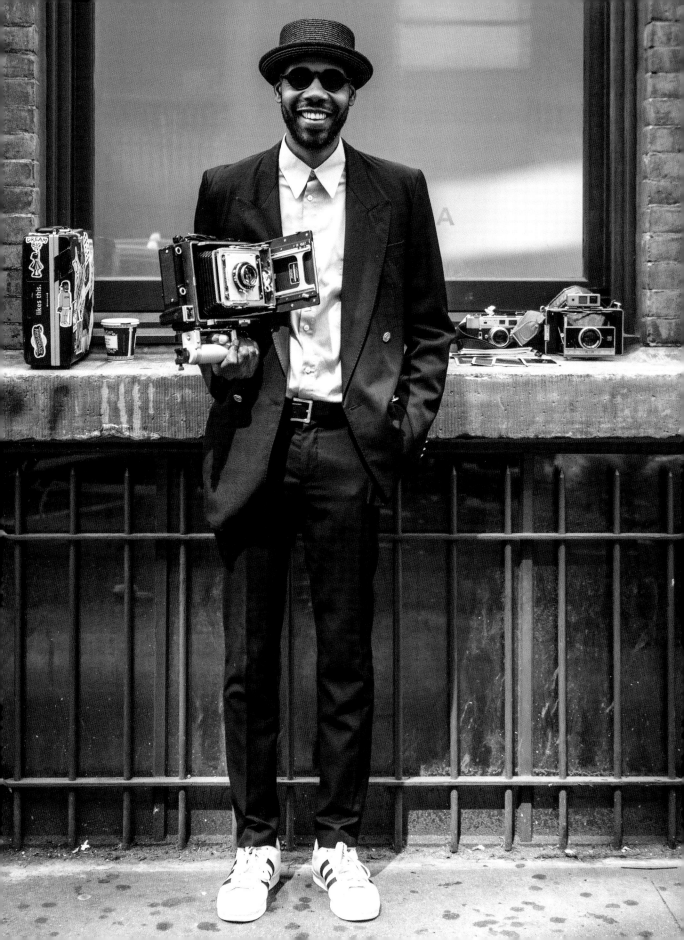

OPPOSITE PAGE
PRINCE STREET

THE PRINCE OF PRINCE STREET.

Who says photographers can't be dapper?! Jean Andre is always a class act, and putting on the right outfit every day is part of getting in the right mindset to take amazing photos time after time with only one shot of his Polaroid.

@JAAPHOTOS

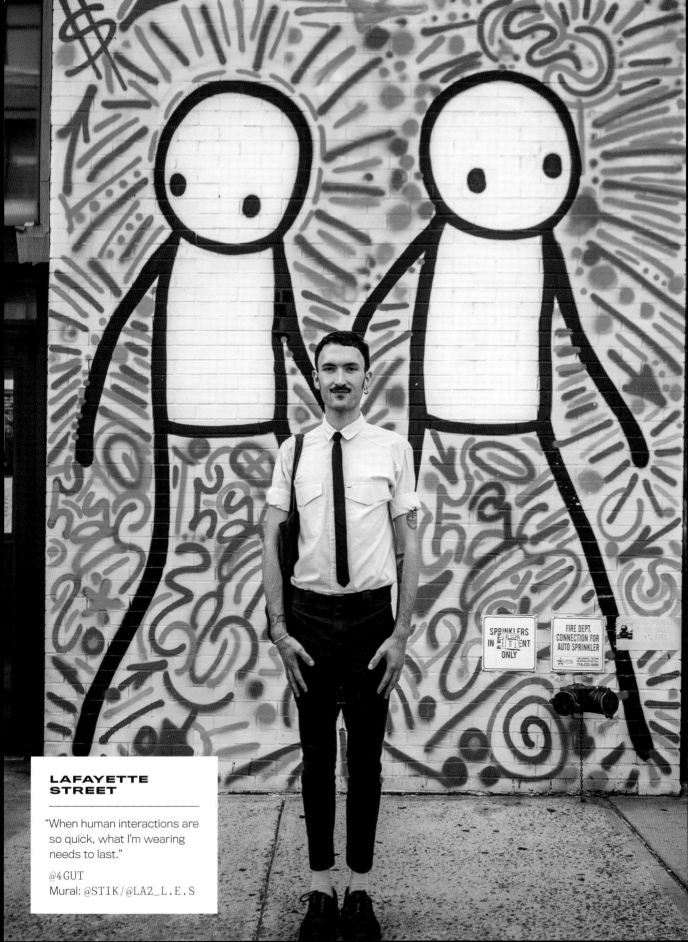

LAFAYETTE STREET

"When human interactions are so quick, what I'm wearing needs to last."

@4GUT
Mural: @STIK/@LA2_L.E.S

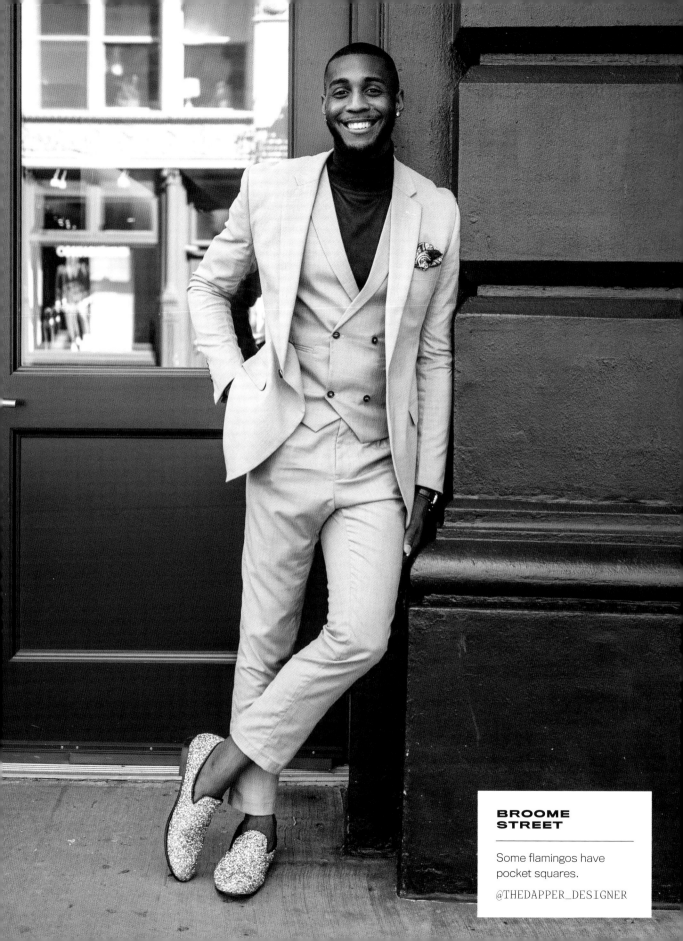

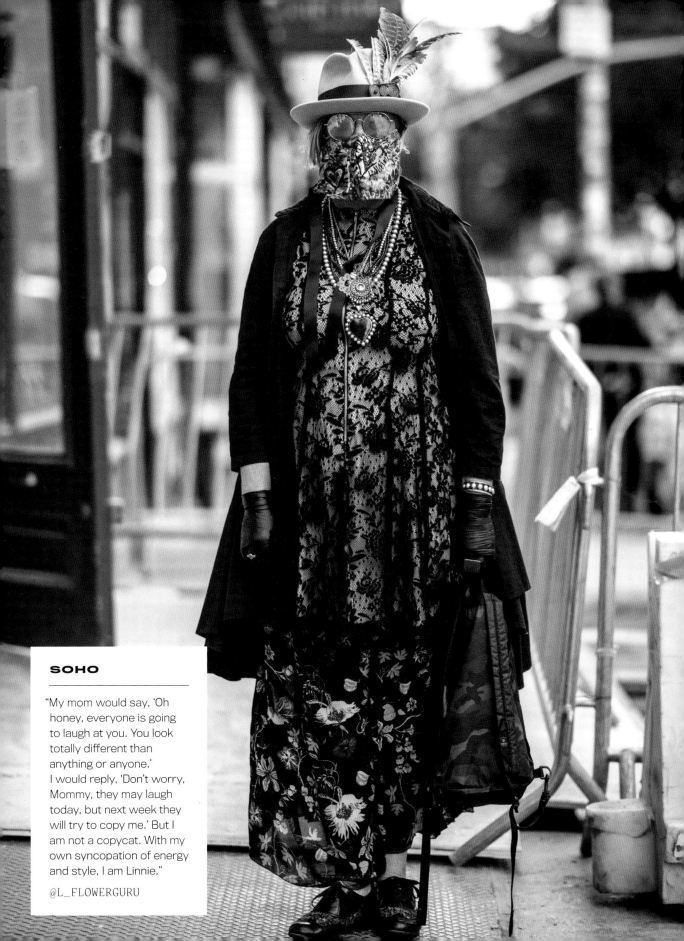

SOHO

"My mom would say, 'Oh honey, everyone is going to laugh at you. You look totally different than anything or anyone.' I would reply, 'Don't worry, Mommy, they may laugh today, but next week they will try to copy me.' But I am not a copycat. With my own syncopation of energy and style, I am Linnie."

@L_FLOWERGURU

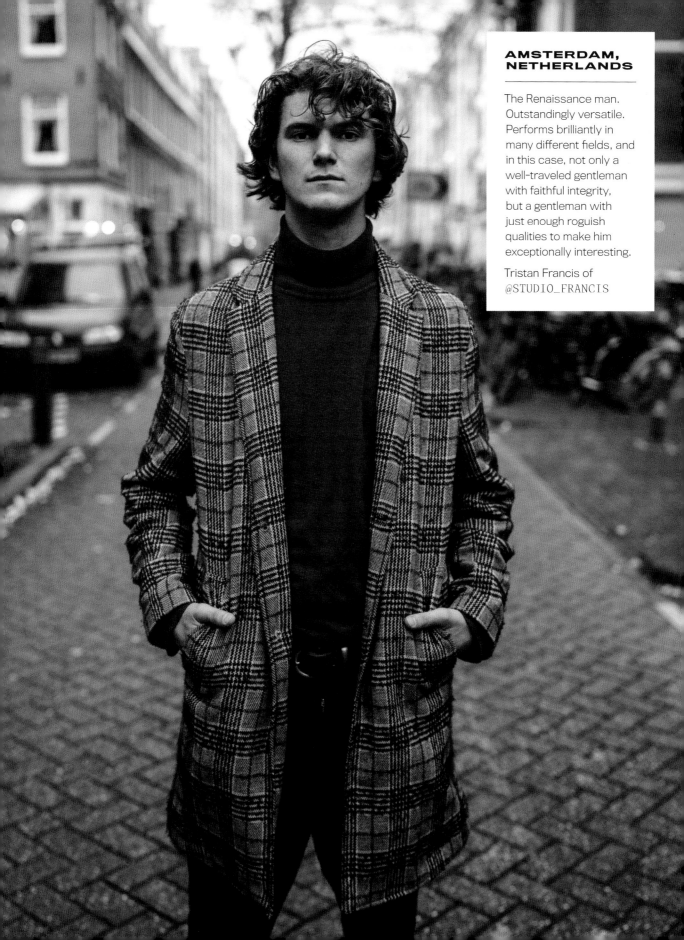

The Renaissance man.
Outstandingly versatile.
Performs brilliantly in
many different fields, and
in this case, not only a
well-traveled gentleman
with faithful integrity,
but a gentleman with
just enough roguish
qualities to make him
exceptionally interesting.

Tristan Francis of
@STUDIO_FRANCIS

JERSEY STREET

"My father was an antique dealer and my mother was a florist. I grew up in an environment where the pursuit of beauty, a taste for uniqueness, and an appreciation for style (even without money) was an absolute. This is what I try to perpetuate today as I face a world that thinks, consumes, and dresses the same way. I continue to believe, as the French writer Charles Peguy wrote, that 'only tradition is revolutionary.' In that way, canes have always occupied a special place in my imagination. My father had a lot of them in his shop, and I would dream of collecting the ones that concealed secrets within them. Isn't the cane ultimately the sword of the esthete? The one I hold here is very important to me. It was given to me by my mother when I left France to go live in the United States to 'bring a little of the Old Continent elegance to the New World.' I'm on duty!"

@RODOLPHELACHAT

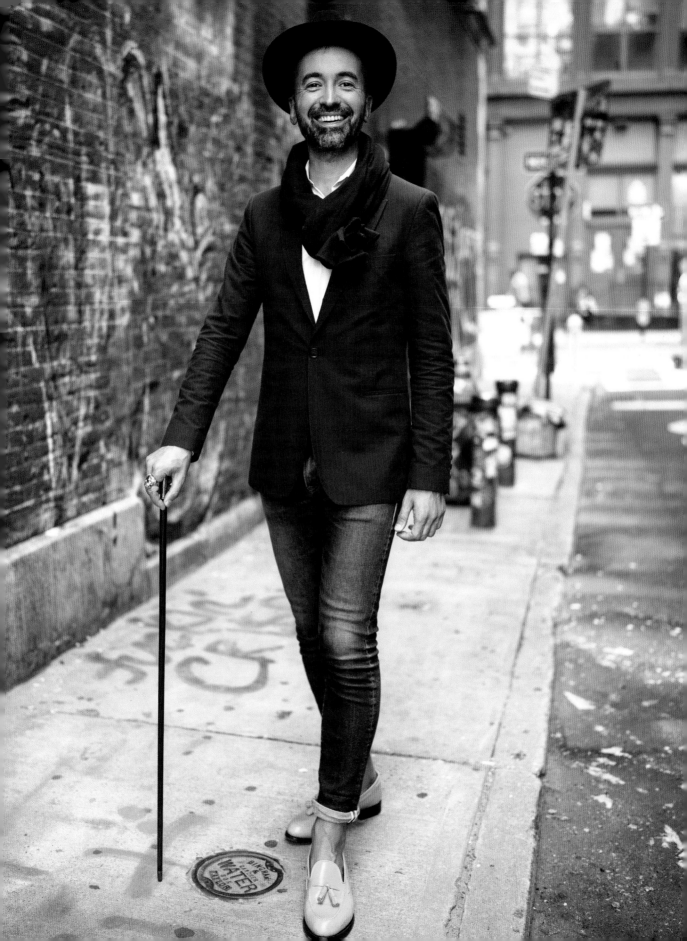

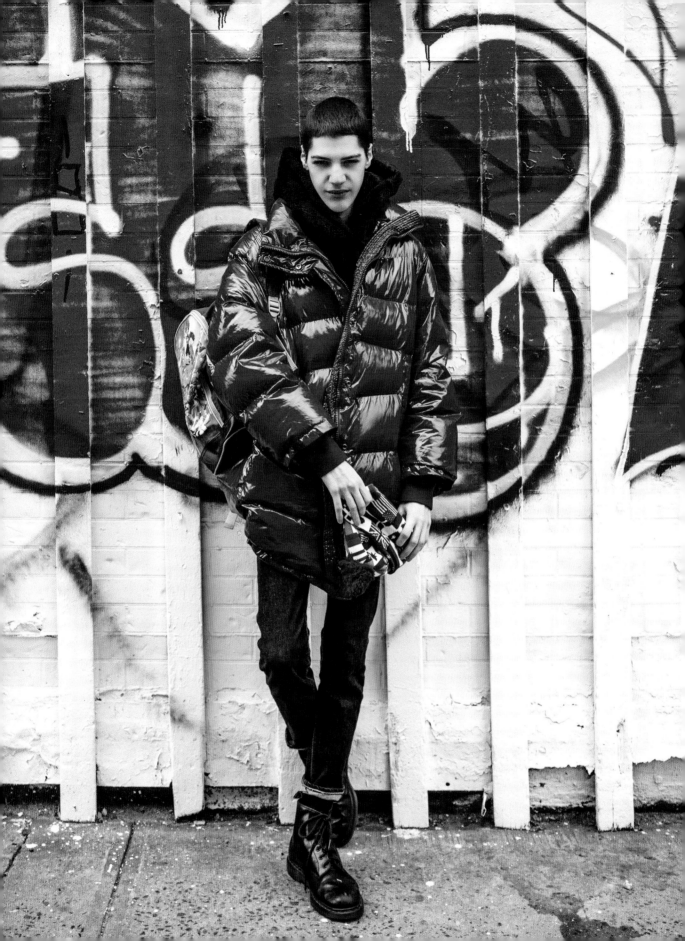

OPPOSITE PAGE
BOWERY

Franco's favorite color? Take a wild guess . . .

Our favorite color seems to find its way into much of the way we express our personal style. It could be our clothes, furniture, our cars, or even our hair color. And most psychologists agree our favorite color suggests our personality traits, too. What's your favorite color, and where does it show up most in your life?

@FRANCOSCHICKE

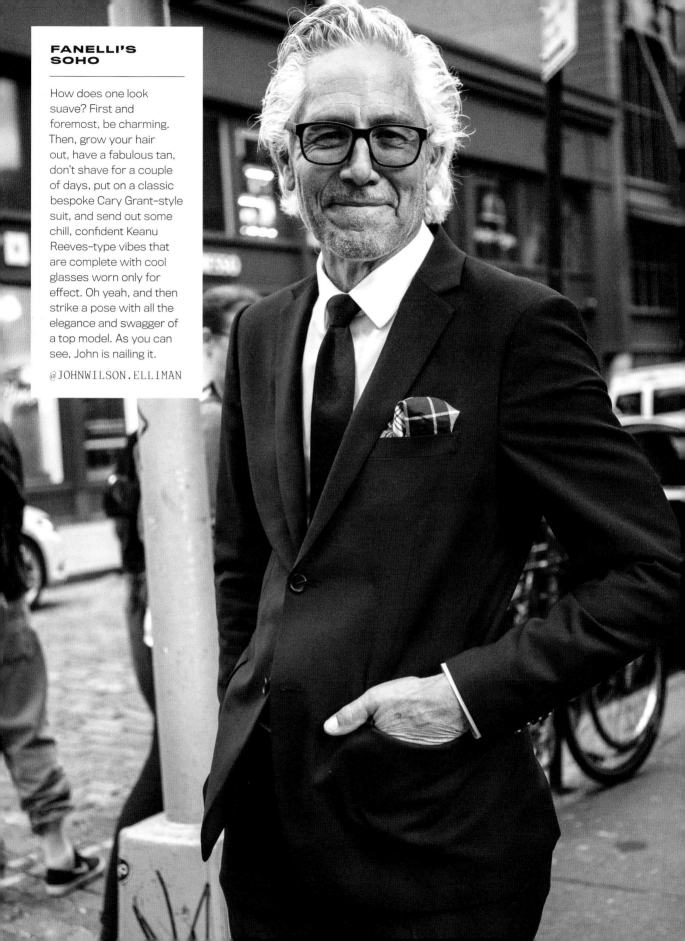

FANELLI'S
SOHO

How does one look suave? First and foremost, be charming. Then, grow your hair out, have a fabulous tan, don't shave for a couple of days, put on a classic bespoke Cary Grant–style suit, and send out some chill, confident Keanu Reeves–type vibes that are complete with cool glasses worn only for effect. Oh yeah, and then strike a pose with all the elegance and swagger of a top model. As you can see, John is nailing it.

@JOHNWILSON.ELLIMAN

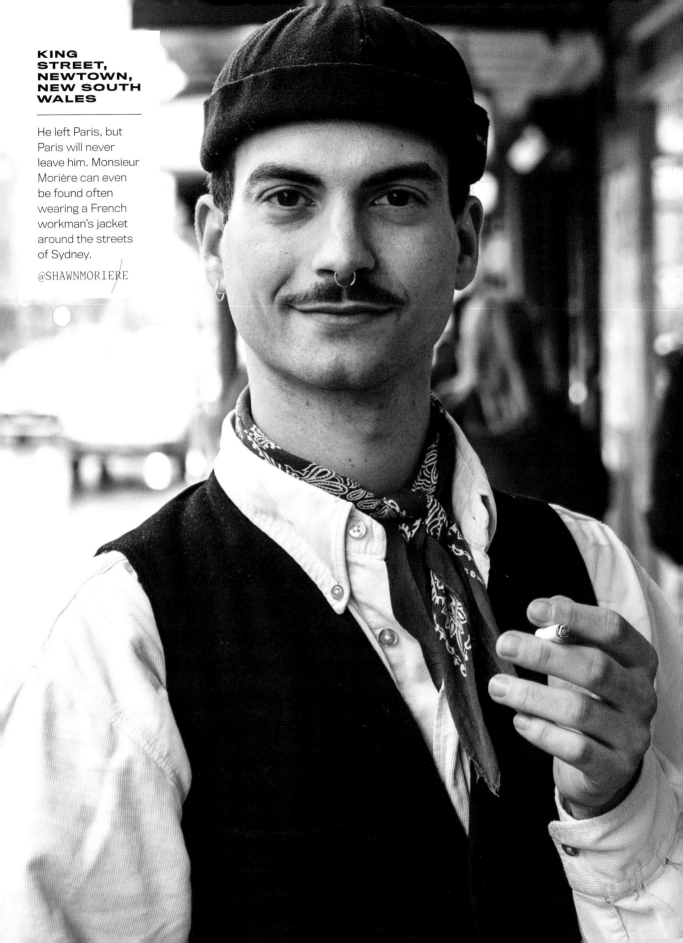

He left Paris, but
Paris will never
leave him. Monsieur
Morière can even
be found often
wearing a French
workman's jacket
around the streets
of Sydney.

@SHAWNMORIERE

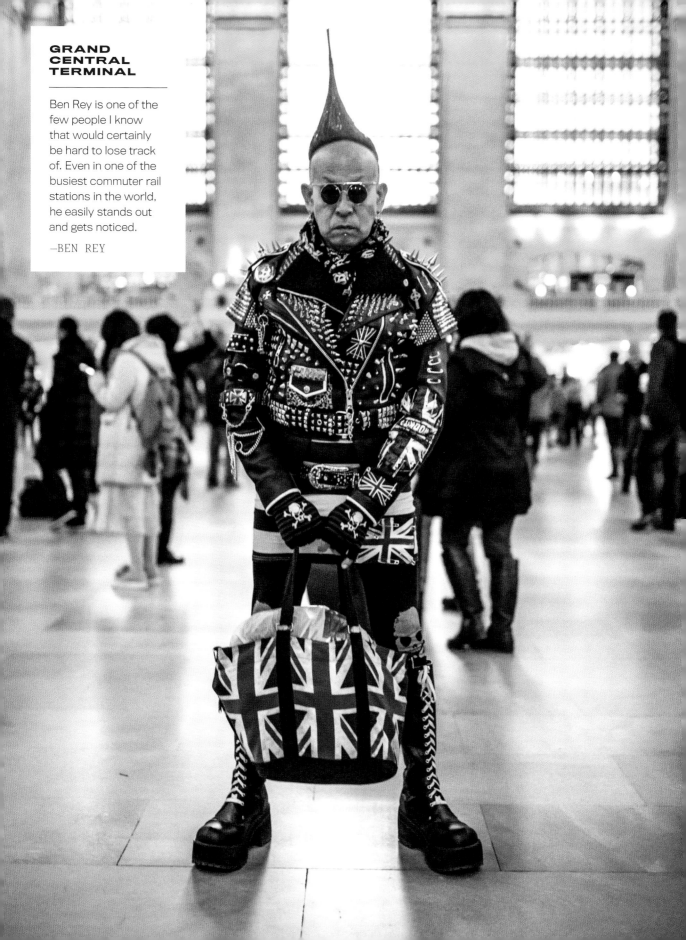

Ben Rey is one of the
few people I know
that would certainly
be hard to lose track
of. Even in one of the
busiest commuter rail
stations in the world,
he easily stands out
and gets noticed.

—BEN REY

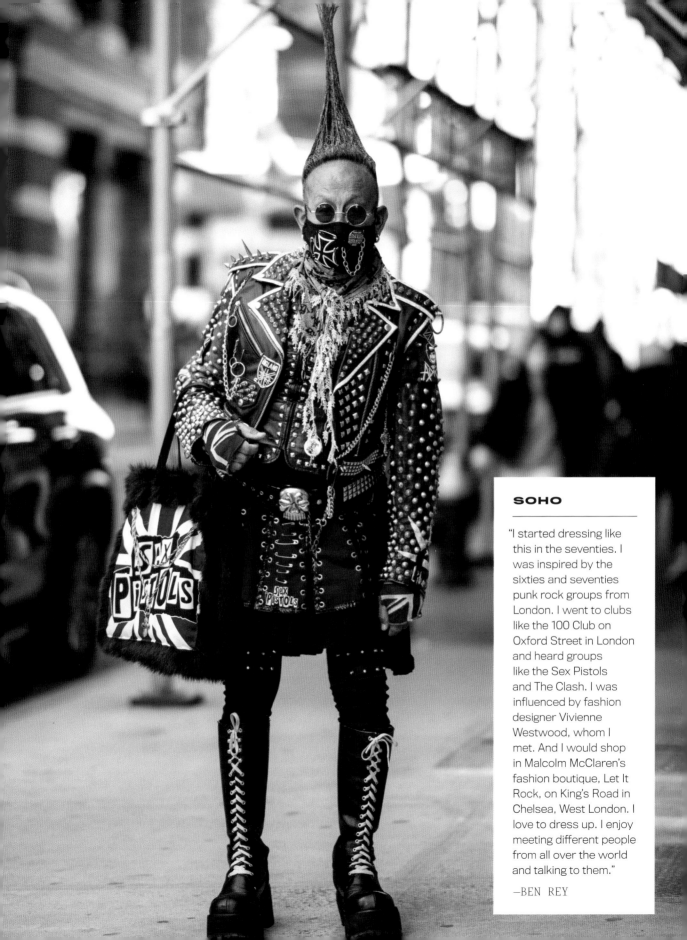

SOHO

"I started dressing like this in the seventies. I was inspired by the sixties and seventies punk rock groups from London. I went to clubs like the 100 Club on Oxford Street in London and heard groups like the Sex Pistols and The Clash. I was influenced by fashion designer Vivienne Westwood, whom I met. And I would shop in Malcolm McClaren's fashion boutique, Let It Rock, on King's Road in Chelsea, West London. I love to dress up. I enjoy meeting different people from all over the world and talking to them."

—BEN REY

PRINCE STREET

"Given the way I dress, people assume I'm an
extrovert. I'm actually very shy. I think my clothes
are my non-confrontational self-introduction, like
saying, 'Hi, I'm a bit unconventional, and you?'
Traditional, conservative people can steer clear
of me if they prefer without appearing rude, and
like-minded people can find me easily. It's kind of
a visual shortcut for people I haven't met. This is
perfect for shy people. And friends tell me they
know me in a crowd even without seeing my face.
My clothes are an expression of the way I think."

@IDIOSYNCRATICFASHIONISTAS

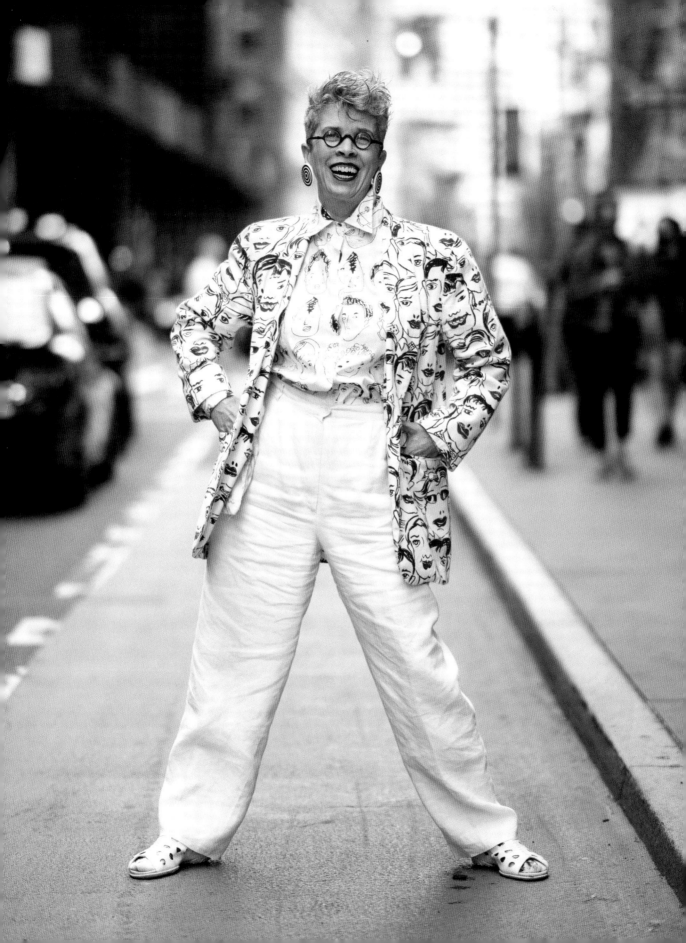

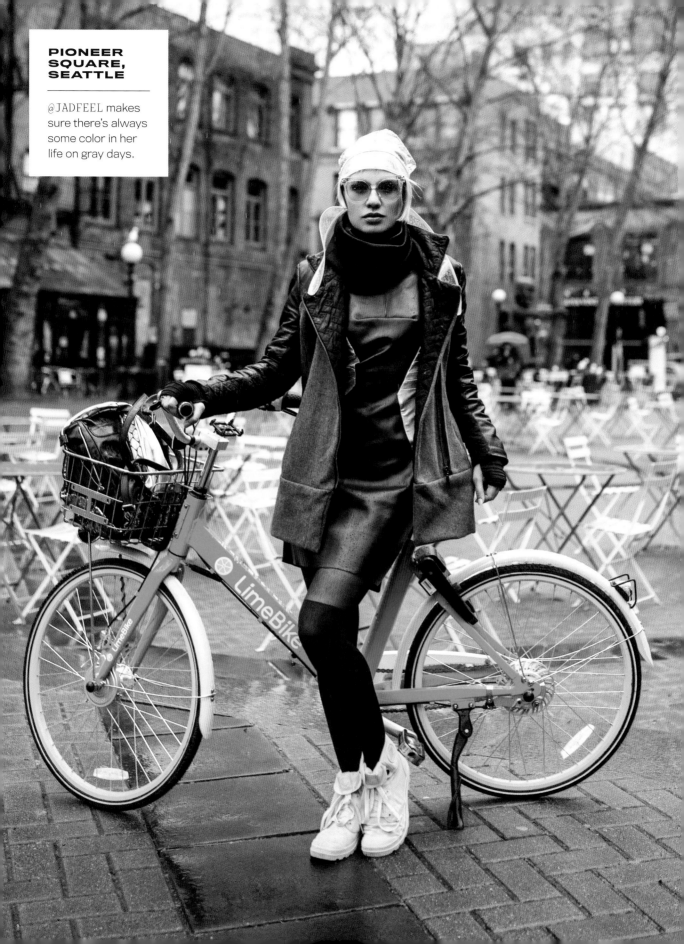

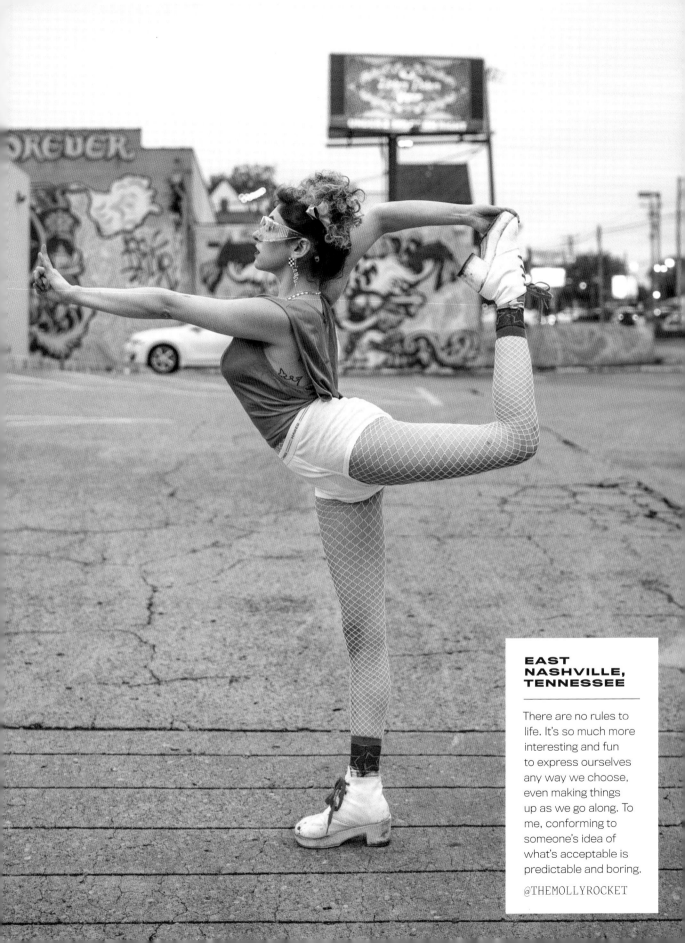

EAST NASHVILLE, TENNESSEE

There are no rules to life. It's so much more interesting and fun to express ourselves any way we choose, even making things up as we go along. To me, conforming to someone's idea of what's acceptable is predictable and boring.

@THEMOLLYROCKET

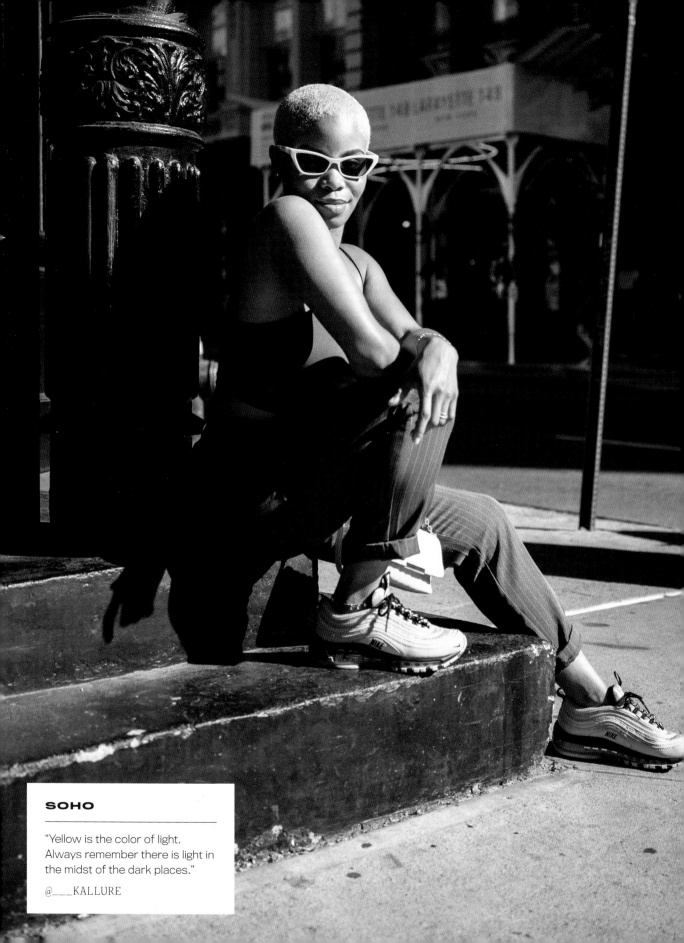

SOHO

"Yellow is the color of light.
Always remember there is light in
the midst of the dark places."

@____KALLURE

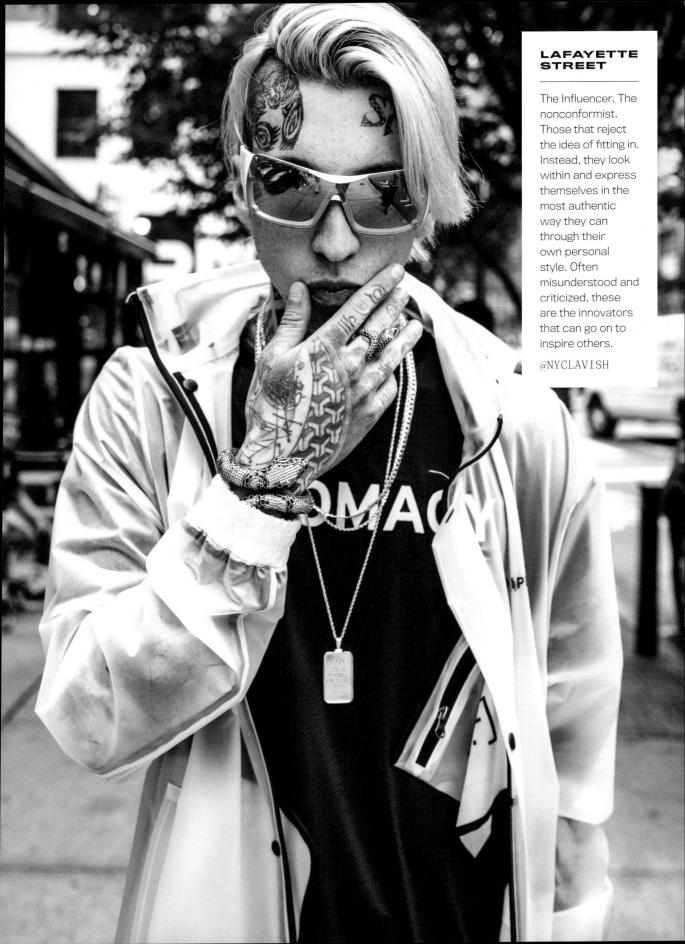

LAFAYETTE STREET

The Influencer. The nonconformist. Those that reject the idea of fitting in. Instead, they look within and express themselves in the most authentic way they can through their own personal style. Often misunderstood and criticized, these are the innovators that can go on to inspire others.

@NYCLAVISH

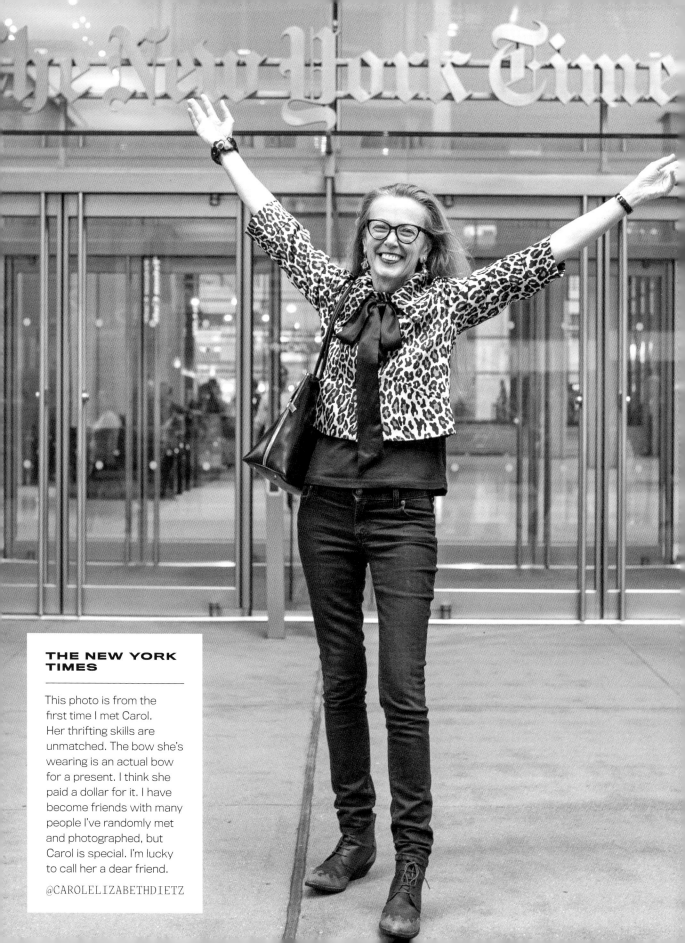

THE NEW YORK TIMES

This photo is from the first time I met Carol. Her thrifting skills are unmatched. The bow she's wearing is an actual bow for a present. I think she paid a dollar for it. I have become friends with many people I've randomly met and photographed, but Carol is special. I'm lucky to call her a dear friend.

@CAROLELIZABETHDIETZ

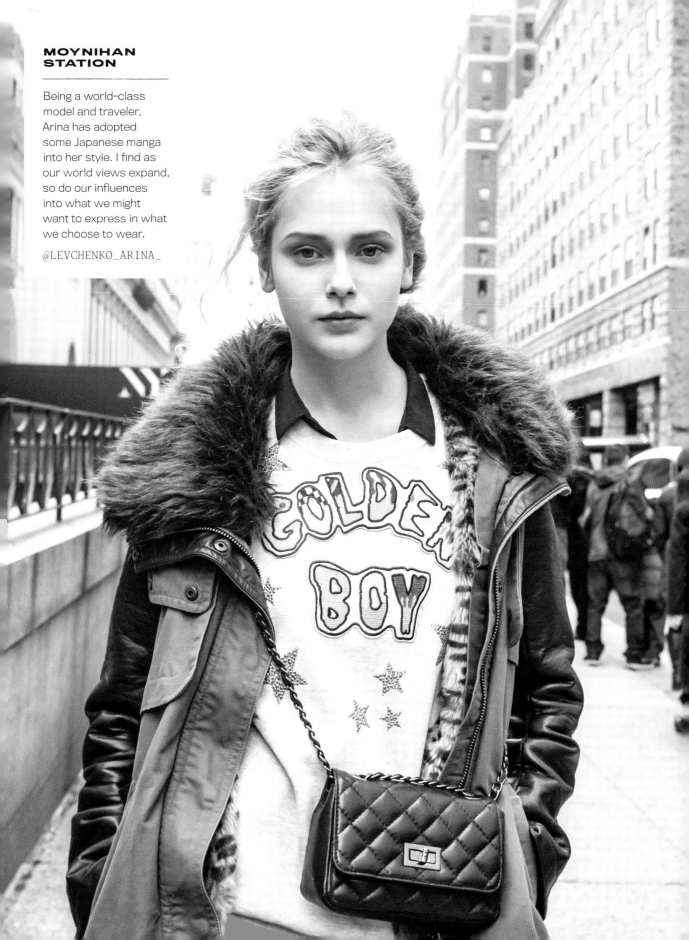

MOYNIHAN STATION

Being a world-class model and traveler, Arina has adopted some Japanese manga into her style. I find as our world views expand, so do our influences into what we might want to express in what we choose to wear.

@LEVCHENKO_ARINA_

"I had people look at me strange and say to me, 'The proportions are wrong, this is wrong.' Well, nothing's wrong in fashion or in style. Style is your own thing. It's your interpretation of what you want to show and what makes you feel good. That's what my style does for me. It makes me feel good. When I'm not feeling good, sometimes if I dress up, it makes me feel better, it helps.

"But my style is evolving constantly. I'm influenced by mixing patterns and mixing colors. It's important to me to experiment with my style. I've experimented with makeup. Everyone knows me for my wacky eyebrows. I had so many people over the years wanting to change that in me. Now I don't wear them, I'm older. I do sometimes, it just takes time to put on and I start to look kind of odd. Odd is good, but I'm at a different stage of my style and who I am right now.

"I never think about what other people are going to think of me and my style. I'm not doing it for a wild reaction. I did it years ago for protection, because I knew if I was that way, I'd walk in a room and I'd attract people that I would want to be around me and keep away people that I didn't want around me. So that was a protective type of thing. It was the armor, like Bill Cunningham said."

@DANDYOFNEWYORK

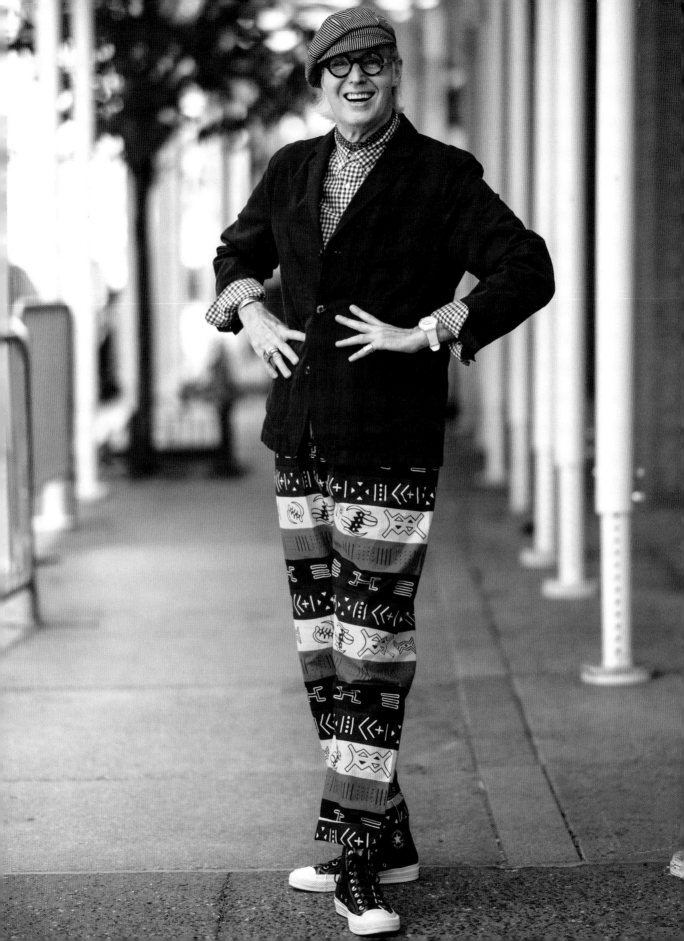

SHOES

Shoes do more than protect our feet
from the hazards of the street.
They greet the people that we meet.
They could leave our funds deplete, and we
might not even eat, but we'll get a receipt,
and they'll make our outfit complete.
Shoes.

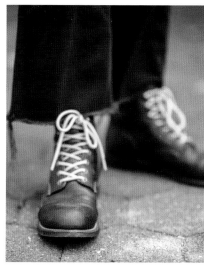
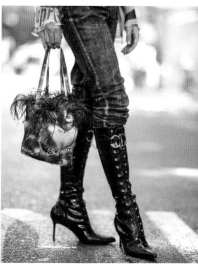
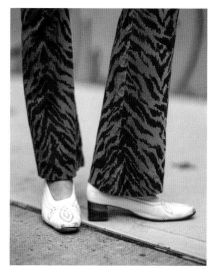
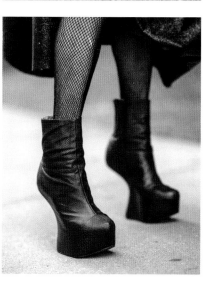
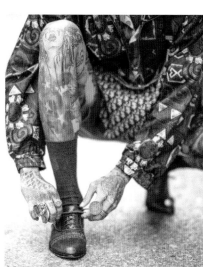

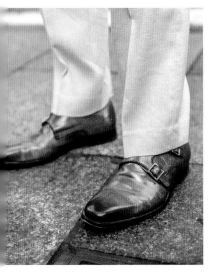
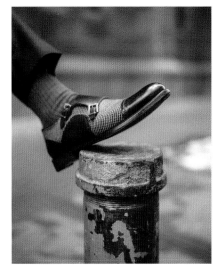
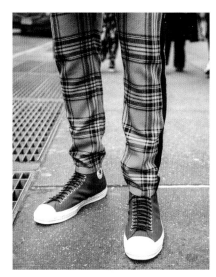
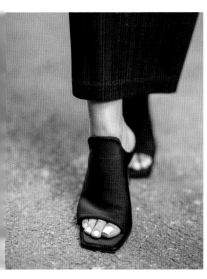
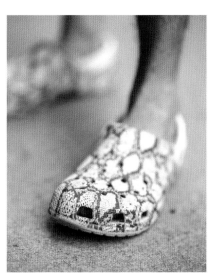
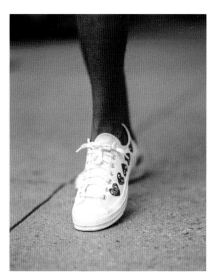
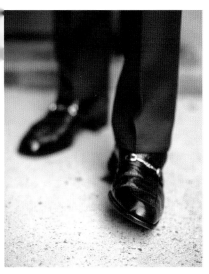
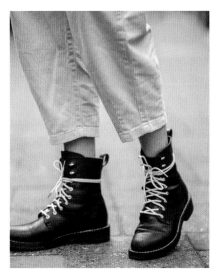
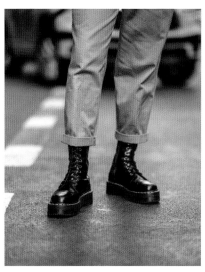

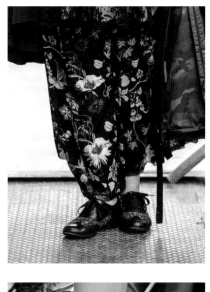 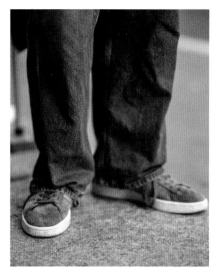 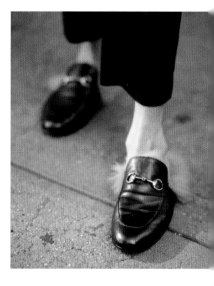

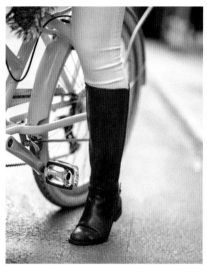 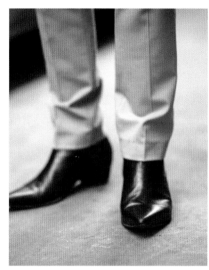 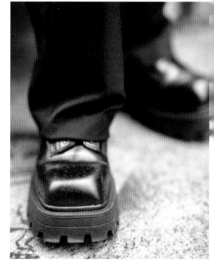

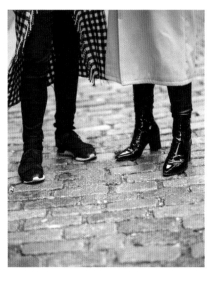 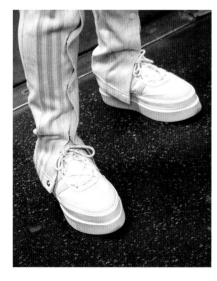 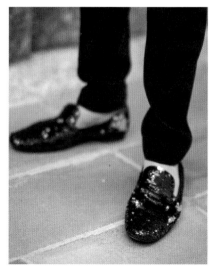

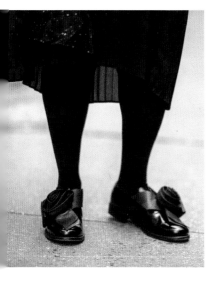
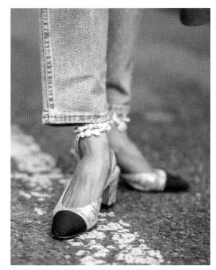
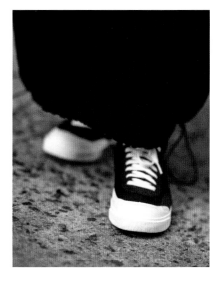
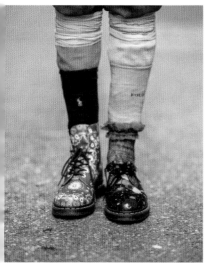
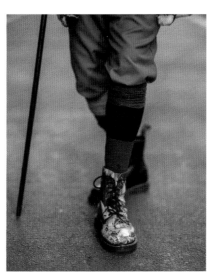
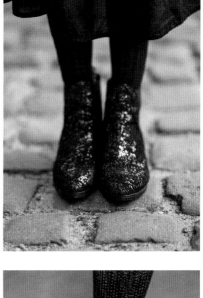
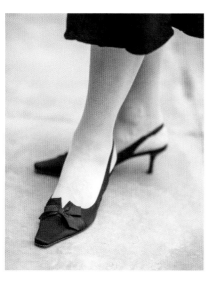
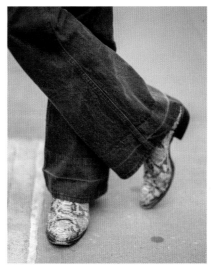
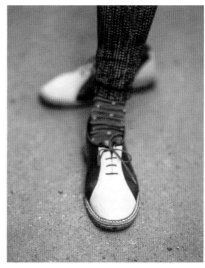

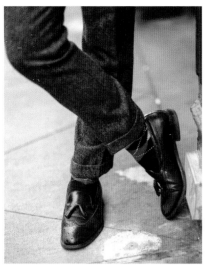
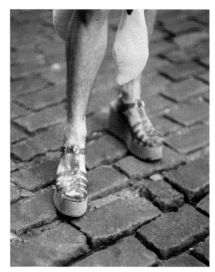
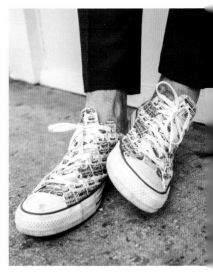
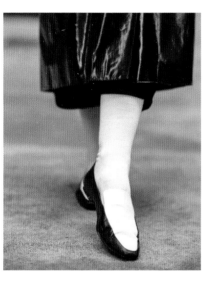
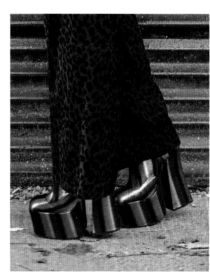
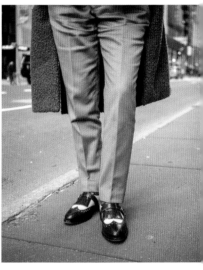
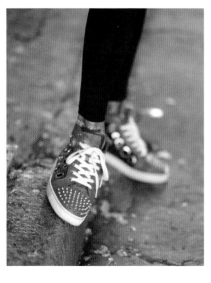
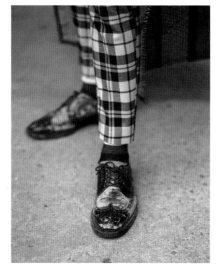
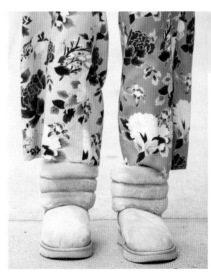

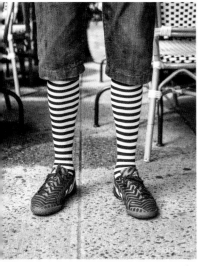
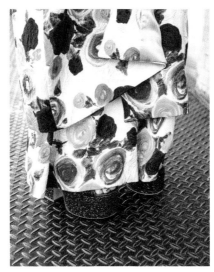
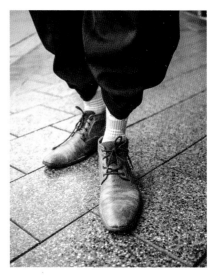
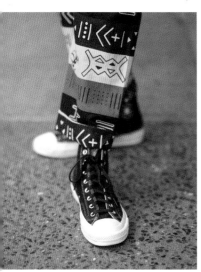
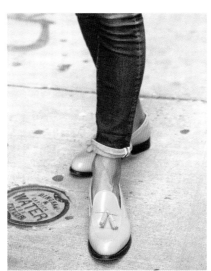
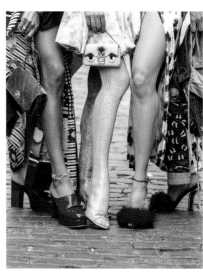
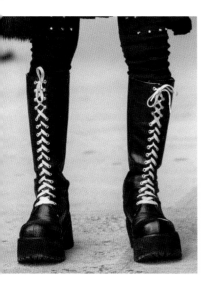
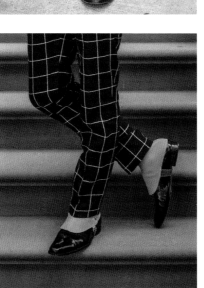
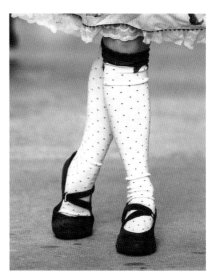

BIOGRAPHY

Robbie Quinn is an award-winning New York photographer who specializes in environmental portraits. Among his clients are rock stars, celebrities, politicians, and CEOs. His assignments have brought him to more than a dozen countries, and his photos make an authentic connection with audiences that scream joy, strength, and celebration. Robbie photographs all types of portrait projects, but by documenting and interviewing uniquely styled individuals from around the world, those who he calls Street Unicorns, Robbie helps promote diversity and inclusion in the hope of inspiring widespread acceptance of and appreciation for others.

More information about Robbie, including ways to connect, can be found at www.robbiequinnnyc.com or www.instagram.com/robbiequinnnnyc

GRATITUDE. BECAUSE YOU WOULD NOT BE READING THIS BOOK IF IT WEREN'T FOR THESE PEOPLE

A special thanks to Carol Dietz for your creative talent, direction, inspiration, and friendship as we tirelessly but delightfully worked together on the initial stages of developing this book.

To Robert Darwell and your team, for your business and legal expertise, your friendship and mixology prowess.

To Will Weisser for your guidance, honesty, and business direction. For your phone calls and hand-holding.

To Rodolphe Lachat and your team for believing in the message, going to bat for me, and for shaping and giving birth to this book. Also, for being a fabuleux Street Unicorn.

To Steven Rice for your encouragement, friendship and all your style advice.

To all the wonderful, bold expressionists of style in this book. You have inspired me, and I have no doubt you'll inspire many others. Thank you.

To my family and the many friends online and in-person that have been cheering me on. You have added to my strength and confidence.

And to Kate O'Neill, for your patience. For being interrupted a thousand and one times to be asked your opinion so I could (sometimes) ignore it. For loving me, believing in me, and being there for me. I love and cherish you.

DEDICATION

This book is dedicated to all Street Unicorns past, present, and future. And to the memory and legacy of the late, great Bill Cunningham.

239

STREET UNICORNS

Cernunnos logo design: Mark Ryden
Book design: Heesang Lee and Benjamin Brard

Library of Congress Control Number: 2021947027

ISBN: 978-1-4197-6204-8
eISBN: 978-1-64700-678-5

Printed and bound in Italy
10 9 8 7 6 5 4 3 2 1

Abrams books are available at special discounts when purchased
in quantity for premiums and promotions as well as fundraising
or educational use. Special editions can also be created to speci-
fication. For details, contact specialsales@abramsbooks.com or
the address below.

Abrams® is a registered trademark of Harry N. Abrams, Inc.

ABRAMS The Art of Books
195 Broadway, New York, NY 10007
abramsbooks.com

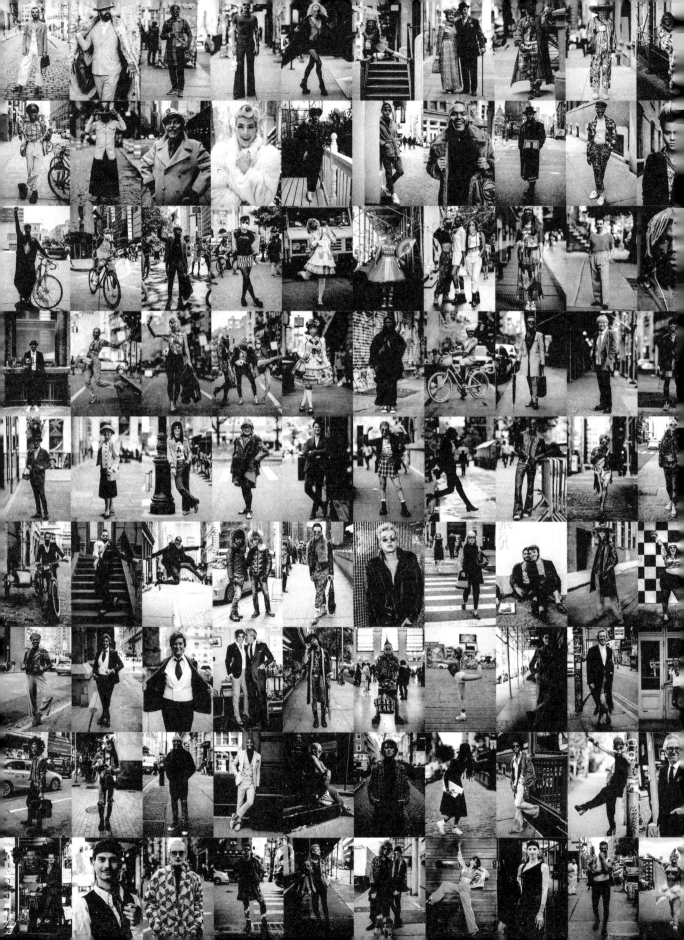